Weird Yet Strange

Enjoy!
Danny Gomez

Weird Yet Strange

*Notes from an
Austin Music Artist*

DANNY GARRETT

TCU Press
Fort Worth, Texas

Library of Congress Cataloging-in-Publication Data

Garrett, Danny, 1945-
 Weird yet strange : notes from an Austin music artist / Danny Garrett. -- First edition.
 pages cm
 Summary: "This book is a collection of the music art I did from 1971 to 2015 in Austin, Texas. Most of these images are posters. Austin music is vast. So too is the art that pictured it, and this collection is just my little corner of that art. It does, however, deal with some significant arenas of that music: Armadillo World Headquarters, Antone's, Progressive Country, outdoor events, and work that I did for Willie Nelson and Stevie Ray Vaughan. In that regard, I would like to offer this work as a partial visual chronicle of what took place in Austin music in the formative decades of the 1970s and 1980s."--Introduction.
 ISBN 978-0-87565-616-8 (alk. paper)
 1. Popular music--Texas--Austin--Pictorial works. 2. Popular music--Texas--Austin--Pictorial works. 3. Popular music--Texas--Austin--History and criticism. 4. Popular music--Texas--Austin--History and criticism. 5. Musicians--Texas--Austin--Pictorial works. 6. Musicians--Texas--Austin--Biography. 7. Popular music--Texas--Austin--Posters. 8. Music in art. 9. Austin (Tex.)--Intellectual life--20th century. I. Title.
 ML3477.8.A97G37 2015
 741.6'74092--dc23
 2015023152

TCU Press
TCU Box 298300
Fort Worth, Texas 76129
817.257.7822
www.prs.tcu.edu
To order books: 1.800.826.8911

Designed by Barbara Mathews Whitehead

This book is respectfully dedicated to

Ken Featherston

Jack Jackson

Bill Narum

Contents

Foreword

Like thousands of other Austinites in the 1970s, I decorated my apartment walls with posters advertising music shows at Soap Creek Saloon, Armadillo World Headquarters, and Antone's, among many others. The posters were colorful and beautifully done, obviously crafted by talented artists. It was great if you had actually attended the show the poster was advertising, or if you knew somebody in the band. But if not, the poster stood on its own as an affordable piece of amazing art, a true thing of beauty, and a sure-fire conversation starter when guests came over.

Danny Garrett was one of a handful of artists creating those phenomenal posters in the 1970s. They lived their lives at the intersection of music and art, and wove those two threads together for many years to create the fabric of life in Austin. Those posters were ephemeral and common as a light pole, but now they are highly prized and valuable. They recorded the colorful history of Austin in its most exciting times.

Austin offered many mind-expanding opportunities to musicians and artists back then. It was the cheapest city in America in which to live, and many found it possible to pursue artistic interests full time, while getting by on a part-time job. This reality contributed a lot to Austin becoming a mecca for creative people from around the state and all across America. People came to Austin to pursue their dreams!

My own mind was greatly expanded when I first visited Austin in 1973 as a serendipitous result of a hitchhiking accident. My new Austin friend took me to the Split Rail my first night in town. It was a funky shack of a beer joint just south of the river, and the place was rocking to the progressive country tunes of Freda and the Firedogs. During their break, a skinny young fellow, very earnest, got up on stage and encouraged people to vote for him for Texas State Senate. He was only a couple of years older than me! Where I came from, only old guys like my dad held public office. And campaigning in a beer joint? I had never seen that before. Could it be that we young people could elect our own leaders? Wow, what a possibility!

When I moved to Austin the next year, it wasn't long 'til we had a hippie mayor, a thirty-year-old former UT student, who often showed up on stage at the Armadillo. What kind of amazing, magical place was this, where folks barely older than myself were running for office and getting elected? The possibilities were exciting, and suddenly my political science degree seemed very relevant.

I have long felt that it is impossible to describe Austin in the 1970s without using the word magic, because it was truly a magical place. When Danny invited me to write a foreword to his book, I had this in mind when I read his manuscript: would he use that word? Yes he did, and very early, too. It let me know that we were on the same page.

Danny has created a well-written, very entertaining history of Austin's most vibrant era.

It is full of the characters, musicians, clubs, and energy that made Austin the "Live Music Capital of the World." He shares his unique perspective of the scene, and recounts his own role in making it happen. I learned a lot in reading this book, and it sparked even more great memories.

The Austin of the 1970s is gone, but captured and fondly remembered in this work. Everything changes, they tell us, and not always for the better.

Reading Danny's book reminds us that we had the best of it.

—Max Nofziger

Max Nofziger *hitchhiked into Austin in 1973 and moved there the next year. For several years, he sold flowers on the street corner at a prominent South Austin location. In 1979, Max ran for city council and lost. He lost three more campaigns, then finally persevered in 1987, winning a seat on the city council. He was reelected twice and was chosen to serve as mayor pro tem by his colleagues before retiring in 1996. Max was a passionate environmentalist, supporter of music and the arts, and a defender of the "little guy."*

In the early 1990s, Max was instrumental in creating the Austin Music Commission. After a few months, he conferred with Chairwoman Nancy Coplin, and after tossing a few ideas around, they came up with the phrase "Live Music Capital of the World." In 1992, it was put before the Austin City Council, and passed unanimously.

Today he is a musician, songwriter, and practicing writer, at work on his memoirs.

Preface

A painter paints pictures on canvas.
But musicians paint their pictures on silence.
—Leopold Stokowski

This book is a collection of the music art I did from 1971 to 2015, in Austin, Texas. Most of these images are posters. Austin music is vast. So too is the art that pictured it—and this collection is just my little corner of it all. It does, however, deal with some significant arenas of that music—Armadillo World Headquarters, Antone's, progressive country, outdoor and freelance events, as well as the work that I did for Willie Nelson and Stevie Ray Vaughan. In that regard, I would like to offer these images as a partial visual chronicle of what took place in Austin music in the formative decades of the 1970s and 1980s.

It was my great pleasure to begin creating music art at precisely the time that such art began to chronicle the establishment of the Austin music scene in the early 1970s. It was my great honor to depict some of the musicians and their music that made it memorable. It was my great privilege to work with other artists so talented and open as to provide me with the confidence, knowledge, and inspiration to actually become an artist myself.

I was fortunate enough to be included in that group of artists, and the images that appear on these pages are my contribution to the music art that was created. In various chapters, I have attempted to write down the contexts in which they appeared, and from which they got their being. It's really a collection of notes—an imperfect palaver—but I have tried to tie together the people, places, times, and circumstances that allow this art to function as a visual narrative of what transpired when the music was being laid down.

This is principally a book of images, and I will be the first to admit that I am probably better at creating such images than I am writing about them. Still, this is a book and the telling of what happened then is essential to understanding what it is that line and tone are also saying. So, bear with me if you will when I journey into realms where names, dates, and places are put forth abundantly without much explanation or analysis. I'm trying to cover a lot of pertinent ground without straying too far from those images.

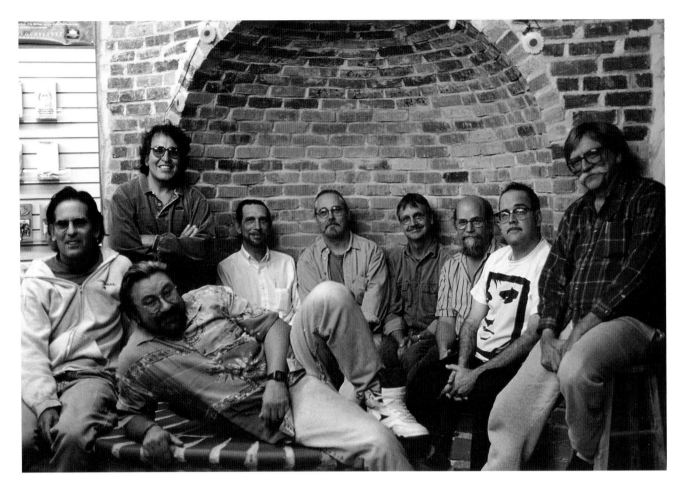

Above: **Music Artists at Vulcan Video, 1997**

These are my music artist colleagues and friends, or rather most of them, and me. On this particular occasion, we were gathered together for a group shot at Vulcan Video I, South Austin's cult video store. The store itself is a creation of Diane White, wife of Houston White, the proprietor and founder of the Vulcan Gas Company, arguably Austin's first live music venue of note. Gathered together in a nook of the store, we sit under a brick façade and quarter-dome constructed by Jim Franklin. Pictured here are, from left to right: Kerry Awn, Micael Priest (reclining), Henry Gonzalez, Bill Narum, Sam Yeates, myself, Mr. Franklin, Guy Juke, and Jack Jackson (Jaxon).

Photograph by Doug La Rue

Acknowledgments

I would like to recognize the many people and places that contributed to the crafting of the music art that I created. They are wide ranging and numerous, and time and memory have conspired to deprive me of many names and circumstances. I have therefore decided to restrict such acknowledgments to the artists and printers that gave this art its being.

The artists: Jim Franklin, the godfather of it all, was already resident with pioneering music art that went all the way back to the midsixties. I arrived on the scene in the spring of 1971. There were others, some getting to town ahead of me and those who shortly followed. Eventually, there were more music artists than I can name; more even than I am aware of. They all made significant contributions to the imaging of Austin music. However, there was a hardcore group of them who created that art along with me during the 1970s and 1980s, and the ones that I consider my closest colleagues. In addition to Jim, they are, in alphabetical order: Kerry Awn, Ken Featherston, Henry Gonzalez, Jack Jackson, Guy Juke, Bill Narum, Micael Priest, Dale Wilkins, and Sam Yeates. These are my cohort, the ones I worked with the most and the ones who influenced me the most.

There were many more, though I cannot name them all. The following were also close colleagues, friends, and influences: Steve Austin, Tom Baumann, Tony Bell, Eddie Canada, Cliff Carter, Robert Ekstrom, Tom Evans, Sam Hurt, Nels Jacobson, Frank Kozik, Richard Mather, Gary McIlheney, Diana Ray, Marian Royal, Gilbert Shelton, Rick Turner, Scout Stormcloud, C. P. Vaughan, and Monica White.

The printers: These are the offset and screen printers who gave the art life. **The poster printers**: Terry Raines, *Speleo Press*; Benny Binford, Straw and Gary Pierson, *Calico Printing*; Michael Morgan and Steve Uzzell, *Express Press*; Chris Houston, *Ginny's*; the folks at *Futura Press* and *Kestrel Printing*. **The screen printers:** Bill Livingood, *Slow Printing*; Jerialice Arsenault and Chris Vreeland, *T Shirt Lady;* Chris Vreeland and Felicia Vreeland, *Vreeland Graphics*; John Schexnayder, *Action Screen Graphics;* Harold and Teresa Harris, *Purple Crayon Graphics.*

It has been years, and I know I've left out some people that should be acknowledged. My apologies for not remembering, and my appreciation to you for printing my work. And a special shout-out to Austin Litho, whose camera work captured the art and enabled the printing, and whose midnight efforts saved many a deadline. And also to Willie Radar, who put up more posters at more places than anyone back in the day. Thank you all.

I would also like to recognize my wife, Kelley. She encouraged me when I despaired of being able to write such a book, and many times believed in it more than I.

Hopefully, the writing on these pages are notes of words illuminating notes of music. In essence, these are really riffs of a visual intent.

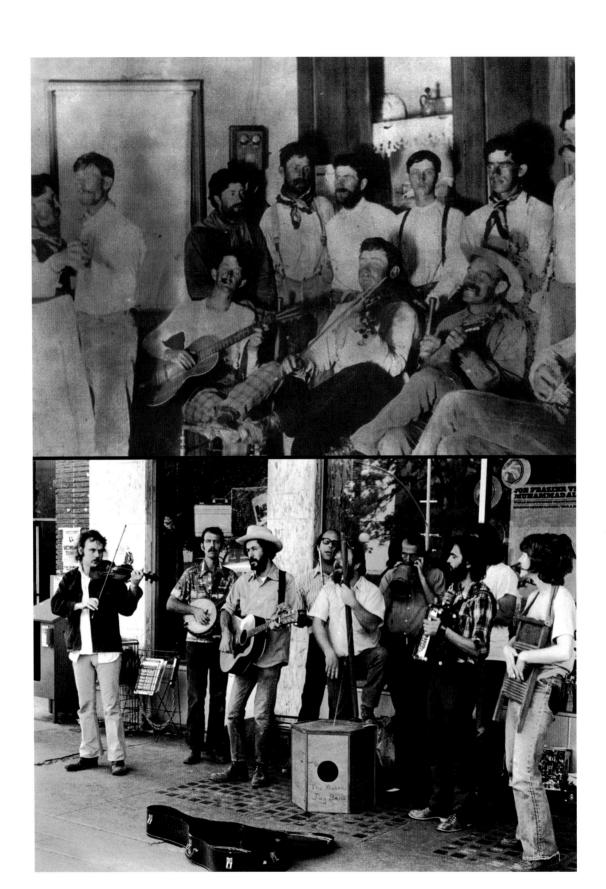

1

Austin 1971

Music!
Was there anything here before it began,
and after it's over, where has it gone?
—Fred Schrier, *The Balloon Vendor*, 1971

I
n the 1970s and 1980s something extraordinary happened in Austin, Texas. What took place during those two decades and the years to follow would establish the state's capital city as a world-renowned music mecca and an exceptional cultural presence. Though the term "Live Music Capital of the World" wouldn't be coined for years, the foundations that would inform such a notion were laid down during these two decades. Such a moniker is only part of the story. It was not just that the music was live, but that much of it had literally come to be alive in the precincts, warrens, and dusky venues of this place through a cultural and human process of attraction that kept the music coming while a community formed around it. When it was done, the cultural force that is Texas music found a locus and a focus here that had been largely elusive elsewhere in the state.

Texas is known for many things, not all of which flatter it. It's a big place after all, and that fact is often reflected in the outsized dimensions of its pride. Such a condition is one of the reasons that many beyond its boundaries hold opinions of a less-than-flattering variety. Yet on one score Texans can be justifiably proud and noncitizens justifiably envious—Texas music. There

Opposite: **Jug band, then and now**
About a century passed between the top picture and the bottom one. In sepia tone and grayscale, they capture an ongoing Texas music legacy. One was in a bunkhouse in the 1870s, while the other was the Austin Jug Band performing on the Drag in the 1970s. Both were taken in establishing decades that followed those of upheaval. While the flavor of the times—and the music—may have changed, the instruments, the hirsute players, and the setting have not. The countenance and bearing of these musicians embody a common denominator of Texas and its music, while the scenes are in the capital of both.
Top: Photographer unknown
Bottom: Photograph by Alan Pogue

just seems to be something about the place that conjures forth an excellence and abundance of it, whatever the type. Certainly this has to do with the land and the spirit that informs it. Perhaps it has to do with dimension itself—the spaciousness that somehow calls forth sound both to describe it and to drive out the silence of isolation. Without a doubt, the music has certainly been inspired by the grand and ordinary beauty of the place.

But it has more to do with the people who were either born or drawn here—the ones that made the music. People like Scott Joplin, Sippie Wallace, Bob Wills, and Willie Nelson, Ornette Coleman, Lydia Mendoza, Buddy Holly, and Roy Orbison. The sounds of the state were propagated through these and others. Joplin refined ragtime so that a couple of generations later Ornette Coleman could spin jazz out of Fort Worth. Sippie Wallace laid down Texas blues in a line that ran directly to Stevie Ray Vaughan through Freddie King in a triangulated vector from Houston, through Gilmer, to Dallas. Willie Nelson helped marry country to rock, just as a generation earlier Bob Wills had wed swing to country and western. Lydia Mendoza took the ancient music of Spain and Mexico to craft material that Selena would draw on to become a star in the last decade of the last millennium. Holly and Orbison would take the rock and roll music of Mississippians Elvis Presley and Muddy Waters and put a Lone Star brand upon it.

As the sixties morphed into the seventies, Austin, practically dead center in the state, was fortuitously positioned to bring all of this together. Both physically and culturally, Austin sits at a crossroads. The spine of the state, the Balcones Fault, divides the city east to west, while the bisecting Colorado River does the same north and south. Looking west, the Balcones formation—its fault and escarpment—marks the beginning of the system of deserts, uplifts, and alpine ranges that constitute the great American West. To the east the black-earth farmlands, forests, and coastal plains stretch into Oklahoma and Dixie. Climate overlays such geology neatly. North of the city is the bottom of a temperate band that allows for some snow in winter along with blazing hot summers, while to the south a subtropical zone stretches over coastal plain and prairie to the humid Gulf of Mexico and the palm-lined valley of the Rio Grande. As for the people, the city demarks the populated eastern half of the state from the more sparsely inhabited western reaches, while a cross matrix separates the northern and eastern parts of the state, settled mostly by northern Europeans, from the historic and Hispanic south and west.

Within the city itself are crossroads. The river separates downtown, the university and government complexes, and affluent, mostly Anglo, neighborhoods north of the river from the working-class precincts on the south bank. Interstate 35 (old East Avenue) has been a huge demographic delineator, separating the white communities west of the highway from the mostly African American and Hispanic east side. In the 1970s such separations were much more compact and distinct. It was a quiet city of modest size with an unarticulated but solid sense of community and long-established neighborhoods of distinct character. The twin economic booms of the early eighties and midnineties began to erase or blur many of these ethnic denominators. In the twenty-

first century it all moved into the third dimension as downtown went vertical with residential high-rises. Within, around, and behind all this, the city was serenaded with a rising crescendo of music continually made.

Such physical and cultural vectors have long invited creativity and paved the way for it to travel about easily. The city has always been a beacon in that way, providing a home for the eclectic and nonusual. Different drummers found a steady beat here. The energy and creativity of the place had always beckoned such—an oasis in the relative cultural wastes of central Texas. That's the way sculptress Elisabet Ney and the writer O. Henry found it in the nineteenth century; that's the way visitors to Austin City Limits or South by Southwest (SXSW) find it today; and the way Willie and Stevie found it in the 1970s. Curiously though, it has not been the differences—in geology, climate, demographics, cultural poise, or strange proclivity—for which this place has been most noted. What really distinguishes it is the ability to synthesize and amalgamate these disparities. It's been a place where new common denominators have been forged from the interplay of older ones.

And in no arena is this more pronounced than in the music created and performed here. It arrived early, steadily, and from all the lines and corners, rivers and coastal bends that bound the state. There was zydeco from the marshlands of the Sabine; blues from the eastern pine forests and deep urban wards of Dallas and Houston; accordion-driven conjunto, norteña, and Tejano sweeping up from the southern rangelands along with the West Side Sound of San Antonio; rock and roll from the metro areas and towns; and country and western from the rural communities and raw stretches of hill, plain, and prairie.

It was to be the joining of these last two forms, rock and country, which would produce a signature sound through which Austin would initially find fame and upon which its live music reputation would be built. The nation was polarized then, and the divisive spirit of the times had radically estranged these two genres, with each embedded in cultural, social, and political perspectives that were at odds with one another. Dialectically described as progressive country or redneck rock, it would become known simply as the "Austin Sound." Conflation or no, the music was a breath of fresh air, even cathartic. A reconciliation of sorts appeared on the music stages and dance floors of Austin that eluded the wider American community. And that piqued interest. It also fit in quite well with the singer-songwriter dynamic that was inherent in Austin's well-established folk scene. Upon this new sound, the city's music reputation would first be founded. It would provide a huge opportunity for a host of new musicians and fire a career boost for others already established. And it would take one, Willie Nelson, from a burned-out house and performing career in Nashville, bring him home, and set him on a trajectory to become a national music icon.

The launch pad for such a shot would be a highly unlikely venue. South of the river and situated on the crossroads of South First Street and Barton Springs Road, it was a cavernous

wrestling and performance arena, semiabandoned and strewn with industrial detritus. Refurbished by a group of hippies, it was called Armadillo World Headquarters, and it would become the cornerstone of Austin's music foundation. That and an odd Elvis concert in the fifties would guarantee it a coveted spot in Austin—and Texas—musical history. But the Armadillo was much more than a major music hall—it was, in fact, something of a cultural center and an alternative state capital for an alternative segment of the Texas population. It would be the first stop and a center of congregation for an ever-growing diaspora of young people arriving daily from all over the state. Yet at the same time, it was just another new venue lighting up the night and joining with older ones to create a growing constellation of listening rooms scattered across the firmament of the city.

One such stellar club blazed into being at a downtown intersection in the hot summer of 1975. When it first appeared at the corner of Brazos and East Sixth, it cast a light that would in time musically illuminate Sixth Street from Congress to the interstate, and beyond. In July, Antone's, "Austin's Home of the Blues," opened across the street from the venerable Driskill Hotel. Clifford Antone had a vision of establishing a music hall committed to bringing the blues and zydeco he grew up with in Port Arthur to the city he first came to as a university student. His dedication to both the aging blues greats and the young blues musicians in Austin would give rise to a musical alchemy between these two groups that would see the Austin Sound turn decidedly blue in the 1980s. One of that number, Stevie Ray Vaughan, through a remarkable personal alchemy of his own, would rise toward superstardom that very same decade.

Along with and outside the expansion of clubs, rooms, and halls, other stages appeared for the presentation of the music. All along, but especially in the early days, freelance promoters booked the music into hired arenas, both public and private, while others sought to move the music outside, supporting a long love affair that Texas has had with al fresco music. Some of these events became serial. One of the most enduring was started in 1972 when Rod Kennedy, a folk enthusiast and promoter, launched the first Kerrville Folk Festival. That same year Willie Nelson invited an intimate coterie of musical friends from Nashville and Austin to a gathering in Dripping Springs. A repeat festival the following year at the same spot became the first Willie Nelson Fourth of July Picnic. These two (almost) annual outdoor festivals, unlike many others, grew in both size and quality over the years and in no small way inspired *Austin City Limits* to start its own in 2002.

Indoor or outdoor, live music in the 1970s became almost an ether of sorts, in that it constituted a pervasive medium in which the most significant communication occurred—from the interpersonal, through the communal and tribal, to the esoteric. Communities of all sorts sprang up around it. There were the musicians that created it. There were the ones who worked for the venues, which in the case of the Armadillo were more like a family than a community. There were those who professionally worked in support of the music—in the industry, so to speak. And there was the larger community that existed just to hear it. Around, behind, and through all of this, a body of art was being crafted that was coming to describe both the music and the communities that thrived upon it.

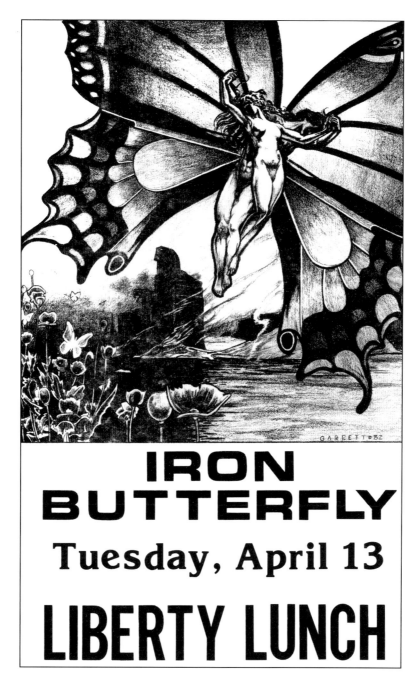

Above: Iron Butterfly, Liberty Lunch, 1982

Iron Butterfly was a viable contemporary band when I arrived in Austin in the spring of 1971, still on the charts. Liberty Lunch didn't exist. A decade and a year later, when I did this poster, the band was now late and great, while the venue had come into being along with dozens more in the intervening years. In this butterfly incarnation, the iron wings flank commingled male and female bodies floating above the waters of a dark lake. Here vapors of waking sleep arise from the poppies that line the shore, while in the distance a statue of Marduk, chief of the Babylonian gods, strains against the very stone that not only constitutes its being, but also confines it to its plinth. The point of the image is to highlight the tension of opposites resident in the name "Iron Butterfly"—such as darkness and light, being and deity, gravity and levity.

Music and Art

There was a genuine, almost fanatical love of the music then—an unconditional kind that seemed to stand in contrast to the affinity many had for the corporate music from the coasts or the studio confections that Nashville was offering up. On the ground in Austin the mood was decidedly countercultural, with a strong tendency toward the unordinary, and an ear toward the roots of American music. And there was no mistaking it—all with a purposeful Texas flavor. Slowly, almost imperceptibly at first, art began to generate a light that would illuminate the heat that the music was producing, and give it form. A growing body of images from a growing number of artists was doing just that. And I was lucky enough to be among that number.

What I would like to present in these subsequent pages is a personal view of the creation of this music art—specifically posters—during a period that so firmly established Austin's version of it. For clarity, and relative to my own personal contributions, I am going to mainly concentrate on the decades of the seventies and eighties and the musicians, venues, and colleagues that informed my work during those years. Though I may venture into what went before and what followed in subsequent years, this is a review of my work, its contexts, and what took place in those two formative decades. Beyond that, this is a story of the Austin music poster and its formative beginnings. The promotional music bill has been around since venue, musician, artist, and printing press first conspired to produce one—back when the city called itself "Waterloo." However, the consistent and consistently high-quality music poster really started with the Vulcan Gas Company, the pioneering venue that died the year the Armadillo was born.

Actually even that had its misty beginnings in the halls and basements of the University of Texas and the state capitol in the early years of the soaring sixties. It all had to do with a group of young artists that initially congregated around a legendary publication. The *Texas Ranger,* like the *Harvard Lampoon,* was an iconic magazine tied to a major regional university. And like the *Lampoon,* it was a satirical humor publication. In its prime, from 1956 to 1965, the periodical was a tribute to Austin's long love affair with the forbidden, the absurd, and just plain fun. In the early sixties a group of the magazine's writers would inadvertently launch a new era of music art in the city by bringing a handful of eclectic artists onto the staff. What these guys crafted would certainly qualify as meaningful relative to the "Keep Austin Weird" sentiment that would emerge decades hence.

These artists—Tony Bell, Gilbert Shelton, and Bob Burns—would lay foundations of weird far beyond the scope of that publication and anything the university could proffer. Added to this eclectic group would be Jack Jackson, a.k.a. "Jaxon," a South Texas artist/historian who would not only contribute materially to the *Ranger,* but who would also produce the world's first underground comic, *God Nose*. Appropriately, this 1964 graphic tome was produced on a Xerox machine after hours in the state capitol print shop, underground beneath the dome.

As graduation and other attritions removed these artists from their academic incubator,

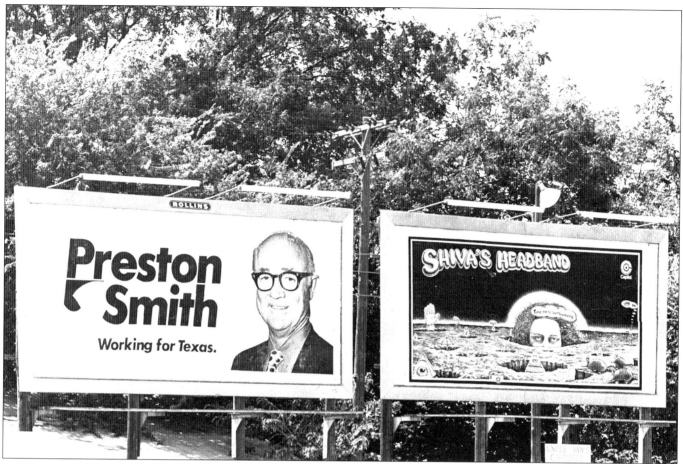

Above: Signs of the times in Houston, 1972

This is a snapshot of a paradigm in midshift, as described by outdoor advertising. The year 1972 was an election year. Preston Smith was hoping to re-up as governor of Texas. In such service, billboards were dealt out everywhere, including this one taken near the University of Houston campus. Overnight another had appeared, touting *Take Me to the Mountain,* a new album by Shiva's Headband on Columbia Records. Here we see the artwork of Jim Franklin, revealing a countercultural new order. Already, the weird from Austin was making itself felt. Even in Houston.

Photograph by Burton Wilson

they sought another receptacle for their well-honed strokes and contrarian ideas. So when the *Rag,* an off-campus underground paper bloomed on the Drag, across Guadalupe from the university, they crossed the street. Joining them was a new up-and-comer from La Marque, Texas, Jim Franklin. The timely political, social, and cultural images that the alternative weekly produced brought the publication alive and increasingly presented an emerging hometown visual iconography. Reflective of a growing counterculture in Austin, the art was very popular, but the market could consume just so much of its often doctrinaire contents. However, subject matter was about to shift from the society, culture, and politics of the community to the music increasingly being made therein.

Tasked by Houston White, an old friend, Gilbert Shelton created a logo for a genuine counterculture music hall. Just four days before Halloween 1967, the Vulcan Gas Company

opened its doors less than a dozen blocks down Congress Avenue from the capitol. Following the lead of similar new venues in San Francisco, the presentation of the music and accompanying light shows brought the Bay Area style onto the shores of central Texas. And like those venues, the Vulcan began to produce psychedelic music posters as well. Following much the same template as the San Francisco pieces, these were eclectic images overlaid with elaborate lettering and printed in bright color schemes. Shelton, Bell, Jaxon, and Franklin quickly began producing signature music bills for the club. These artists would soon be joined by John Shelton, Jim Harter, and Charlie Loving. Riffing off—and materially contributing to—the San Francisco style, these artists couldn't help but give it a Texas twist. And with that the Austin type began to diverge from the San Francisco form just when the latter was becoming known and famous worldwide.

The Vulcan posters could be quite large, sometimes twenty-three by twenty-nine inches. Over the nearly three-year life of the venue, some forty-five or so of these posters were produced. Because many were screen-printed and expensive, they represented a unique Austin offering. They were also a tangible connection between Austin and San Francisco. Toward the end of the next year, Gilbert Shelton intensified this link by following Janis Joplin and Chet Helms out to California, adding further Texas flavor to the West Coast images. There he would be joined by still other Austin expats—Jaxon, Fred Todd, and Dave Moriarty, to found Rip Off Press, the Gutenberg of America's counterculture.

Back in Austin, other music venues started to emerge as bands began to proliferate, and with them the need to promote. Even with the loss of such establishing lights as Shelton and Jaxon, the posters kept on coming—with Franklin more and more droving the herd. Other artists were now starting to find their way into town as these new places opened. The vibrancy of the Vulcan posters was imitated in the bills for these venues. Problem was, most of the smaller rooms couldn't afford that kind of effort and expense. So while the Vulcan bills were the standard to shoot for, smaller one- or two-color pieces started to appear, usually as flyers and similarly sized bills. The Austin music poster was about to enter a new phase.

In the pages to follow I will attempt to trace that evolution, as well as to comment upon the history of the music, musicians, and venues that informed it. I also want to present a visual linguistic of the music bill—the grammar and syntax of the images thus created. I would like to explore the ideas behind the art and the ability of pencil, pen, and brush to speak clearly to their subject. And, make no mistake, that subject is music. Though I was never a creator of the music, I was fortunate to be among the few who came to enhance it visually, and among the many who remained to hear it. And that was a hallmark of this period—the love of the music and the desire to remain where it was performed.

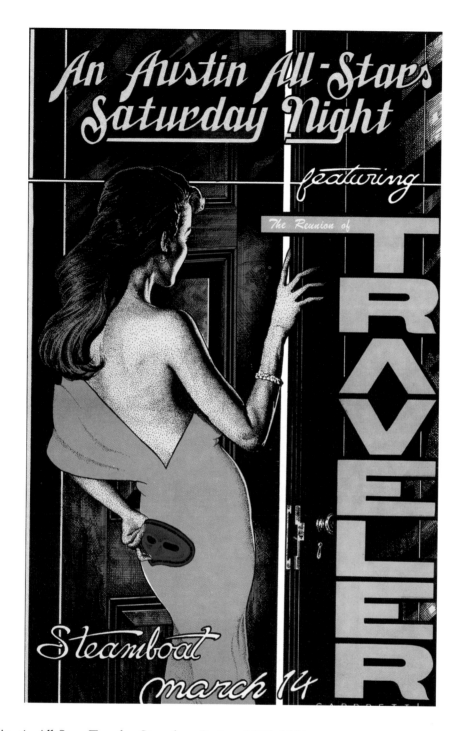

Above: **Austin All-Stars/Traveler, Steamboat Springs 1874, 1981**

About a decade after arriving in Austin, I was producing posters like this one, celebrating iterations of local musicians. This is the standard 11"×17" format, but quite unusual in that it is a full-color (four-color) bill instead of the typical two-color piece. At the time, Steamboat sprang for three more of these colored pieces. Mystery is served up in this image. Here we have an elegantly dressed woman facing away and opening a door on the promoted festivities. The mask she holds is made of denim. *Denim* was also the name of the band of the reunion, after it became *Traveler.*

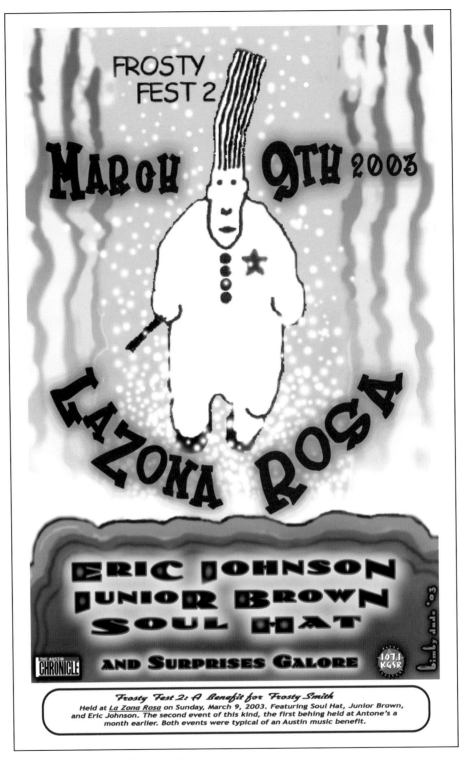

Above: **Frosty Fest 2, La Zona Rosa, 2003**

This poster was my contribution to promote a benefit for drummer Barry "Frosty" Smith. Frosty had played with national acts such as Parliament/Funkadelic as well as numerous Austin bands. Taking place at La Zona Rosa, this was the second such show, intended to raise money for a medical condition. I've done a number of benefit posters, but on this particular one I used art generated by Frosty himself. I merely laid out the poster and provided the lettering. This is one of the very first posters that I created by computer.

2

The Armadillo

You can't read the label if you're inside the bottle
—Wally Stopher

It was nearing midnight and I was alone at Sheauxnough (sho'nuff) Studios. The old Bolm Building was large and cavernous, and the creaks and moans that wafted about indicated that I was not alone. Unseen souls stirred somewhere. Most everyone was across the river at the Armadillo seeing the Charlie Daniels show, while I sat there working on the poster for it. I had missed a deadline—mightily so. No matter, at this juncture all marketing was essentially pointless. The club, and the decade that contained its being entirely, had only another three weeks to live. The poster would be afforded no chance to sell a single ticket; it would become an artifact without passing "Go." So I sat there in the silence in the late-night gloom, rendering Charlie as a fragmented shadow behind a frosted glass door. That's when the call came in.

It was from one of Micael Priest's friends in New York City. She was obviously distressed as she passed on tragic news—John Lennon had just been shot dead outside the Dakota, his residence across from Central Park. I went a bit numb, mumbled something to the caller and replaced the receiver into its cradle. The silence only deepened as I tried to get my head around what I had just heard. It seemed old news of the worst sort, as if the assassinations of the sixties had reached out to claim another victim on the eve of the eighties.

I opened up one of the casement windows, leaned out into the cool December air, and gazed down the street toward the university. Low, rusty clouds balled up just above the UT Tower, gathering the beams from spotlights fixed on the building so that the whole thing resembled nothing so much as a huge inverted exclamation mark rising out of the trees. And, it now seemed, the whole city was inverted with it.

All over town, the earth had shifted under everyone's feet, and everyone knew it. It all looked the same, even felt the same, but the same it definitely was not. It still resembled the magic place that I had come to almost a decade before, but significant parts were starting to fade out and vanish. What remained of the older stately homes and period buildings were being torn down all over town, particularly in the university area. And along with them went the affordable rents

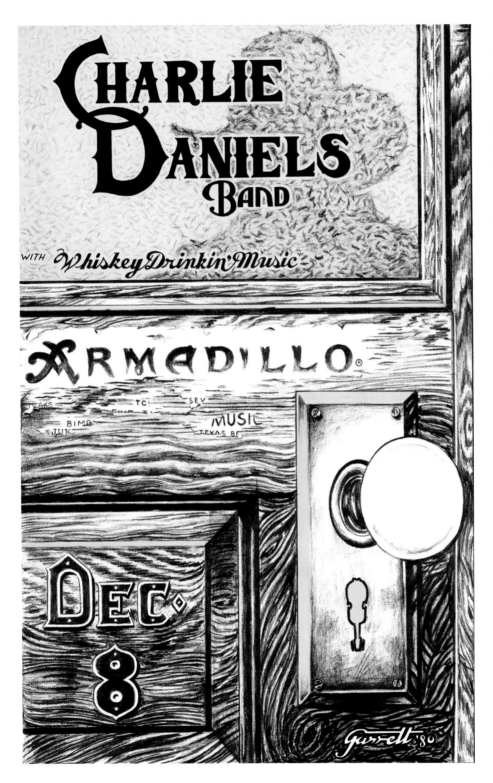

Left: Charlie Daniels Band, the Armadillo, 1980

I always enjoyed doing posters for the Armadillo; they tended to be fun, and you can add to that, unusual and a bit absurd. In what I have created here, you will see these three elements in abundance. On this poster, I went a bit noir, as I felt that particular cultural slant had nothing to do with Charlie Daniels whatsoever. This is a cropped, front-on view of the office door of a shamus, or private eye—So Cal style. Charlie, beneath his famous domed cowboy hat, hovers in silhouette behind the frosted glass. The venue name appears in bits of torn-away paper that had been affixed to the wooden door, while the date takes the form of an office number riveted under that. Beneath a ceramic doorknob, on a metal plate, light pushing through the keyhole illuminates the shape of Charlie's fiddle.

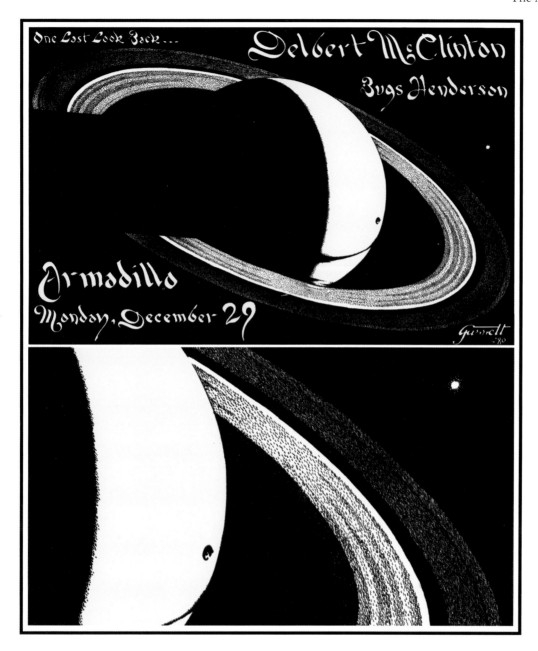

Above: **Delbert McClinton, the Armadillo, 1980**

This is the last poster I did for the Armadillo World Headquarters—Delbert McClinton and Bugs Henderson. The date for it was December 29, 1980, two days before the final performances there. I chose as my subject matter an image that had appeared recently in the news—the photograph taken by the space probe *Voyager I* as it passed by and looked back at Saturn, on its way out to the outer solar system, and beyond. In one last incongruist nod, I chose a Mideast script as my model for the lettering. I felt the image and that glyphic assemblage as improbable enough to suffice. Curiously, this is also the only poster that I did for the 'Dillo that contained an image of the armored mammal, *Dasypus novemcinctus.* But it's not really an image of an armadillo at all, just a moon shadow—and only visible in detail. This is my parting homage to the one hall most responsible for making Austin music what it is today.

for residential and workspaces. Even the Bolm itself, whose warrens teemed with artists, musicians, jewelers, luthiers, and hermits, was under notice. Across the street the *Austin Sun*, the seventies alternative weekly newspaper, had closed its doors the year before. Musically, venues like the One Knite, South Door, Alliance Wagon Yard, and the first Soap Creek Saloon were all gone as well. A couple of new clubs were appearing down from Antone's on Sixth Street, though Antone's too had closed.

On Sixth the new "entertainment district" blossomed, feeding the illusion of both continuity and progress in the burgeoning music scene. But during the day, as the clubs lay dormant, more and more cranes appeared downtown, casting long shadows over them. The skyline was changing. Oil money from Houston was starting to pour into the city, chasing down the new high-tech potential and buying up property. This was sending tectonic shocks through real estate strata all over town. Rumblings warned that the buckling and folding were about to begin. And more than just skylines were bound to change.

I felt it there in the Bolm and I'm sure they felt it over at the Armadillo as well—when you're of a certain age, there's nothing like the first death of a Beatle to make you feel that connection between feet and earth. It reminded you that ultimately in life it is almost always gravity over levity. Something bumped and scraped down the hallway by the stairs; a door opened briefly and thin music was heard before it closed again. I began to wonder if there had been a phone call at all. Moving away from the window, I returned the phone to Priest's area. Slipping into the record room, I cued up "Working Class Hero" from *Plastic Ono Band* and then returned, heavier now with new and unbidden knowledge, to the drawing board.

As Lennon's voice penetrated the studio, I found it difficult to focus upon the task at hand. The world seemed to have diminished palpably. I tried to concentrate, but once more found myself at the window, once more looking at the UT Tower. It struck me viscerally how fortunate I was to be a part of the music, if only to give it visual form, while those like Charlie and Lennon gave it being, and places like the Armadillo gave it a home. Over the next week I was to do one more bill for the place, this one on time. It was for the December 29th show with Delbert McClinton. Two days later Asleep at the Wheel and Commander Cody would close out the seventies with a final performance on New Year's Eve. As the last notes faded from the stage in the weest hours of the morning, the Armadillo World Headquarters was no more.

A Counterculture Capital

It was on the seventh of August, 1970, that the Armadillo World Headquarters opened its doors for the very first time. It was high summer in Austin, Texas. By this time of year any moisture that might have lingered or strayed into July is usually long gone, and baking heat replaces humidity as the seasonal complicant. Over at AWHQ the new tenants had barely moved in. The space was vast and still being brought under control. Nooks yielded the accumulated stuff of years;

crannies revealed more. Dressed in cutoffs, huaraches, tank tops, and for the most part, little else, some seven hundred or so souls came to be sitting around on pieces of carpet scattered on the concrete floor before a solid brick stage at the south wall of the large building. Because there was as yet no beer license, little more than water was available to cut the heat. They listened that first night as the dulcet tones of Shiva's Headband and the Hub City Movers pushed about through the caged air.

The vast majority of those listening that first night were born shortly after the Second World War; hardly a one was over twenty-five. Most had come of age in Texas, and many in the Armadillo that night had deliberately absented themselves from the various communities into which they had grown up in order to live a countercultural lifestyle in the state capital. To many, Austin was first a refuge and then a home. For a large number of those who journeyed to Austin as the seventies began, being countercultural was typically the case. Even if it wasn't, if you were young it was still the best place in Texas to be. If your interests or profession were connected to music, there were very few places on the planet as good, and none better. As always, the city was openly welcoming of the young and the different.

But it was more than just being young, or energetic, or even creative that brought them to town. Something was happening; something special, and something essential. Culturally essential. Whether what was happening was revolutionary or evolutionary is now something of a real question, looking back over it. Of course at the time, we all thought it was revolutionary—just check out the literature of the day. We were young, and from that particular perspective much flows. Because all was dynamic, from a youthful view it was also active and reactive, and we were young revolutionaries. Now that years have passed, and as is wont in life, youthful action has given way to the pensiveness of maturity. Then it looked like revolution, but now it feels more evolutionary in nature. It was not merely a reaction to what had gone before; it was also a big departure from it. Whatever it was, it unleashed a primal energy that seemed to infuse everything—and nothing captures that energy so much as the music that emerged from it.

The timing was more or less perfect. While the music was first forming up, both the United States and the world at large were in a rare state of cultural fermentation. This followed an unsettling period of shifting paradigms that the sixties had brought. That decade had upended the planet. Change that eluded the fifties defined the sixties. In America, the civil rights movement and the war in Vietnam were the events that dominated the decade. Mostly around these two issues, it all just opened up. The resistance to the war had created, as a side effect, a strong sense of solidarity among the young, as had the struggle for civil rights and equality years earlier. Where there is yin though, there is inevitably yang. Segregation, the American flavor of apartheid, was gone, but at the price of having viable local black communities. The war had widened, but even more so, the opposition to it. Eastern thought and mind-expanding drugs had awakened a sense of spirituality in many, even as renewed hubris and hedonism, along with heroin, cocaine, and speed moved up to check it.

The sixties emancipation of race and gender tended to emancipate consciousness in general. Expanded horizons of thought brought forth exploration, creativity, and a budding confidence in the new. The sixties critically informed the seventies and those maturing in it. However, there was no real demarcation to mark the decade's passage, though Woodstock, Altamont, Apollo 11, and Charles Manson sure pegged out 1969. Beyond all of that, the decade was marked by a powerful artistic expansion that transformed the cultural and intellectual landscape. While such an explosion produced the requisite heat, it also produced an abundance of light that would brighten the decades to come. That creativity provided a new looking glass for the world even as it transformed it.

Embedded in all of this, a generation had come of age. As it did so, it was serenaded by a richness of music that the idea of America had always generously allowed. It was a musical heritage which described the national experience, but also produced something indefinable that found its way into the inner landscapes of its listeners. It filled them with the heartbeat of a nation, from the systolic beat of gandy dancers and field hands conjuring forth ballads and rhythms from soil and toil, to the diastolic melodies of the American songbook. All of this was jazzed in the prewar years and electrified in the postwar years, giving this generation a muse of their own.

As the seventies dawned, the cultural and social landscape of Texas had become downright interesting. Suddenly longhairs were everywhere. A full-blown popular youth movement dominated the national scene, especially in the universities, which were filling with baby-boomer young. Forged in the assassinations, the liberation movements, and the broadening opposition to the war, a new counterculture took shape across the land. But many, if not most, did not join in. Society split, and in Texas, cowboys and hippies squared off.

In many of its communities the next generation clearly felt unwanted, and in many they were. In the small and midsized towns the generation still in charge was neither persuaded nor amused. The tensions created were not only uncomfortable, but could often be downright dangerous for those of unconventional mindset and appearance. Many young people became isolated in their own hometowns. Advantages of mass offered some respite in college towns and larger cities, but there as well life could be perilous if one's hair was long and one's opinions unacceptably contrary. From such situations a cultural diaspora was soon forming up.

This was the environment into which the Armadillo was born, and it was no accident that the birthplace was Austin. The city was not only large enough to afford some anonymity, but as home to the state's biggest university it offered up tolerance, even acceptance. Countercitizens found acceptance here not generally proffered elsewhere. A community founded on a cultural identity—and idea—was forming up. Within the city limits there was a large, like-minded population, some of the cheapest living costs around, and a spectacular natural and urban environment. They came from all over the state and beyond. Around UT, Clarksville, the Avenues, Travis Heights, but especially in old South Austin, they established themselves. And if these enclaves

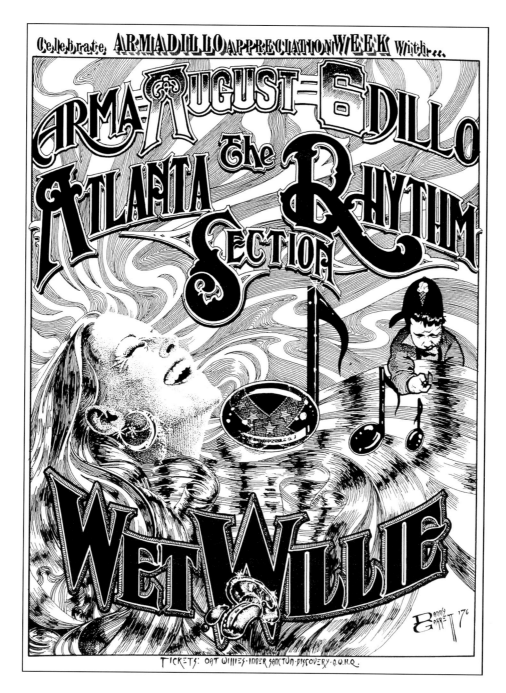

Above: Armadillo Appreciation Week, the Armadillo, 1976

As the fifth anniversary of the AWHQ rolled around in the bicentennial year of 1976, a weeklong celebration ensued. A $100 ticket got you in all week. Each of the Armadillo poster artists produced a bill for each of those days. Here's mine. In the lettering I split the word 'Armadillo' with the date—in clear violation of the who/when/where doctrine of strict informational posterizing. The centerpiece is a quarter-note reflecting a Confederate flag—it's one of a batch a little kid shoots like marbles. It's a source of delight for the female listener who basks in the swirling sounds. Her earring, carrying my palm tree, swings upward out of cascading hair, trailing sparkles. The Wet Willie logo speaks for itself and represents a chromed tribute to Robert Williams, a favorite artist of mine.

17

contained the "embassies" of the various cities, towns, and rural regions of the state they represented, then easily the capital to which such credentials mattered was the Armadillo World Headquarters.

A Music Hall and More

He was seeking relief, but what he found was revelation. It all started in the Cactus Club, a small beer joint at the intersection of Barton Springs Road and Riverside Drive, wherein Eddie Wilson was downing a few with musicians John X. Reed and Jimmie Dale Gilmore. Stepping outside to pay the rent on the beer, he noticed a high window up a neighboring wall partially hidden behind shrubbery and trees. Some internal gear shifted into pondering mode as he returned to his friends and suggested they all check out the building next door. After finding an opening in the chain-link fencing big enough to maneuver a car through, the trio stepped out and pushed open a large side door. They were able to clear out enough debris to ease the car into a wide corridor that opened into a cavernous interior.

What Eddie must have seen that first night he shined the headlights of his car into that desolate and cluttered space had to have been a true vision. There was precious little there to indicate what would follow in the years ahead. To others the scene would have seemed just a derelict structure in one of the nearer precincts south of the river. But to Wilson it was nothing short of a true revelation. He'd been thinking long and hard on the subject of another—and better—space in which to build a music hall somewhat along the lines of the recently defunct Vulcan Gas Company. This place definitely had potential in that regard. Not only that, it was affordable and available. The absence of the Vulcan was very keenly felt by many yearning for a place where the music could continue to play. That night, in an epiphany, this place suddenly seemed inevitable—as Eddie would later say, "I didn't find it; it found me."

Conjecture has it that the structure at 525½ Barton Springs Road was built just after the war, but nobody seems quite sure exactly when. Whatever the case, it seemed to have been used briefly by the federal government for storage and such—hence the rumor that it had been a National Guard armory. In the early fifties it was called the Austin Sports Center and was mainly used for boxing and wrestling matches, but live music was also very much in the mix. The place had a genuine entertainment history, one chapter of which prefaced its later music hall status—a show with ultimate rock and roll royalty. A surviving twin—Elvis Aaron Presley—from Tupelo, Mississippi, mounted its stage on the twenty-fifth of August, 1955, some fifteen years before the Armadillo opened its doors. Judging from what followed, the ghost of that particular performance never left the building.

Built of cinder block and ceramic brick around a girded steel frame under a shallow peaked roof, the three-story building had a lot going for it. Situated on a seven-and-a-half-acre site at the gateway to South Austin, it afforded plenty of room inside. This was a real boon, as

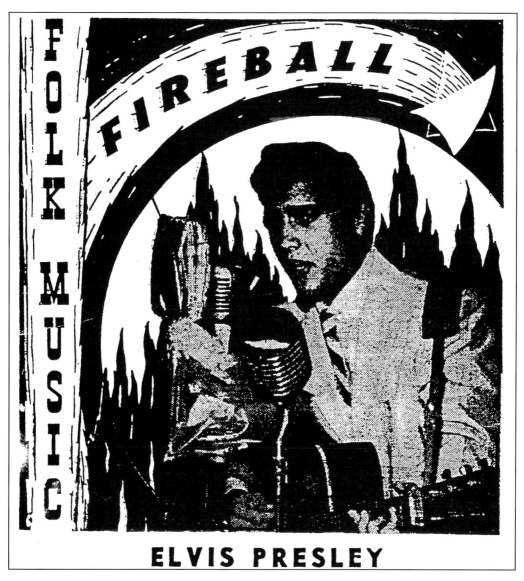

FIREBALL

FOLK MUSIC

ELVIS PRESLEY

Above: **Elvis Presley graphic from a promotional flyer, 1955**

The radio ads called him "the flaming folkster." Now that we know him as "the King," that moniker sounds a bit, well, silly. After all, he was the singer that validated rock and roll to a 1950s white American middle class. But even though he wasn't able to be labeled, Elvis did play the hall that would one day become the Armadillo World Headquarters. It's a rock and roll validation that's a bit like a church having a piece of the true cross. It did happen though, and here's a mimeographed image from the flyer—with flames and fireball attendant—to tell the world it's so.

Austin music venues, while generally good listening rooms, tended to be smallish. Not only that, there was also plenty of room outdoors, more than enough for a spacious beer garden, with stages of its own, that would be added later. There was ample parking as well, though the parking lot's moon-like surface put it in direct competition with the road to Soap Creek Saloon as a champion inflictor of automotive undercarriage trauma. And relative to recent countercultural music-hall activity (i.e., the Vulcan) it had two more things going for it: it was not downtown and north of the river, and it was not considered an "attractive nuisance" that drew in cops like flies.

While absorbing much from the Vulcan Gas Company including its patrons, premise, and product, Armadillo World Headquarters would have one thing that the Congress venue never managed to secure for itself—a license to sell beer. This would not only transform the business model of the new hall, it would do much, much more. The availability of beer would allow for the establishment of a grand common denominator. Here was an area where opposing avatars in a split culture and society—the hippies and the rednecks—could come together for a beer in common cause. The shared access to the legal beer and the illegal sharing of marijuana formed a dual sacrament of communion that helped establish the Armadillo's reputation as a cultural game changer. This is the essence of what made the place unique to that time and what helped establish its reputation throughout the nation and the world. Here was a shared space where all were welcomed, no matter their politics or length of hair. This would also be an attribute associated with the Austin Sound, and one of the principal reasons it gained such wide attention.

Once cleaned up, renovated, and established, it was truly a space to behold. When in full bloom, the Armadillo was essentially divided into three arenas: first off, the vast open music hall itself, complete with a main stage and backstage toward the north, and at the opposite end a raised rear bar and cafe area adjacent to a kitchen. In the beginning this raised area, a three-and-a-half-foot high brick platform, had functioned as the main stage, but only briefly. In the second year of operation, the stage moved north and this area became a bar and cafe space with tables and chairs. Off to the side was a stairway down to a large subterranean space that served variously as storage, game room, and illicit smoking arena. Between the former and functioning stages was the listening space itself. Starting out, this was just a large patch of concrete floor strewn with carpet pieces. Later, facing bleachers would be added to the western and eastern sides, with further raised space and chairs beyond the eastern bleachers and against the outer wall. Situated directly in front of the bar and cafe was the sound booth, with the main listening and dancing space directly in front of that and in between the bleachers.

The second arena was mostly hidden from patrons and audience—the office and commercial space between the backstage area and the front of the building. Acquired from Junior Achievement tenancy, it was here that the Armadillo was administered and had its official residence. Once the floor space was reworked, framed, and clad in drywall, it was converted into functional business and work areas. Included here was Jim Franklin's studio and sometime residence, a rather large layout on the second floor filled with odds-and-ends material deemed sufficient for

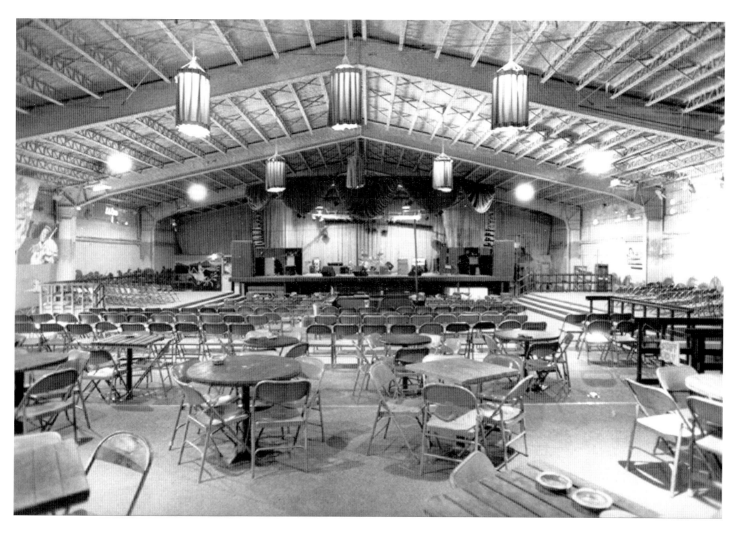

***Above:* Interior of Armadillo World Headquarters**

Here is where it all took place. This point of view is looking north toward the main stage, and is taken from the cabaret bar, which is situated on the original brick stage. Directly in front is the soundboard. In front of that is the main listening arena with four-tiered risers on either side. The stage, dead center, commands the entire room. Behind its curtains the backstage and office areas run to the front of the building facing Barton Springs Road. Three pieces of art can be seen in the scene. Jim Franklin's rendering of Freddie King resides on the wall to the left; Gilbert Shelton's portraits of the Fabulous Furry Freak Brothers on the wall to the right; and Marian Royal's splashing dragon guards the backstage entrance to the left of the stage.

Photograph by Jim Richardson

inspiration and show. Much of the art, both freestanding and mural, that decorated the hall was conceived and produced here—the lion's share by Jim. Later on, exhibition space would be created at street level, where much of this and other art was displayed. Other than that and the offices, most of the square footage in the rest of the space was rehearsal and dressing room space, along with storage.

The third arena was the outdoor space that stretched southward from the main building to the property's boundary. In 1977 this area was developed into a patio and beer garden that continued to evolve until the doors closed. It included the spot where meals and beer were dispensed from the kitchen, a big covered area for eating, and a range of cable-spool tables along with herds of gray folding metal chairs. There was also a wisteria-covered arbor and several railroad-tie raised flowerbeds, crushed granite walkways, and other forms of landscaping, including hopeful trees planted here and there. Later a swag-selling hut was set up just across from the ticket booth and the main entrance to the hall. The beer garden became very popular in the last years of the venue's existence and did much to put the entire operation somewhat in the black, accounting-wise.

That the Armadillo World Headquarters was not exactly run along the lines that the Wharton School of Business might recognize is pretty much a no-brainer to even the most casual observer of what went down. Despite the presence of some effective business acumen, this remained an endeavor embarked upon and maintained largely through the skills of hippies-with-a-vision. But like most worthwhile endeavors existing in this material world, it was still dependent on commercial success. The ebb and flow of monies through valves of income and outgo constituted a beating heart that allowed the music hall to live. And no one was more responsible for maintaining that beat than Hank Alrich. Eddie Wilson had the vision and actuated the decision that gave birth to the Armadillo, but it was Hank who enabled it to continue and thrive. The very existence of the music created there was the result of their combined efforts.

Eddie would head up the operation until the bicentennial year of 1976, but he yielded the reins to Hank in November of that year. Hank had really been there since the get-go, both on and behind the stage. The personal investments by him—in terms of performing, hard work, vision and guidance, and cold hard cash—enabled the music to keep coming for over half a decade. When Eddie left, Hank was in charge. The situation that the music hall found itself in at that point was dire, with little more than the thrust foot of Chapter 11 bankruptcy keeping the doors open. An infusion of more vision and more money meant that the place could continue, Lazarus-like, into the future.

And though that future was less than another, all-too-brief half decade, it was a hell of a ride to the finish line. Hank added the lovely and profitable beer garden in 1977, just as he had added a sound studio the year before. Physical improvements were made to the building itself—the lighting and sound systems, and the general operation of the club was brought more into line

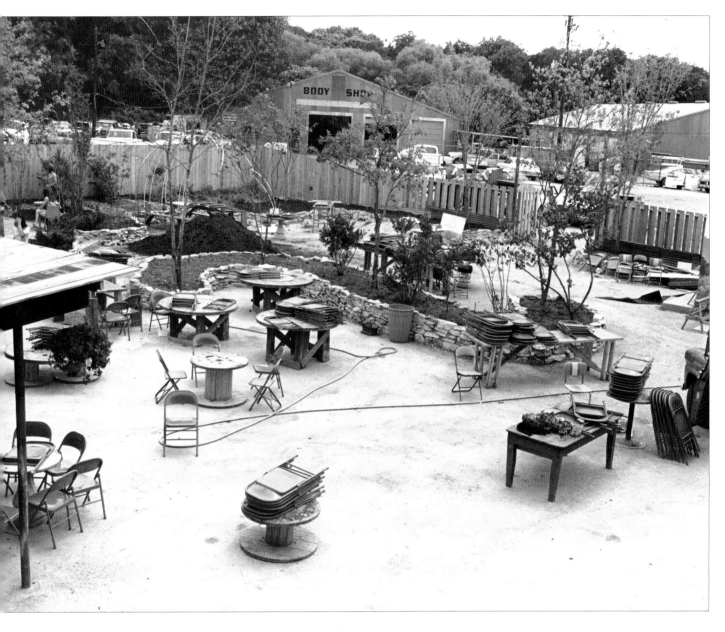

Above: **Armadillo World Headquarters Beer Garden, 1977**
This is the famous Armadillo beer garden as it appeared in early manifestation. The photo was taken from the roof of the kitchen, which was located in the extreme southeast corner of the building and looked toward the outer perimeter. In another year, a frolicking wisteria-clad arbor appeared across from the stone-lined garden bed, chock full of imbibers and eaters of saucer-sized nachos. A year later, a stage rose in the far back corner, and a souvenir shop was situated to the right of the short gate a year after that. This area was a thing of spatial beauty, even when the folding chairs were corralled.
Photographer unknown

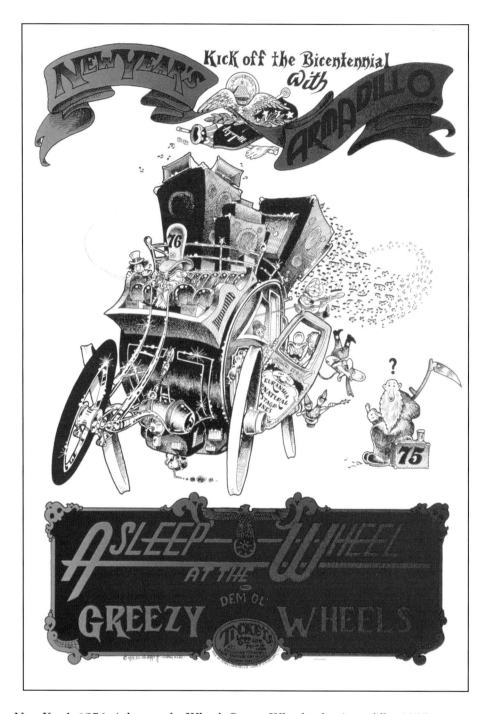

Above: **New Year's 1976, Asleep at the Wheel, Greezy Wheels, the Armadillo, 1975**

This could easily be called the "wheels poster," as both bands contained that word in their titles. In point of fact, no band played the Armadillo more than Greezy Wheels. It is probably also true that many listened to Asleep at the Wheel for the first time at one of their gigs there. At any rate, I obviously concentrated on wheels when I did this poster. Here, the new year of 1976 in the form of a motorcycle/stagecoach driven by a mysterious cosmic cowboy baby passes the old year in the guise of R. Crumb's character, Mr. Natural. Between the banners at the top sits a bevy of patriotic talismans in honor of America's upcoming 200th birthday.

with a better business approach, even though that meant attrition in some quarters. More importantly, the continuation of solid bookings begun under Wilson continued and improved, growing more eclectic with shows as varied as Count Basie and the Austin Ballet. Most important of all though, was the continued ginning-up of the reputation of both the Armadillo and Austin in the national and international music industries.

While music was most definitely the holy grail—sought, found, and enshrined—the Armadillo was dedicated to art in all of its forms, not just the one named for the muse. From the very beginning it was a cultural endeavor. It just seemed to be in the DNA of this Austin brand of counterculture to invest the music hall as an artistic enclave as well. Creativity was what flowed through the veins of the place. What was happening onstage was reflected in the promotional bills and wall art that chronicled those selfsame performances.

The Art of the Armadillo

In the summer of 1970 the Vulcan Gas Company closed; in the summer of 1970 the Armadillo World Headquarters opened. The Armadillo would carry on the music-poster tradition established by the Vulcan. While the 1960s San Francisco rock posters captured the attention of mass media, Austin gave as much as it took in this arena, and actually contributed much to that Bay Area form. And while there were similarities between the San Francisco pieces and those of Austin, there were also differences. The Vulcan pieces were often quite large, although there were some smaller offerings as well. Some were also screen printed by hand, often involving complex processes such as multiple split founts utilizing vibrant inks. In fact, they resembled art serigraphs more than commercial bills.

Because the Armadillo was promoting more music more often, it would employ a much svelter critter and, in the process, set a community standard for the bill, which other venues followed. The new AWHQ posters measured a bit less than the old Vulcan bills, with eleven-by-seventeen inches the standard size, though more important acts usually doubled that to a seventeen-by-twenty-two-inch format, with multitudes of eight-and-a-half by eleven-inch flyers printed up for lesser-known acts and for those with regular slots. Use of color was also significantly different, with Armadillo bills typically being one- to two-color pieces—usually a black base with a single spot color on white or neutral stock. They were also commercially printed as photolithographs or "photomechanical prints." These terms simply indicate that the image plates were etched through a chemical/light—or photographic—process and printed by mechanical press. Because small offset-printing shops had proliferated in the late sixties, the AWHQ could get its posters—and more of them—at a fraction of the cost that the Vulcan had paid.

In the beginning, the Armadillo couldn't afford radio or even much newspaper advertising, so posters proved to be quite an effective marketing tool. The realities and demographics of the

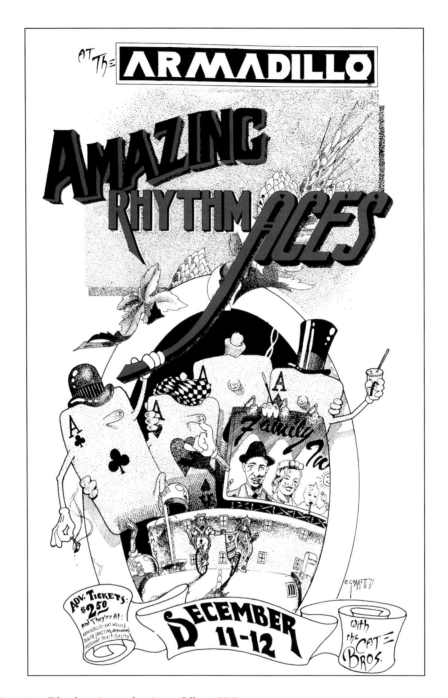

Above: Amazing Rhythm Aces, the Armadillo, 1975

Although most of the playing card themes were reserved for my Antone's pieces, this poster and another constitute Armadillo offerings that preceded those blues posters. Holding hands, a king and a queen ride unicycles on a street flanked by a fire hydrant and a mail receptacle for playing cards, probably of the bicycle persuasion. Behind them the Family Inn, a hostelry made famous in "Third Rate Romance," looms ominously. And behind that, cultural golems in the form of hatted aces also hover—only more in merriment than menace. One even interacts with colored lettering.

counterculture also amplified this effect—posters did not need to be put up citywide in a saturating fashion; they just needed to be concentrated in neighborhoods and commercial areas where countercultural people gathered. Not only that, but because of the way things had unfolded in San Francisco, Austin music posters became collectibles almost the minute they hit the streets. They vanished quickly from telephone poles and brick walls, although a few would remain in storefront windows (taped on the inside) to push the shows as intended. No matter, in the intensely insular demographics of the period, posters on living room walls served essentially the same function as those on poles. The word did get out.

The very word *armadillo* can hardly be uttered in a cultural context without mentioning Jim Franklin. If he didn't invent the word (or the critter), he certainly did make it visually iconic. And he is the one who capitalized the word and all the rest relative to naming the music hall. With the opening of Armadillo World Headquarters, Franklin changed more than just job location. He followed a familiar, and now perennial, personal pattern and changed residencies as well. Ensconced in his new digs, he would get the ball rolling by producing the logo and the very first posters. He also installed large works of his own around the hall and illuminated the place with lots of accent renderings and murals. Before too very long he would be working side by side with a gaggle of artists who also would produce murals, banners, backdrops, and signage for the music hall—and, of course, a poster or two. They would all find influence and inspiration in the art that he made. They would loosely be known as the "Armadillo Art Squad." Fortune put me among that number.

Space prevents me from naming everyone, but I can list those who did most of the work, my closest colleagues there. They came to Austin from all over the state, some as part of that Lone Star diaspora. Micael Priest came down from Hurst, in the middle of the Metroplex. Sam Yeates was also from that neck of the woods—Stephenville, via Denton. Guy Juke (DeForest White) came in from San Angelo. Jack Jackson up from South Texas, to Austin, then to San Francisco, then back to Austin again. Dale Wilkins ventured up from Beaumont, late of California. Ken Featherston, Henry Gonzalez, and Gary McIlheney all came from Corpus Christi—the most from any one community. And Kerry Awn along with Bill Narum left Houston. Technically, I arrived from Houston as well, though only because I did a year there after my discharge from the US Army—I really came up from Lake Jackson. Together, along with Mr. Franklin (from La Marque), this group made up the hard core of the squad, producing the bulk of the Armadillo posters. But it's Jim Franklin who was the godfather of us all, and really of Austin music art; he pretty much owns that distinction. He has crafted more images, reproduced more often, in more media, for more venues, depicting more musicians over a longer period of time than any other I can think of.

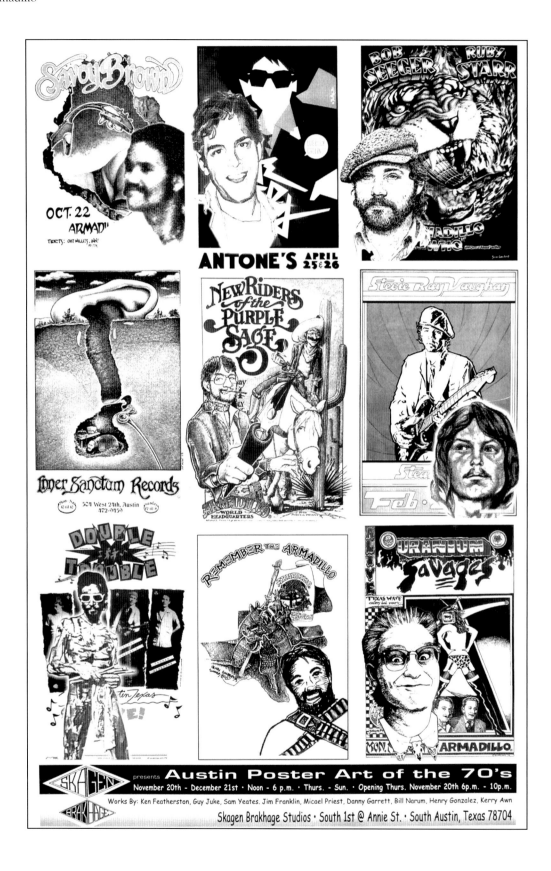

My Work for the Armadillo

I first met Jim Franklin in his large, cluttered, and sweltering work/living space on the second floor of the Armadillo in late spring of 1971. I had arranged to visit him because I was trying to put together an underground comic book, and he had just published one, titled *Armadillo Comics*. I was seeking advice on the matter. I had brought along some recent art that I had done, and he immediately picked out an over-the-top cosmic piece and suggested that it would be just perfect to promote an upcoming John Sebastian concert. He had been tasked to do it, but was very involved in doing a Mother Earth poster and quite frank(lin)ly did not want to have to deal with the Sebastian piece. So after a quick lesson in creating and registering color acetate overlays and a crash course in process-color printing, I left with the rubylith sheets he provided and two days later returned with camera-ready art for the poster. This was my first Armadillo poster, and even though the poster was, like the show, somewhat less than successful, it was really something for me to see my art come to life under the Armadillo name.

That was my first; the last was a Delbert McClinton/Bugs Henderson piece for a show two days before the 'Dillo closed. In between there were nine other music bills, totaling thirteen, or a bit over one a year, for the life of the venue. That was a fairly small number relative to my colleagues, but unlike them I was freelancing for the 'Dillo and they actually worked there, pulling down other duties such as mastering ceremonies, security, kitchen and stage work, and the odd bit of construction. Even though I wasn't officially part of the Armadillo family, it was an honor to work beside and be associated with those that were. Like most everyone who walked through its doors, to me it felt like home.

Franklin doled out the assignments for a while, but then absented himself for a few years. Micael Priest took over as art director, first through Directions, a promotional company, and then for the Armadillo itself. When Hank ran the club after Eddie departed, that job went to Ramsey Wiggins. With all these art sergeants, suitability was usually the first consideration in commissioning posters, but as time went on, it was more and more availability that was determinant.

The main thing about doing the Armadillo posters was that after a couple of initial assignments to see what I would come up with, I was given almost complete artistic freedom in

Opposite: **Austin Poster Artists of the Seventies, 1997**
These are also my music artist colleagues and friends—most of them—and me, as rendered by ourselves. This particular occasion was a celebration of our poster art at the Skagen Brakhage Studios in 1997. For this poster, and its occasion, we were asked to choose one of our posters to be displayed along with a self-rendered portrait of ourselves back in the day. What you see here is the result of that compilation. Top, left to right: Ken Featherston, *Savoy Brown*; Guy Juke, *Joe Ely*; Sam Yeates, *Bob Seger*; Jim Franklin, *Inner Sanctum Records*; Micael Priest, *New Riders of the Purple Sage*; myself, *Stevie Ray Vaughan*; Bill Narum, *SRV and Double Trouble*; Henry Gonzalez, *Remember the Alamo*; and Kerry Awn, *Uranium Savages*.

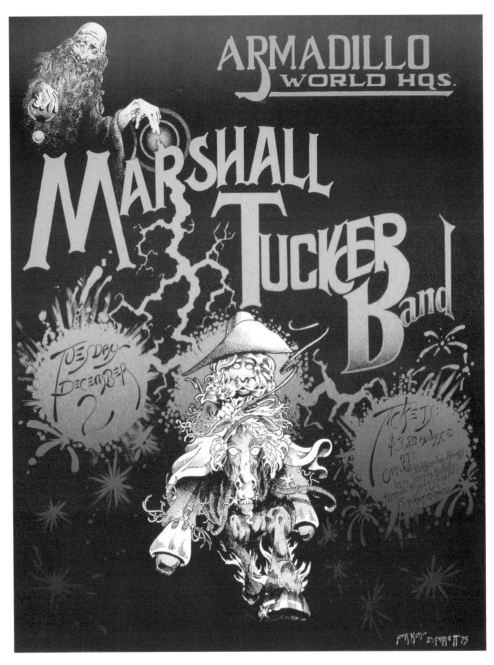

Above: Marshall Tucker Band, the Armadillo, 1975

Having native talent, but no real art training, I relied heavily on my Armadillo Art Squad colleagues to get up to speed; and none more than Ken Featherston. He was a master of both the air brush and stippling—the method of pen-and-ink valuing using dots rather than lines. Both of these techniques I was determined to learn, and in those years no one did it better than Ken. He also did double duty as security for the Armadillo and on November 11, 1975, in that capacity, he was tragically shot and killed by a patron who had been ejected earlier from the hall. A year before that, he had done a classic poster for the Marshall Tucker Band showing a bronco-busting cowboy bucking over a crescent moon. I referred to that image when asked to do a poster for the band when they next appeared at AWHQ. This is what you see here. In a double split-fount image, I show that same cowboy jolted on by a bearded man in the sky. Above my signature I dedicated the piece to my colleague, mentor, and very good friend, Ken Featherston.

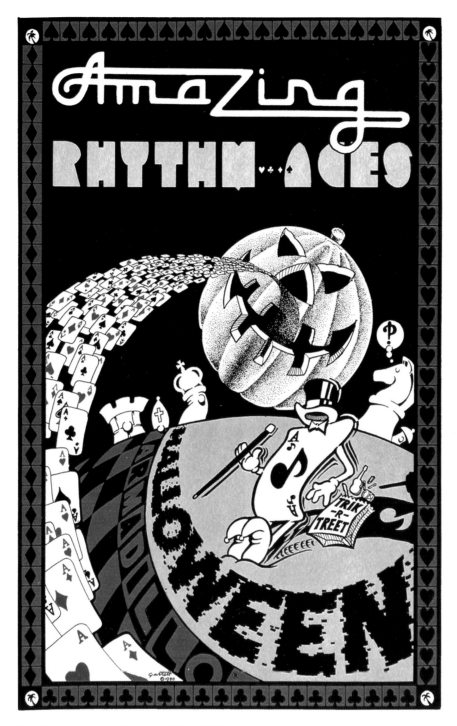

Above: Amazing Rhythm Aces, the Armadillo, 1980

The second Aces poster features a moon-like jack-o'-lantern spewing aces over a checkerboard world. Another trick-or-treating musical ace—an avatar for the band—is brought up short as the shadow from the flying aces overhead heralds the play date of Halloween. In defiance of optics, the quarter-note signifying on the avatar goes transparent as its shadow is cast. Meanwhile, over the horizon, other game minions, in the form of chess pieces, take notice. An observing knight throws up a hammer-bang within a thought balloon signifying both delight and puzzlement at such a sight.

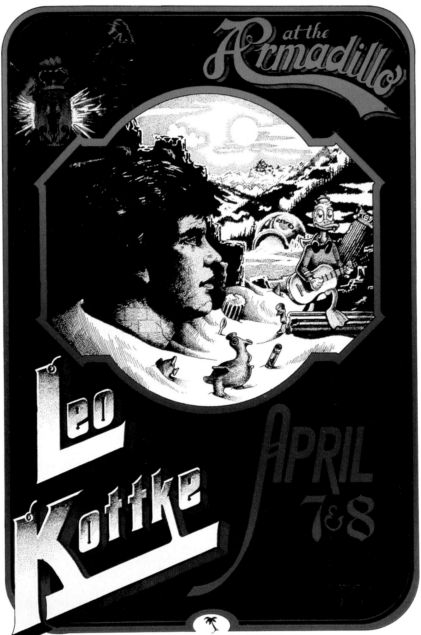

Above: Leo Kottke, the Armadillo, 1976

A commentary on the times, this is a profile portrait set against a snowy landscape—a metaphor for the appearance of cocaine on the scene. This in no way reflects upon Leo himself. However, it does show the social/cultural latitude that was allowed the artists in doing poster work for AWHQ. Scattered about behind Leo's stone head, related semiotics abound. There's an overturned sugar bowl, spoons and rolled-up bills, ruined pillars, and a curious assemblage of terracotta Peruvian ducks in intimate contact with the snow. Graphically segueing back to Leo, a Disney-inspired avatar appears as a similar type of waterfowl that idly strums while also "stoned."

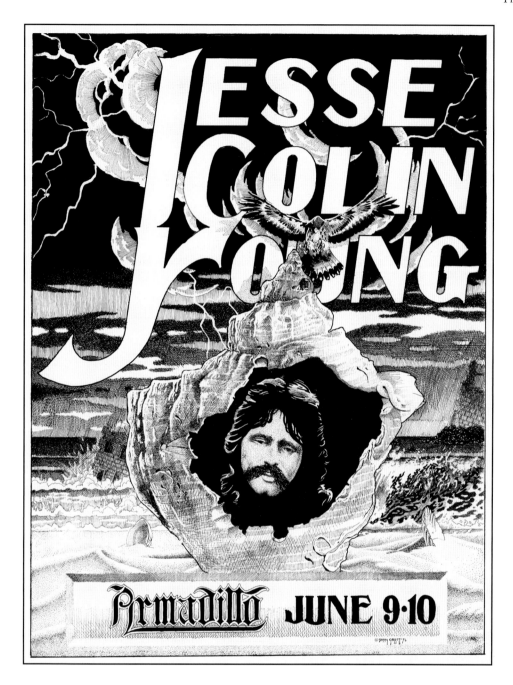

Above: **Jesse Colin Young, the Armadillo, 1980**

Another portrait piece—these are the only portraiture posters I produced for AWHQ. Continuing to riff off the Leo Kottke piece, this poster trades snow for sand in a mixture of natural granulated metaphors. Sometimes as an artist, you have the freedom to create something for which there is no plausible explanation. This is an example of such an occasion. I chose a seashore motif, again with ruins. It is complete with shells and breaking wave, both cockled. I chose to have an eagle descend from a tempest in the heavens. Ghostlike, the head of Jesse emerges from a hole in the shell. It's just something I came up with.

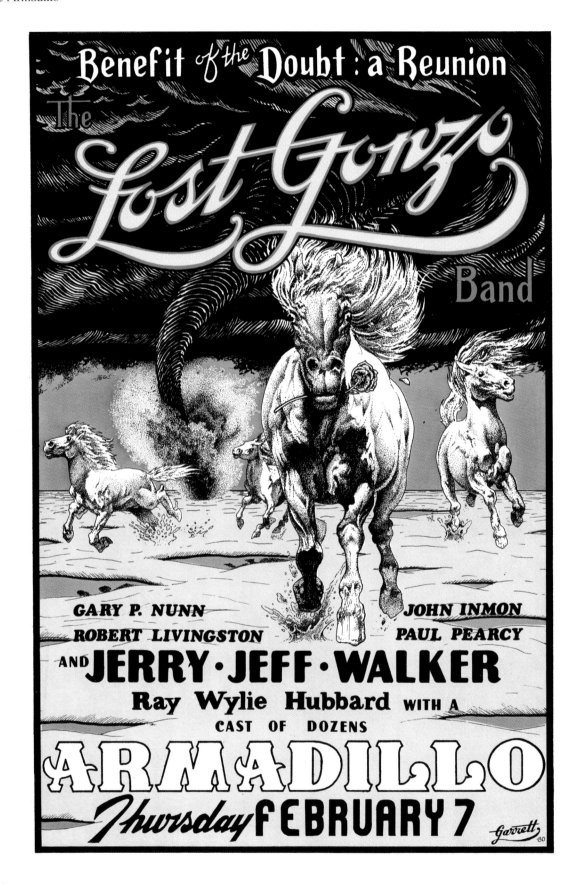

producing the pieces. As a member of the squad, I paid close attention to what my colleagues were doing. I soon began to feel that although our styles and proclivities were very different, nonetheless a sort of school developed around the posters that tied our work together. I think three dynamics underpinned that school: a respect for the power of simple absurdity, an appreciation and expansion of Texas/Austin iconography, and making and having fun with it all—especially the music. If there was one common graphic denominator, it would have to be the armadillo itself, which appeared on practically every Franklin piece and on many, if not most, of my fellow squad members' renderings.

As for other themes, they were many and varied, but none that quite functioned in any unifying fashion as did the armadillo. Portraiture, caricature, or other sorts of images of the musician(s) were a common approach. In only two Armadillo offerings did I do portraits—Leo Kottke and Jesse Colin Young. I tried to use the artistic freedom to create interesting graphic vignettes to spin a little tale about the subject(s)—usually images that spoke to a particular song, album, or aspect of their lives or careers. The posters I did for the first Amazing Rhythm Aces and the Lost Gonzo Band are good examples of this type. Sometimes I just chose to explore pure and unassociated whimsy, as I did with the second Amazing Rhythm Aces poster. I never had more fun doing a music poster than I did when I was doing one for the Armadillo World Headquarters.

Music seems to have been a part of Austin for as long as it has been Austin, and probably before that. It seems to be in the very DNA of the place, and many who have lived here would contend that by virtue of that fact and through some sort of cosmic denizen-to-citizen osmosis, it has become a part of their own personal genetic material as well. The city has been the capital of Texas since 1839. It has been the capital of Texas music, I would argue, since August 7, 1970, when the

Opposite: **The Lost Gonzo Band, the Armadillo, 1980**
In my opinion, the Lost Gonzo Band is among the best and one of the least recognized bands to come out of Austin. Named by Bob Livingston in 1973 when they were backing Jerry Jeff Walker, the band had been the Cosmic Cowboy Orchestra when they had previously backed up Michael (not yet Martin) Murphey. When doing this poster, I referred to their first, just-released album. On the cover, a wild-eyed and clearly agitated white horse cavorts before a flat landscape while a roaring tornado spins about in the background. For the poster I upped the ante from one horse to four and assigned each a position as well as a band member. Bob's horse is the principal one—the one coming right at you with the rose in its mouth and the look in its eyes. Gary P. Nunn is embodied in the horse to the left, veering off on a path somewhat separate from the others.Lead guitarist John Inmon is personified by the horse on the right, mane vigorous and flying, the real muscle of the band. Paul Pearcy's horse takes up the traditional drummer's position at the rear. And the tornado? Perhaps it's merely the beneficent doubt that the poster calls forth, dropping down for the occasion of reunion. Or it might be a simple Texas tornado—musical—not meteorological in nature. The twister hums at first, then sings in a whine as it spins down, becoming a raw howl when it meets the ground. Here a great and thick plume is thrown up over the puddles that checker the flat surface—a metaphor for the music. It is the beating heart of their world, which is why it is shaped like one.

Armadillo World Headquarters was introduced to the world. The city still provides that voice for Texas music, and through such showcases as Austin City Limits and South By Southwest, sings it out to the rest of the world. And while such festivals and confabs do a fantastic job of putting that notion and this music forward, I would argue that the Armadillo World Headquarters did it like no other. Either before or since.

3

Cosmic Cowboys

The Improbable Rise of the Hirsute Galoot

From the beginning it all seemed quite improbable. If you grew up in Texas, it really seemed impossible. It certainly didn't feel all that natural until it happened, and then somehow it was the most natural thing in the world. From the get-go it captured the imagination of the nation. And why not? It flew in the face of the prevailing polarization while at the same time holding forth scenarios of what might be. I am speaking of the musical phenomenon that was arguably most responsible for the establishment of Austin's musical reputation. Easily recognizable, it is generally known by three names: redneck rock, cosmic cowboy, and progressive country. It was the cultural and social phenom that brought estranged communities together through the medium of music. In short order, it would become known as the Austin Sound.

Whatever called, the music that was joining longhairs and rednecks was establishing Austin's reputation at a time when things really started to jell in the early 1970s. It was no accident that this music took off so rapidly here or that the ingredients for the sound should reside in this city in such abundance, yet it also seemed that a series of happy accidents and fortuitous—if meandering—circumstance led to the relationship between the music and the city.

The ground had been preparing itself for this unlikely pairing for some time in the capital. Music had always found a home here, but it all really took off in the 1960s. Folk music tended to dominate the live-music scene through much of the decade, especially in the neighborhoods, cafes, and watering holes around the University of Texas. Folk provided deep and fertile soil for the roots of the singer-songwriter tradition from which much of the new sound would grow. The musician authoring his or her own material had been grounded in Texas music for about as long as anyone could remember, whatever the genre. But one Texas musician and songwriter, long absent from the state, would shortly return home as a very improbable music revolutionary.

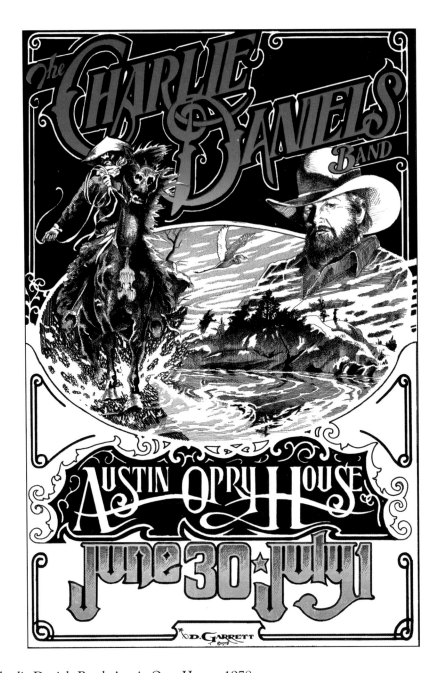

Above: **Charlie Daniels Band, Austin Opry House, 1978**

Here Charlie is both the Frederick Remington-inspired rider fording the stream as well as the godlike bust of himself floating in the mist above the rocky far shore. Connecting the two is an egret in flight. In a subnarrative, directly below the portrait, a woman is silhouetted against the sky. Back at the galloping horse, a fiddle shape distinguishes its breast. This piece is still heavy on the Victorian lettering, and a vestigial palm tree marks my signature. This piece is also a good example of split fountain printing. Where you see multiple colors over the lettering and in parts of the graphic image is actually a single spot-color run. The multiple colors are achieved by orienting the ink tray vertically and blending the inks from blue to gold within the tray.

Streams

...ted to have been born when Willie Nelson took the Armadillo ...on a hot summer's night in 1972. It had a history and an evolu-..., however. Whatever flowed from that stage on August 12 was ...ved and mingled for years from varying points across the musical ...nd out. As Willie himself put it, "I came to Austin, found a ...front to lead it."

...son had an earlier role in kicking off progressive country long ...his contribution had roots in the music that Nashville crafted back in the fifties when he came of age professionally. That music got a big makeover in the next decade, yielding the "Nashville Sound," including strings and orchestration. It constituted an atmosphere Willie eventually found trouble breathing. Though he loved to write and suc-ceeded in that arena spectacularly, his heart yearned for the stage. Pushback from above on this score sparked a renegade spirit in Willie that only strengthened over time. By the late sixties he joined other country musicians—outlaws, if you will—who sought to bring a bit of grit to the smoothness of it all.

As Willie was pulling away from Nashville's industrial base, Bob Dylan moved in its di-rection. He was leaving the purer—and pop—aspects of folk music and moving deeper into its country roots. Inspired from the beginning by Woody Guthrie and the "white blues" of the heart-land, Dylan overtly upped the ante for a country-roots return in 1969 with the release of *Nashville Skyline*. It was noticed. Dylan wielded tremendous influence over American popular music. He even nudged British musicians such as the Beatles and the Stones into country explorations of their own. The Brits, in fact, were long familiar with American country and western music, having embraced rockabilly as soon as it emerged, while maintaining an abiding love affair with the music of Buddy Holly. They welcomed such explorations, just as they had earlier with the blues.

At the same time, on the West Coast, rock and roll was also going country. A unique type of country rock was beginning to be played there, led by bands such as Buffalo Springfield. Other groups like Credence Clearwater Revival and Poco had also emerged, pushing the country rock envelope further. When the Byrds released *Sweetheart of the Rodeo* a clear trend seemed to be forming. The departure of Gram Parsons and bandmate Chris Hillman from the group to form the Flying Burrito Brothers only seemed to confirm it. Austin noticed.

On the other side of the continent musical streams were flowing toward Texas as well. American roots music is seriously concentrated in the southern states. Most of the music was rural in origin, but over time it migrated to the cities along with the population, especially during and after the Great Depression. Once there it acquired an urbanized sound of its own, and started appealing universally after World War II.

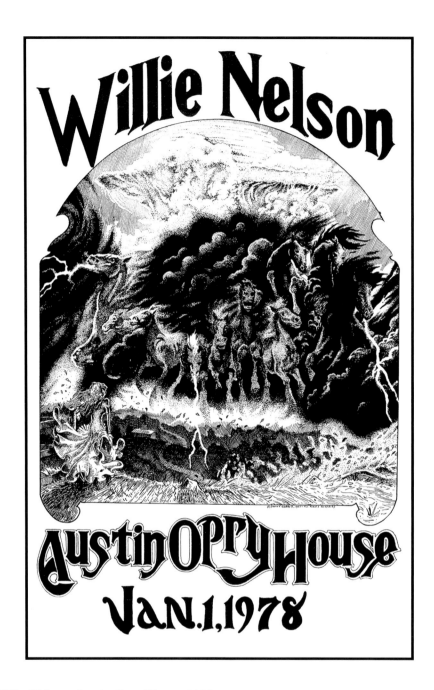

Above: Willie Nelson, Austin Opry House, 1978

A New Year's Day performance, this is one of many posters I'd draw for Willie Nelson concerts during the ten-plus years of the Opry House's existence. Many of the posters involved portraiture but this was a departure into narrative. Here I chose to interpret his music as a herd of wild horses emerging from a thunderstorm. A woman observes the gathering storm's approach, feeling the full effect of the wind as it passes, kicking up dust and leaves all around. Apparently, at least once in 1978 I was into graphic meteorological drama.

Above left: **Guy Clark, Castle Creek, 1976**

In this flyer I've highlighted Clark's two songs, made famous by Jerry Jeff's renditions on the albums *Jerry Jeff Walker* (1972) and *!Viva Terlingua!* (1973), respectively. Clark was a leading contributor to the Austin Sound, not only through Walker but with other musicians, notably Townes Van Zandt. Clark is a song-writer of monumental talent. To see him during the day that the Austin Sound was transcendent was a treat beyond words. This is one of a handful of one-color, flyer-sized pieces I did for Castle Creek.

Above right: **Ramblin' Jack Elliott, Castle Creek, 1976**

Another black background flyer for Castle Creek; this one celebrates Ramblin' Jack Elliott—fresh from the Rolling Thunder Revue after it rolled through town. From Woody Guthrie through Bob Dylan, Lead-belly, and Mississippi John Hurt to Kris Kristofferson and Johnny Cash, his involvement in American roots music and influence on other musicians is hard to overstate. Castle Creek was one of the few places in the world that such seminal musicians as this—hardly recognized or generally known—could be seen and heard. Up close and personal.

Toward the end of the sixties, something seemed to stir all across Dixie. Southern rock was rising. The Allman Brothers Band, a group from Macon, Georgia, emerged in 1969. From the get-go the band openly joined the hard rock of the sixties with the sounds of country, complete with emerging outlaw attitudes from Nashville. In addition, their music drew powerfully from the blues. A bit of blues also informed the Marshall Tucker Band, who hailed from Spartanburg, South Carolina, just across the state line from the Allman Brothers' shop. Both of these bands would frequently perform at the Armadillo, as would Wet Willie out of Alabama, the Elvin Bishop Group out of Oklahoma, and Charlie Daniels of Tennessee. Another wave of this southern rock yielded groups like Lynyrd Skynyrd, Molly Hatchet, and Black Oak Arkansas, who would feature prominently in the venues and arenas of Austin. They would do so as "cousins"—playing regional and contemporary musical forms much akin to the new sound associated with the Texas capital. Like California, the Deep South was providing the precursor elements necessary for the creation of that music.

All of these musical streams flowed into Austin and mingled at just the right time. Once here they merged with the folk scene already resident. Also wading into these streams were rock and roll as well as psychedelic musicians. Folk music tended to offer up lyrics that made the young listen to the music as well as hear it. The sound that made them feel so deeply—rock and roll—was joined to one that made them think. And now, it was all headed outside, into the country. The movement of rock and country toward one another seemed to be upon the well-traveled path of folk music. Something was in the air.

Texas Streams

Meanwhile, back at the ranch, these three main tributaries denominated into an emerging stream of Texas progressive country. In Austin, folk abided. Country and western had both been resident but largely dormant as a scene. It simply awaited the return of a native son. The progressive side, rock and roll, did enjoy a scene, but likewise awaited the timely return of another prodigal son from the Lone Star State, late by way of California.

When Willie Nelson first played the Armadillo, there were those in the audience who would never have been there otherwise had it not been for the fact that a genuine country legend had mounted the stage. There were hippies there to see what the booking would reveal. During the show both impulses were rewarded. Something new had emerged, and it was felt on the stage as well as in the audience. When his last encore echoed out, Willie had found both an appreciation for his music and a resonance that had not been expected. Almost within shouting distance of that very night, another Texas-born musician was playing a honky-tonk in the wooded hills just west of town—only a handful of miles from the Armadillo. Just as Willie personified the country aspect of the new sound that was about to form up, this guy embodied its rock-and-roll half.

In the spring of 1971 a buzz moved through the music community in Austin—Doug Sahm

they left their communities of origin and choice, took up their instruments, and made their way out through those Lone Star crossroads and from there down the highway to Austin.

An approach to country and western—and rock—developed across the northern part of

Right: **Jerry Jeff Walker,**
Hill on the Moon, 1972
Here's Jackie Jack performing at Crady Bond's Hill on the Moon. The place afforded just a small wooden stage with poles at each corner, and incandescent light bulbs strung between. One can be seen hovering in the northeast corner of the photo. Located on City Park Road, it was a rustic setting dedicated to hearing music and Crady always insisted it be free. Being able to actually see Jerry Jeff, Willie, and others was one of the main reasons people flocked there back in the day. Those kinds of performances and that kind of desire are what built Austin music early on.
Photograph by Sue Spicer

Texas with a strong visual and narrative bent to it. Though the form and feel of the music stayed true to its roots, there was a powerful lyrical drive within. Like the white bluesmen who were to follow, the first of these practitioners were from Dallas. Three of them, Michael Murphey (later Michael Martin Murphey), B. W. Stevenson, and Ray Wylie Hubbard were in high school together. After graduation Murphey attended North Texas State University in Denton. There he entered the music department that was run by Stan Alexander, an ex-fellow-traveler and roommate of Janis Joplin. Alexander inducted Murphey into the Folk Music Club there, where he reunited with Ray Wylie and met Steven Fromholz, another musician and songwriter.

B. W. Stevenson also joined up at North Texas, but didn't stay there very long before he found his way to Austin. There he released a cover of an early Murphey tune called "Texas Morning," which hit the charts and became a standard on Austin radio for much of the decade. Though never really based in the city, he nonetheless became associated with its sound, recorded there, and joined the ranks of its working musicians. Hubbard also made it to Austin after some matriculation in Denton. A charter member of redneck rock, he enjoyed a second wave of success later in life as an elder statesman of same.

Michael Martin Murphey strayed off the reservation all the way out to Los Angeles, where he became part of that city's music recording establishment. He returned to Texas and Austin with a powerful pedigree and the wind at his back. In 1972 he released *Geronimo's Cadillac,* which skillfully wove together country and rock in what many consider to be the first real album in the progressive country genre. After a European sabbatical he returned to the United States and Nashville. There, in 1973, he brought up his Austin sidemen and cut the album *Cosmic Cowboy Souvenir.* There was no doubt that this was definitely a progressive country album, both in substance and in name. On it he produced a cut called "Alleys of Austin" that he wrote about the alley behind Castle Creek, an inspiring and secluded locale frequented between sets. It's a haunting piece and speaks directly to the relationship between the city and its music. The club is no more, and for the most part, neither is the alley. However, if you venture up the driveway just left of the entrance to the Texas Chili Parlor, you can see the last remaining bit of it just out the Parlor's back door.

There was another seminal album that came out in 1972, and one that challenges *Geronimo's Cadillac's* claim as the first progressive country album. This was the release of *Willis Alan Ramsey.* Willis Alan originally hailed from Alabama, but was raised in Dallas. The album was a brilliant piece of musicianship, and both the music and the lyrics venture into the poetic. About the same time, Robert Durham, another gifted lyricist from outside Texas, emerged in northern Louisiana. After channeling Jim Bridger, the nineteenth-century mountain man he called a distant relative, into a record project for RCA, he changed his name to Bobby Bridger. He would also contribute eclectically to the Austin Sound.

In very short order many talented Texans joined the Austin scene. One quite remarkable among this group was Townes Van Zandt. Scion of an old, prominent, and wealthy Texas family,

he was a lyrical genius. Townes's life was a difficult one; a bipolar diagnosis coupled with insulin shock therapy left him with depression, alcoholism, and drug issues that ultimately led to professional and marital turbulence. Nonetheless his talent, especially for poetic songwriting, was [...] stellar and transcendent. As a performer he never made it big, but many of his songs were ve[...] big for others, including Bob Dylan and Willie Nelson. His writing was masterful, both envied and admired by his peers and other music professionals. Living and playing around Austin for years, he was a musical vagabond who ultimately found his way back to Nashville. On January 1, 1997, he died there from complications due to a fall. It was forty-four years to the day after Hank

Above: Plum Nelly, 1974

This is the logo I did for Plum Nelly, a local band that played throughout the 1970s. The group was quintessentially Austin and was an exceptional example of the Austin Sound. Though it definitely delivered on progressive country, it was also a strong amalgam of both the folk and psychedelic traditions of the city's music. Here, in a tight stippled pen-and-ink piece, I have placed the band's lead singer, Jerrie Jo Jones, in an oval, holding a plum sporting a glistening dewdrop, as roses compliment her curly locks. I still wasn't signing my pieces as the signature palm-tree glyph plainly shows. However, my art was improving.

Williams had died. Williams had been a huge influence on Townes, and the two men's lives and careers shared many of the same circumstances and curves.

Another great descriptor of the Texas soul was Steven Fromholz, who hailed from Temple. In 1969 he released *From Here to There*, containing "Texas Trilogy," the magnum opus of the progressive country sound. An homage to vanished small-town Texas, it is really a musical poem in three parts—"Daybreak," "Trainride," and "Bosque County Romance." The separate songs neatly weave together, describing daily life in the 1950s rural town of Kopperl, within an almost literary summation. The good songwriting continued, and though it never attained the epic status of the Trilogy, it did help propel him to the position of Poet Laureate of the State of Texas, conferred by the state legislature in 2007. Killed in a hunting accident in 2014, Fromholz stands as one of the founders of the Austin Sound.

The only native Austinite in the bunch was Rusty Wier. Born and raised in the Texas capital, Wier was already under the big tent when the circus arrived. He started out early, playing drums for the Lavender Hill Express, a group that experimented with combining folk and country. Although there was a brief relocation to Los Angeles, Wier essentially remained in his hometown. It was after the trip to Los Angeles, however, that his career really took off. He toured with many of the progressive country performers and solidly attached his reputation to that sound. He was both famous and beloved locally, holding down a weekly spot for more than a dozen years at the Saxon Pub. Rusty died of cancer in October of 2009, an Austin and progressive country institution.

Jerry Jeff Walker is one of the last of the major folkies to be closely associated with progressive country. After busking in New Orleans and across the South while AWOL from the National Guard, he wrote and recorded "Mr. Bojangles" in the late sixties. It was a huge hit that immediately established his reputation as a singer and songwriter. Drawn by the growing buzz and his natural predilection for a party, or anything outlaw, Walker made his way to Austin just as the scene was commencing. He fit right in and straightaway became one of the high-profile purveyors of the new sound. Assuming the name "Scamp" and then ginning up the persona that went with it, he produced music and attracted media attention to such a degree that he was—and is—credited with being one of the innovators of the music. He spurred on some of his colleagues, such as Townes and Jimmy Buffett, to write some of their best music. He also reaped the songwriting talents of others, like Guy Clark, Ray Wylie Hubbard, and Gary P. Nunn, to crank out progressive country tunes largely associated with him. Also intimately associated with him was his backup band, an incredible and grossly underrated force of musicianship called the Lost Gonzo Band.

On August 18, 1973, the Gonzos, along with Mickey Raphael on harp, Mary Egan on fiddle, and a few others, backed Jerry Jeff in Luckenbach, Texas, to record the seminal progressive country album, *!Viva Terlingua!* Except for Hubbard's "Up Against the Wall Redneck Mother," Guy Clark's "Desperados Waiting for a Train," and Michael Murphey's "Backslider's Wine," all of the songs were Walker originals. It was his finest record, and went a long way toward pointing America toward this new music. The album is not only considered one of the defining releases

Jerry Jeff Walker, Austin Opry House, 1978
Known by Opry House staff as "Jackie Jack Wonder," he consistently lived up to his chosen moniker of "Scamp." Here he is depicted with his favorite imaginary friend, Biff the Bear—who often appeared in conversation once JJW intoned his famous lament, "I wish I had joined the circus sooner." For more on bears, see Steven Fromholz.

that established the sound, but also introduced the world to the tiny hamlet of Luckenbach, forever placing it on the mythical and actual landscape of essential Texas music. A famous collaboration in 1977 between Willie Nelson and Waylon Jennings would bookend the community between the two in the mind of the nation under its very name.

Folk and folk rock had provided many of the musicians who transitioned to progressive country. This is evidenced by the many established and hopeful singers and songwriters who migrated to the new music. And though they would come from all over, it was these Lone Star musicians and songwriters who would give the Austin Sound its real soul. From literally deep in the heart of Texas.

Honky-Tonks and Such

Initially, the small number of venues was offset by a series of entrepreneurial bookings into local arenas and some performance halls. The attention—and the money—generated guaranteed that such a venue shortage would be short-lived. A few sprang up prematurely. One of the biggest was the Alliance Wagon Yard, but a fire at the original location on Nueces Street downtown and an unfortunate resurrection in a commercial park took it out early on. Other venues such as the Split Rail were just simply too frail—and commercially located—to survive.

Just prior to the opening of the Armadillo, there was an old ramshackle party barn out west in what was then a cedar thicket at the end of a caliche "road" south of Bee Caves. It was known as the Rolling Hills Country Club. A change of ownership rechristened it the Soap Creek Saloon. Walls were thrown up where missing, the roof repaired, and the whole thing was expanded a bit and fully dried in. It soon became, in effect, the house that Doug Sahm built. Although the room, like the Armadillo, booked acts of different persuasions, there seemed to be an inclination to put forth bands known for a raucous good time, whatever the genre. The joint was almost always jumping. A lot of the energy inherent in the club reflected the energy brought by Doug and the many Texas musicians like him. The venue pulled them in from all over the nation and the state; but particularly those from the direction of the setting sun.

West of Austin and all the way to the New Mexico line, powerful sounds had for some time appeared among the scattered communities in that vast and open space. There were talents such as Roy Orbison from Wink and Waylon Jennings from Littlefield. But when Buddy Holly launched a brief, star-crossed but incandescent career out of Lubbock, that particular city began to shine as the brightest star in the West Texas musical sky. The light that Buddy cast shone all the way to Britain, where in the 1960s a band called The Hollies came to be. Such a glow also shone on Soap Creek. Perhaps it was the energetic vibes of the joint, or simply the fact that at that time Soap Creek Saloon was the closest Austin club to them. Whatever the case, in the 1970s the venue exerted a particularly strong gravitational pull to a bunch of top-notch Lubbock players.

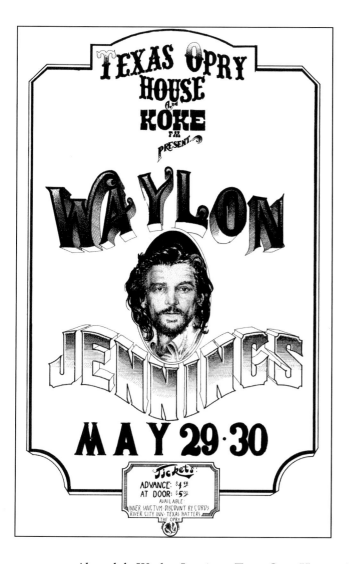

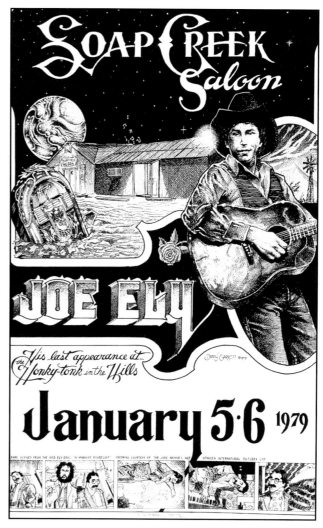

Above left: **Waylon Jennings, Texas Opry House, 1974**

During much of the seventies, it was often heard that "where there's a Willie, there's a Waylon," riffing off the old saw concerning the duality of will and way. In those days Waylon was second only to Willie as prime booking for the cosmic cowboy sound. This is a show that could have easily been "stolen" from the Armadillo. Waylon's career, like Willie Nelson's, arced toward his association with the music and his reputation as an industry outlaw. Starting out in Buddy Holly's band, his roots in Texas music run deep, very deep.

Above right: **Joe Ely, Soap Creek Saloon, 1979**

Kerry Awn did the posters and the calendars for Soap Creek pretty much exclusively. However, when word came down that the club was closing at its original location, I asked Carlyne Majewski if I could do just one—to honor this important venue. Here you see a young Joe Ely leaning into his work, as well as the club. Behind him, the venerable venue enjoys a canoodling moon, leaning into the building as well. Faint music seeps out into the night air above the roofline. Erupting from the car-punishing caliche is the club's iconic jukebox. At the very bottom, my working of a Spinoza (Butch Hancock) contact sheet yields a cartoon, starring De White as Guy Juke and Joe Ely as Groucho Marx.

Above: Castle Creek, Austin, 1973

One of the first things I started out doing was logos. I had always been fascinated with lettering, especially heavily serifed Victorian lettering, which seemed to fit right in with the Austin Sound. So that's what I turned to when Doug Moyes asked me to create a logo for Castle Creek, his intimate listening room near Fifteenth and Lavaca. What you see here is that lettering, ensconced in a beveled frame, with floral filagree bookending an oval frame at the top. Within that frame is a picture of a structure upon the banks of Castle Creek; the waterfall is added for dramatic effect. That is taken from a photo, which was provided by Doug, of an actual place in Colorado.

About as unlikely a place as you could imagine to find inspired musicianship, Lubbock has produced this particular commodity in abundance. Such is the tensile strength of Texas music. After Buddy and the music died, Waylon Jennings, the one band member from his group to pull up alongside Buddy's success, was one of the first to leave town. More were to follow, including Tommy X. Hancock, longtime proprietor of Lubbock's famed Cotton Club and patriarch of the Supernatural Family Band. Also leaving for Austin were Bob Livingston, founder of the Lost Gonzo Band; Rodney Craig, drummer for the Cobras; and Angela Strehli, white blues chanteuse and godmother of Antone's. But it was the "Lubbock Mafia" of Joe Ely, Jimmie Dale Gilmore, and Butch Hancock, famous separately but also together as the Flatlanders, that brought new appreciation of the sounds haunting the Texas high plains. All of these players, and more, found their way east to Soap Creek, Austin's honky-tonk in the hills.

Before that, in town there flowed another musical creek, Castle Creek. Founded by Doug Moyes, just down from Colorado, looking at schooling but finding a calling for music. He was a very early—and prescient—entrepreneur in the rapidly growing scene. Doug was shortly joined by Tim O'Connor, also from Colorado, as a partner. In short order the venue near Lavaca and Fifteenth became one of the hottest clubs in town. Musicians came in from all over, especially

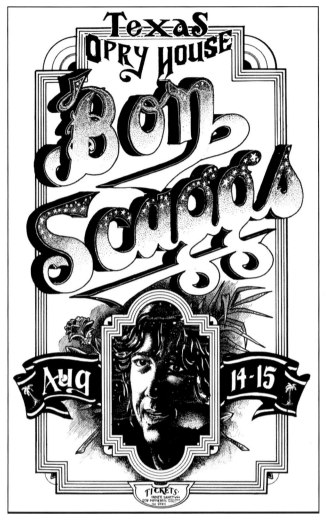

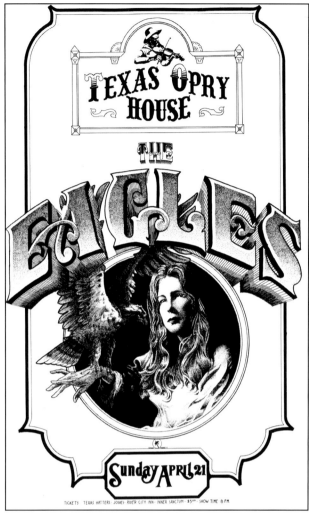

Above left: Boz Skaggs, Texas Opry House, 1973

The Texas Opry House had only been in operation a few months when I was asked to do this poster. I was still finding my legs relative to this drawing business. This piece is a mixed bag. The graphic was all right, as was the embellishing of the portrait frame and the border motif. What is wrong with this piece is the lettering. Never mind that the lower case 'z' looks more like a gang sign, or the double 'g' is just weird—the lettering is just not there. The tip-off that this is an early attempt are the two palm trees in the date banner. Later pieces would actually be signed.

Above right: The Eagles, Texas Opry House, 1973

Booking the Eagles was a huge coup for the Texas Opry House, scored before the doors were even opened. A woman I was seeing at the time graciously posed for this image; it later turned out that she was the sister of someone I served with in Vietnam. This is one of the tightest pen-and-ink pieces that I had done at this point in time, utilizing the stippling technique. The Opry House logo is an applique— literally a "cut and paste." The rest is my artwork. In that sense, this is a significant piece for me. My drawing ability had improved enormously, and by studying Micael Priest, the master, so had my lettering. If you look below the portrait, you'll see my palm tree, only this time my name appears with it.

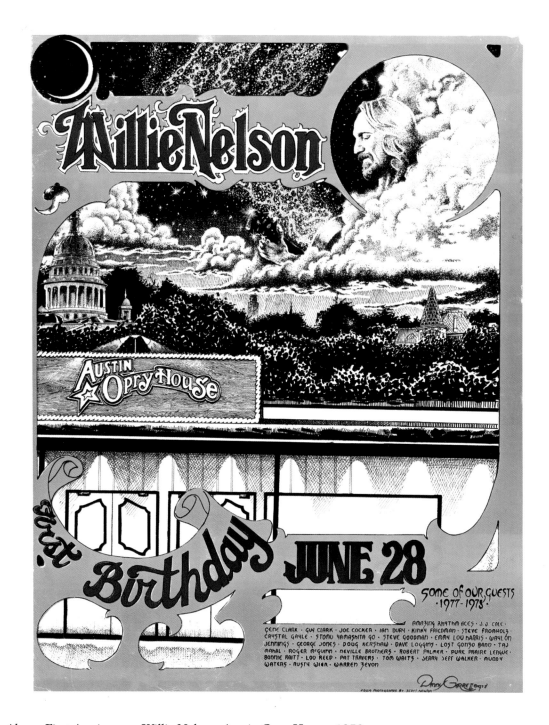

Above: **First Anniversary/Willie Nelson, Austin Opry House, 1978**

From 1977 to 1978, the Austin Opry House showcased dozens of national/international acts, among them: Joe Cocker, Steve Goodman, Emmy Lou Harris, George Jones, Doug Kershaw, Taj Mahal, Neville Brothers, Robert Palmer, Lou Reed, Tom Waits, and Warren Zevon. Locally, it was more like Steven Fromholz, Lost Gonzo Band, Jerry Jeff Walker, and Rusty Wier. Here is the poster for that show. Inside an art nouveau mat, I constructed a fantasy view of Austin, looking north from the venue at night. Since it was fantasy, I put one of the owners, Willie Nelson, emerging from a cloud bank—the music he makes takes the form of the Milky Way.

singer-songwriters of whatever persuasion. Willie, Townes, and Jerry Jeff all played there regularly, as well as out-of-towners such as John Prine, Steve Goodman, Jimmy Buffett, and Guy Clark. Blues greats like Muddy Waters, Lightnin' Hopkins, and Mance Lipscomb played serial gigs there as well. The superb sound and the intimacy of the place really made the music not so much an event as an experience. In my opinion, what Doug Moyes built there was the finest intimate listening room that Austin has ever seen.

In 1973 a big new venue was opened that provided space not only for the progressive country pickers, but for other big-name touring acts. A group of investors acquired a sprawling complex just off South Congress Avenue called the Terrace, and renamed it the Texas Opry House. It was built during the fifties as a convention center and contained a couple of large meeting halls, shops, a restaurant, bars, swimming pool with cabanas, and a goodly number of motel rooms. The new owners saw that it could be what the Armadillo wasn't. Though a bit rundown, they viewed it as an upscale alternative to that industrial venue on Barton Springs Road. They were certainly able to book some of the biggest acts of the day, including Ray Charles, Ike and Tina Turner, Tom Waits, and the Eagles. But the vagaries of putting on shows continuously and maintaining such a massive piece of real estate proved to be too much in the end. The venue closed its doors at the end of 1974.

Even before the demise of the Texas Opry House another group of investors expressed strong interest in the place. This group had a bit more substance and experience. It also had a big-name backer—Willie Nelson. At the time, Willie's career was poised to go large, and he really needed a showcase for his talents and those of his friends, as well as a launching pad for the many plans he had for the future. It seemed a great opportunity, and after several months of the kind of renovation and innovation that the space called for, the doors reopened late in 1975.

When it opened, its name localized as the *Austin* Opry House, and was a much-improved version of the original. Both of the big main rooms were outfitted with operational stages, with three bars in the large hall and two servicing the smaller one. There was also a bar and a functioning performance space out by the pool. In addition, many of the shops and some of the motel rooms had been remodeled into rehearsal halls, offices, living quarters, and storage spaces for touring musicians. By design, the Opry House was meant to upstage and surpass the other predominately progressive country venues. Not only was it meant to compete with the Armadillo in that regard, it also served as a kind of payback for the contention between Willie and the Armadillo that went back to their partnership in the first couple of Dripping Springs outdoor shows a few years earlier.

In 1977, the name was officially changed to the Austin Opera House. This sort of heralded a more serious attitude at the venue. It expanded its bookings beyond its bread-and-butter progressive country acts. A large outbuilding that belonged to the complex, down Academy towards South Congress Avenue, was converted to an intimate bar and club and opened as the Backstage. This was booked almost continuously by local and regional musicians, with an occasional short-gig

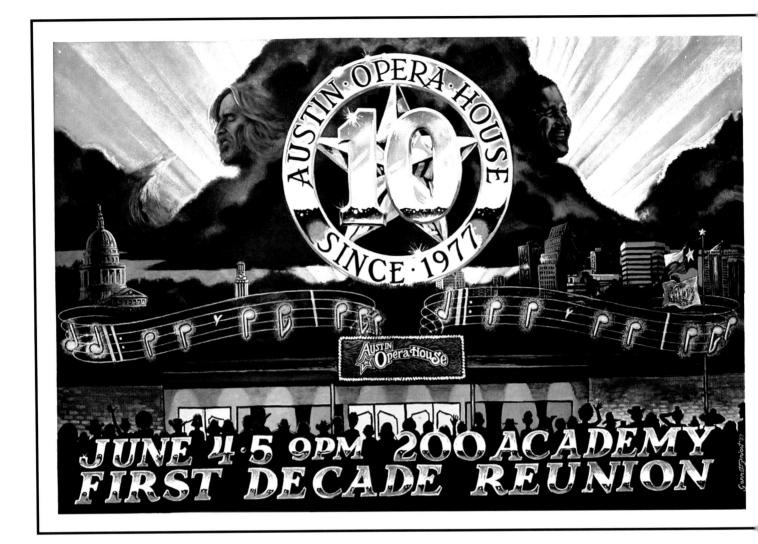

Above: Tenth Anniversary/First Decade Reunion, Austin Opera House, 1987

This is a very rare three-artist collaborative piece. Sam Yeates did the tenth anniversary logo, Micael Priest did the silhouetted crowd and the lettering, and I did the rest. Since it was a celebration of a decade, they sprang for a full-color large-format poster. Here I reprised and enhanced my first anniversary image. This time I created an even more fanciful view for the venue, again looking north. Newer buildings (for 1987) appear, along with an Austin Opera House flag flying beneath the Lone Star one. The horizontal bias orientation gives enough room for two owners to appear in the sky—Willie again, now joined by Tim O'Connor.

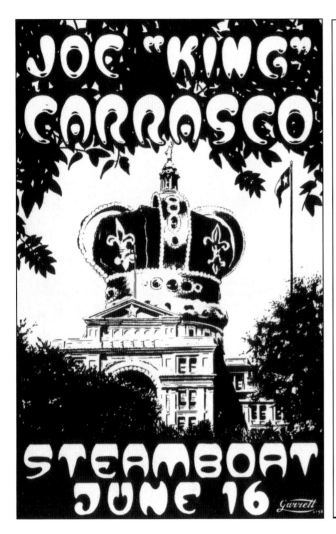

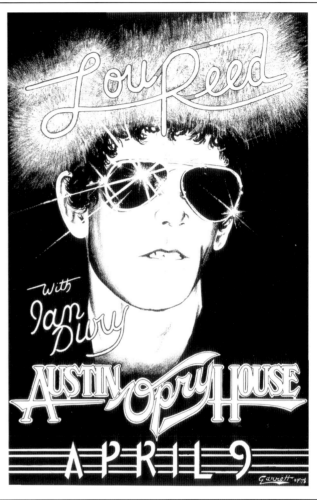

Above left: **Joe King Carrasco, Steamboat Springs 1874, 1979**

The poster that wasn't. This piece was intended to be the last in a series that Steamboat commissioned in 1979-80. However the show was canceled just as I started to do the color overlays. So what you have here is the black and white image that was to be imprinted over the color ones. It's really the simplest of concepts—I replaced the Texas capitol dome with Joe's trademark crown. Joe King's music represents an Hispanic corollary, albeit punk and alt, to the cosmic cowboy predomination.

Above right: **Lou Reed, Austin Opry House, 1978**

The great Lou Reed did such an outstanding show to a sell-out crowd on the ninth that they added a second show on the tenth, another sell-out performance. I was there at both shows; they were amazing. I was also there when Reed and his band arrived at the club late on the evening of the eighth. Instructed where to stow some baggage, they came running back to the office, obviously freaked out. It seems there was a group of people moaning near the room they were directed to. In fact, it was a cleaning crew from the nearby Texas State School for the Deaf—their "moaning" was just them singing.

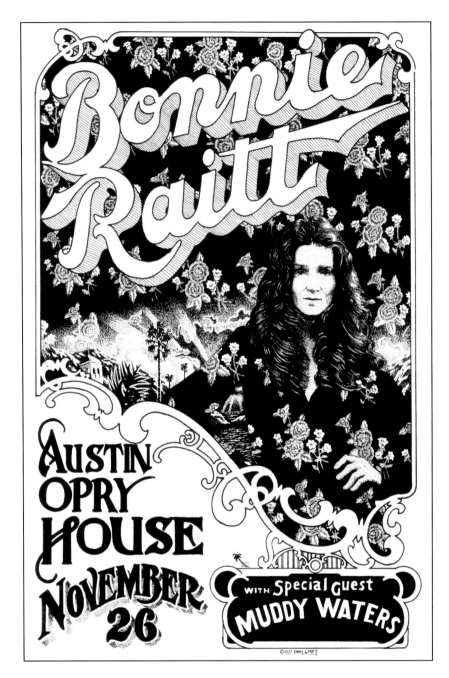

Above: **Bonnie Raitt/Muddy Waters, Austin Opry House, 1977**
Though I am a huge fan of Bonnie, in terms of musical credit, she probably should have been opening for Muddy. However, the times were the times, and he did a bluesy opening for her accomplished set. Here, I used a wallpaper pattern of roses both for her dress and for the Southern California background. However, a series of cloned images is an approach now much better suited for digital media.

spillover from the Opera House of someone nationally renowned. Later, when the second Soap Creek location at the old Skyline Club way up north crashed, the famed honky-tonk would relocate here for a bit in its third incarnation. However, after little more than a year it became the Backstage again, and sadly, Soap Creek was gone for good.

The bookings at the Opera House were impressive for the times—Lou Reed, Dire Straits, Bonnie Raitt, and Warren Zevon, just to name a few. It grew into and became a top-notch venue, eventually celebrating a tenth anniversary in 1987. By 1990, most of Willie's operations had moved out to his headquarters on the Pedernales and his partner, Tim O'Connor, was focused on starting up his incredible, bucolic music venue, the Backyard, nearby. What remained of the complex was sold in the 1990s to a sound and light technician, who eventually turned it into a high-tech establishment during that high-tech decade.

Winding Down

As the seventies drew to a close, progressive country was losing its grip as the number-one musical genre for the city. The two components of the Austin Sound, rock and country, were themselves going through a fundamental makeover in both form and spirit; consciously differentiating themselves from one another yet again. In Austin itself, the blues was having another rebirth. It was on the rise even as Antone's, its declared home and the impetus for its new popularity, was forced from its Sixth Street birthplace. The contemporary success of the Fabulous Thunderbirds and Lou Ann Barton combined with the even greater emerging potential of Stevie Vaughan was suggesting that blues, not redneck rock, would be the defining sound of the city in the 1980s. The sound that had built Austin's reputation would still be powerful, but its primal force felt spent.

It was this music in particular that galvanized the nation's attention and really sparked the music explosion here. This recognition gave vital impetus to the creation and airing of *Austin City Limits* on PBS in 1976. The show initially was intended to showcase what was happening in Texas music, but it ended up presenting national and international music and players as well. Because it focused on the Austin Sound, the program explored American roots music as well as popular sounds in new ways, and became more open to other experimental combinations. The series became a coveted showcase for musicians of all stripes, and proved to be so popular that it has become the longest continuously running concert program on American television.

Progressive country provided the city with a solid musical identity and behind that an equally solid musical reputation on the world stage. This fact was instrumental in the success of South By Southwest, an international music industry convention first held in 1987. The continued success of this gathering has given Austin a global musical presence that appears almost unparalleled elsewhere. The openness to all kinds of music and the desire to play it live have come to inform the perception of what goes on here. As the musical arena shifted from local to global, this

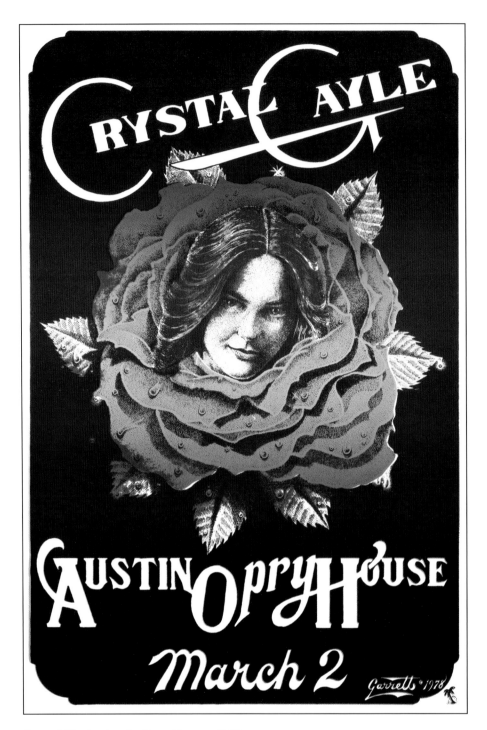

Above: **Crystal Gayle, Austin Opry House, 1978**

A bona fide beauty, Crystal Gayle, sister of Loretta Lynn, was a pretty hot country and western commodity in 1978. "Don't It Make Your Brown Eyes Blue" was her big hit, and it made her a star. Placing her portrait within a rose, I attempted to capture through a floral metaphor her very feminine nature. Outside the image area and into the gripper (the poster's margin) is a vestige of the palm-tree-glyph signature that I have used for years. This double split fount was produced by Calico Printing.

Right: Kelly Willis, Steamboat Springs 1874, 1995

A genuine sweetheart, Kelly is the subject of this Valentine's poster. It is always a pleasure to draw beautiful women; I am especially attracted to rendering hair and eyes. Here is my offering to this Steamboat Springs show. I've drawn the background as a rough-textured mass while framing Kelly with the lettering. Keeping with the Valentine's theme, I've placed hearts around her initials, as well as on a chain around her neck—in a pendant containing a quarter note. I made one huge mistake here though—the spelling of Valentine's. I left out the first 'n.' Perhaps that is the price one pays for stacking lettering and not paying enough attention.

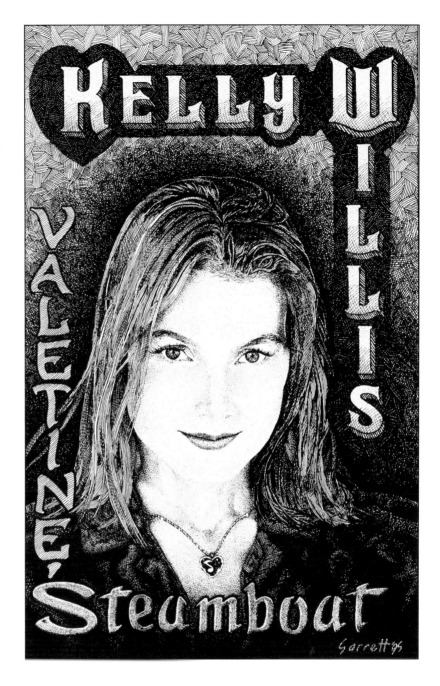

attitude has only served to enhance the city's reputation and fortunes culturally.

In the end, what I think really set progressive country or the Austin Sound apart was the fact that it was quintessentially Austin and the fact that it sprang wholly formed from the abundant tradition—and heart—of Texas music.

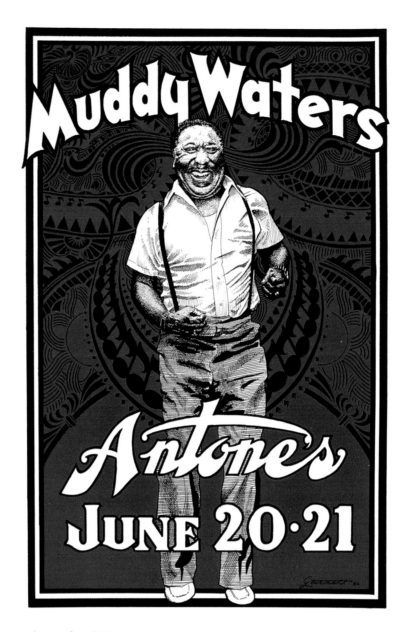

Muddy Waters, Antone's, 1980

The second of only two posters that I did of Muddy for Antone's. Taken from a photograph of him performing at the original spot downtown, this was for a show at the second location on Great Northern Boulevard. Born in Jug's Corner, Mississippi, Muddy spent much of his youth in the cotton fields thereabouts. His first guitar was six strings strung on an exterior wall in the small cabin that he shared with his grandmother near Stovall Plantation. Honoring these rural roots, I chose a bandana motif against which the dancing figure played. This is another attempt to visualize the music. Actually, it's a departure from the use of strictly music glyphs and a move to directly visualize sound. The innovation in this piece is the flow lines. The visualization process is evolving, as glyphs are replaced with art—and interspersed with card suits.

4

Antone's

This be an empty world without the blues.
—August Wilson

The blues is more American than apple pie.

The blues is, I would argue, the most original American musical form. That is because of the experience of African Americans in this country. Alone among the immigrant groups that have come to call the United States home, those who came from Africa in the sixteenth through the nineteenth centuries did so without benefit of having their native culture with them as a comfort, an identity, and a human resource. Bereft of their roots, they had to establish new ones in the land in which they were now forced to live. Along with its twin sister gospel, this music emerged directly from American soil. The initial sound of the blues was a primal howl that emanated directly from that experience. Its first recognizable form arose in the North Mississippi Delta following the Civil War. It didn't become what we might call the blues, however, until the 1890s, as it began to merge into the general culture. As the twentieth century progressed and its popularity grew, the blues became an integral part of black communities across the United States, but especially in its cradle, the South.

By the end of the 1960s, the Austin blues scene had been around for about as long as anyone could remember. When you speak of the history of the blues here, it can generally be summed up in three words—the East Side. W. C. Clark, born in 1939, is probably the longest-performing native practitioner of the musical form in Austin still standing. "When I was born," he said, "the blues were already happening on the East Side." Clark is the real deal, born in Austin's Colorado bottom, and raised in a musical family. He honed his talent while playing solitary gigs and sometimes alongside other East Austin legends such as T. D. Bell, Erbie Bowser, and Henry "Blues Boy" Hubbard. The music he grew up with stayed put there long after East Avenue became Interstate 35.

Adventuresome college students, some local toughs, and the musically literate in town had gone over to the East Side from time to time for a taste. In supreme irony this vibrant blues

scene, along with the cohesion of the black community in general, suffered after the civil rights movement enjoyed success in 1965. The ending of statutory segregation came at a cultural price. After the passage of the Civil Rights Act, contemporary black culture and homegrown identity, including the blues, began a slow fade in the precincts of Austin's African American community.

Shortly after that, however, an improbable new blues scene dawned in Austin—a blue-eyed variety largely drifting in from out of town. These young white people, mostly from the big cities of Texas, had sought out the source of rock and roll as teenagers and discovered a blue heart beating there. Questing that beat, they mixed with some of the East Side blues musicians and began forming bands of their own. Beginning just as the seventies dawned, groups like Texas Storm, Hard Times, James Polk and the Brothers, Sunnyland Special, the Nightcrawlers, and Southern Feeling emerged. Struggling for money and gigs, this growing family of Austin players honed their skills performing in a series of musical groupings. It wasn't very long before they were all getting very good at it.

However, in Austin during that time they seemed a group apart—the real outlaws in the local music scene. They didn't evolve from the folkies that hovered around UT, they weren't rock and rollers like those that gigged at Mother Earth on North Lamar or the South Door off East Riverside, and they had little to do with venues like the Texas Opry House, Split Rail, or Alliance Wagon Yard that spun out progressive country. Though many wore their hair longish in the fashion of the day, they didn't dress or look like hippies, and they weren't in cowboy hats ogling Willie Nelson. They moved by the light of their own vision and the sound of a resident different drummer. They were bluesmen and blueswomen and they were quite confident in being so.

These musicians felt their music deeply and stuck with it tenaciously. In the heated atmosphere of the early seventies they mostly played the familiar blues turf of the East Side and a few other welcoming venues west of I-35. They were as good as or better than any musicians in town, but they were much marginalized in those heady days when Austin was laying the foundations of its musical reputation through the Austin Sound. It had been that way for a while and it seemed that it might continue to be that way for blues musicians in the city for some time to come. That is, until a twenty-five-year-old from Port Arthur had a plan for Austin and this music. That changed everything.

Opposite: Antone's Logo, Antone's, 1976
When I heard about the new blues club opening up on Sixth Street in 1975, I approached Clifford Antone and asked about work. The first thing he said he needed was a logo. At the time he was using the logo from his family's chain of sandwich shops and wanted to keep that lettering. He commissioned me to do a unique logo for the club incorporating it with an image of Little Walter and a tag line proclaiming "Austin's Home of the Blues." He liked the turn-of-the-century style that I was fond of, so I turned out one within the parameters he put forth, gilded by adapted scripophily. The result is what you see here.

Antone's I: Sixth and Brazos

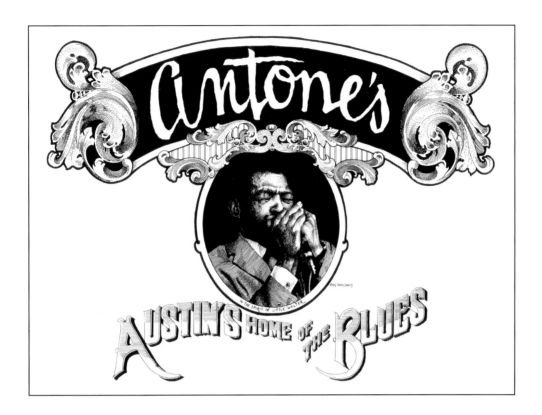

Clifford Jamal Antone would give a special gift to Austin music, and to the city itself. He took a passion for the music and a compassion for the musicians, both of which he was unable to contain, and gave Austin a home for its blues. Through vision, unwavering enthusiasm, and the tenacity to persevere, he willed that home into being. From it, the blues was renewed again to another generation—and not only for the city, but ultimately also for the country and the world at large.

Clifford grew up in the Golden Triangle of Southeast Texas, an area bound by connecting the dots of Beaumont, Port Arthur, and Orange. It is a special cultural region that has been and remains one of the primal centers of Texas music. This part of the state produced musicians such as Janis Joplin, George Jones, Johnny Winter, and Marcia Ball. Born in 1949 to a Lebanese-American family, Clifford Antone had a chance to experience all the music of the day there—rock and roll, rockabilly, boogie-woogie, country and country swing, gospel, and soul. But it was the indigenous sounds—the blues, R&B, swamp rock, and zydeco, whose roots went deep into the cultural soil of the place, which would inform his musical sensibilities the most.

Clifford allowed that his real music education began when he realized that the popular tunes he was hearing on the extreme southeastern end of Texas popular radio were echoes of

something much deeper, richer, and more familiar. When he traced the roots of British musicians of the day such as Eric Clapton or Mick Jagger to the heart of American blues, an epiphany occurred that would direct the rest of his life. Despite his deep love and respect for this general form however, the real promised land for Clifford was across the Sabine River in Southwest Louisiana. There he found what his heart was seeking. He reveled in the blue-eyed soul and R&B acts such as G. G. Shinn and the Boogie Kings when they appeared at the Big Oaks Club in Vinton. Further on down the road at Lou Ann's, Clifford took in his first full measure of swamp blues as well as the seductive beat of zydeco. Fittingly, it would be this unique Louisiana sound that would herald the opening of his new club in the summer of 1975.

Antone first arrived in Austin as a freshman at the University of Texas in the fall of 1968. He had come to town to study law, but proved to be somewhat of a middling student. Following the best instincts of his mercantile family, he opened a modest import business and later on, one of his family's sandwich shops. It wasn't long before he had befriended the small coterie of blues musicians in town and had regular sessions in the back room of his shop. This was a godsend to the local players and heaven to the young blues lover—it would spawn relationships that lasted the rest of his days. Fate, however, was spurring him on to greater involvement with the music, and his passion for that simply would not let him rest.

Levines Department Store occupied the downtown corner of Sixth and Brazos across from the grand Victorian edifice of the Driskill Hotel. By the middle of the 1970s the two-story building stood empty. In the late spring of 1975, Clifford and Angela Strehli approached one of its large storefront windows and peered in. According to him they inaugurated an epic musical journey with just a silent glance and two big smiles. "I didn't find it, it found me," Clifford would say, replicating Eddie Wilson's exact words at a similar epiphany. "There was nothing down there— nothing. But we went down there and took one look in the window and said, 'This is it.' It was a beautiful building, ready for some beautiful music." Austin had a home for its blues.

On July 15, 1975, the doors opened to welcome its first guests. Not forgetting where he came from, Clifford booked Clifton Chenier & His Red Hot Louisiana Band for that initial greeting. Opening night was a real occasion, with lines out the door and down the street. Austin music was well into its seventies roll, and many were curious about the new club that was bucking prevailing trends. The "King of Zydeco" was booked for a solid week. This was a standard booking practice for most blues venues at the time, and one that would be the template for the club's start-up.

The attendance tapered off as the rest of the gig played out there. Percy Mayfield did a week at the club after Clifton left, again with sparse crowds after the opening. At that point in time most club-goers were still deep into the cosmic cowboy phenom, as well as other musical offerings, and seemed to take limited notice of the soul great from Minden, Louisiana. Two weeks into its life and the club was bumping against some hard realities concerning the local music market. And as yet no blues musician had mounted its stage. That all changed during the club's third

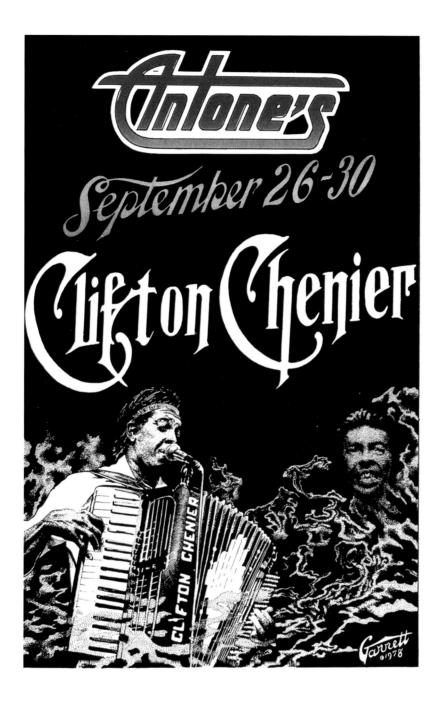

Above: **Clifton Chenier, Antone's, 1978**

Clifton Chenier opened Antone's in the summer of 1975. Three years later I did my first poster of him. Here I have presented him in two forms—both as the creator of the music, and as the spirit that informs it. Here is that image, conjured forth from the swamp vapors I have chosen to represent that music, zydeco. A vertical split fount stretches the spot color from one to four—red at the top, down through orange and full green to its pastel version. This was the music that Clifford Antone grew up with in the Golden Triangle, and so it was only fitting that it herald the opening of his club. The energy that attends this music is so penetrating that it is literally hard to keep still in its presence.

week of operation, when Sunnyland Slim and Big Walter Horton came to town. The blues had officially entered its home, and the occasion was a defining moment of the new venue.

When Sunnyland returned to Chicago, he quickly spread the word among the working blues musicians there about what was happening down in Austin. At a time when the fortunes of this music were about as low as they had ever been, the news that the towering blues man brought to the Windy City was more than welcomed. For the first time since some of the Chicago guys had journeyed to Britain in the fifties and early sixties, a serious new center had developed that appreciated the blues—one outside the other traditional arenas of St. Louis, Memphis, Kansas City, and New Orleans, or the cosmopolitan music markets of New York, San Francisco, and Los Angeles. Not only that, but the entrepreneur who opened this new venue paid well, with advances and travel covered. This was great news, as even the giants in the genre, such as Muddy Waters, B. B. King, and John Lee Hooker, were finding sparse bookings at the time. For the younger musicians and older sidemen who were struggling to eke out a living as well as to make their own marks, such news came as a godsend. In Chicago it was both a wonder and a revelation that a scene like this might even exist at all, and in a hotbed of country rock to boot.

Such a situation was easily explained. Clifford had a selfish intent—he simply wanted a place where he could see these guys up close and personal before they died. Unselfishly, he also wanted to introduce and share such musical treasures with others. He recognized what was happening in Austin and saw it as an opportunity to spread his love of this music to the people joining the burgeoning music scene there. Even while the prevailing winds were whispering progressive country, eclectic venues such as the Armadillo World Headquarters, Castle Creek, and Soap Creek Saloon had been promoting and staging the blues for some time now. Before that, the Vulcan Gas Company had booked many blues acts back in the 1960s, even pairing Johnny Winter with Muddy Waters. These venues and a few others had prepared fertile ground for the blues and zydeco acts to play, thrive, and grow beyond the currently hot scene. Clifford's vision and his aim, however, were not to legitimize and normalize these musical forms, but to exalt them.

At about the same time, the local blues scene began to really percolate. Native black players as well as early white blues pilgrims such as Smithville guitarist Bill Campbell had played the East Side for years in Austin's "Chitlin' Circuit" clubs, gracing such venues as the Victory Grill, the Show Bar, Charlie's Playhouse, and Ernie's Chicken Shack. Because the blues had been played so well for so long east of downtown, a taste for it had developed. As the music scene grew, here and there local blues beachheads had been established west of the interstate, such as the New Orleans Club, Alexander's, and the One Knite. Now, the white blues players were really starting to come into their own. The One Knite especially became a first home and a launching pad for their music.

Gradually a critical mass of sorts developed that began to pull in blues musicians from all over. Angela Strehli was one of the first of the Texas musicians to heed the call; she traveled to

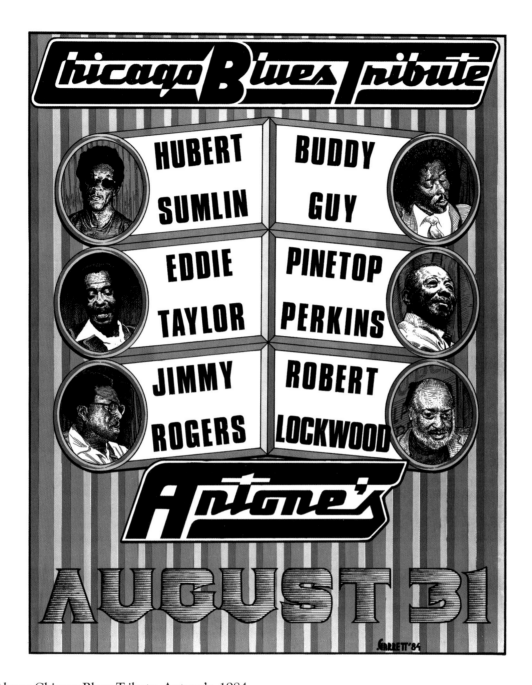

Above: **Chicago Blues Tribute, Antone's, 1984**

Chicago became blues central after World War II. Electrified and amplified, it moved into the second half of the twentieth century. This is a tribute to the sidemen for those early pioneers. It was a historical gathering just one year before Antone's celebrated its first decade. This was a hell of a one-night show, and its like would not be repeated again while these guys were still alive. It was one of the occasions that really made Antone's the world-renowned blues club that it was. I chose bands of purple—Antone's color—for the occasion.

Austin from the sunset city of Lubbock, as did drummer Rodney Craig. From Fort Worth, Lou Ann Barton and Mike Buck headed south down the west branch of I-35. Keith Ferguson came up from Houston. Kim Wilson ventured in from California (by way of Minnesota), as did George Rains, who migrated in from the Bay Area where he had drummed for Mother Earth between USO tours to Vietnam.

But by far, the largest contingent of blues musicians came from Dallas—Denny Freeman, Derek O'Brien, Paul Ray, Doyle Bramhall, Alex Napier, Mike Kindred, and the Brothers Vaughan—Jimmie and later, his younger brother Stevie—among others. Since 1970 the small local blues scene in Austin had come alive with this influx of new blood. They crowded the available venues and formed bands, broke up and regrouped into newer ones, getting better and better as they did so.

The atmosphere was promising, and Austin's Home of the Blues was about to earn its moniker. The blues scene in town, essentially rumbling for well over half a decade, was about to explode as the blues greats from Chicago and elsewhere poised to enter the mix at ground zero— Sixth and Brazos. All the combustibles were in place and primed when Sunnyland Slim lit the fuse. Paul Ray later allowed, "And that's how it all started; he (Sunnyland) told Muddy Waters, and Muddy Waters told the world."

It seemed that at Muddy's word, the older players started to stream in. It was a trickle at first, with Eddie Taylor phoning up right away to see if there might be a job, and then a few others looking for the same thing. Clifford responded favorably and invited them to come down. And so they did. In short order they appeared—Muddy Waters, Willie Dixon, John Lee Hooker, Big Walter Horton, Jimmy Reed, Koko Taylor, Otis Rush, Buddy Guy, and Junior Wells; practically every practitioner of the Chicago form. Top names from elsewhere also showed up—B. B. King and Junior Parker from Memphis; Fats Domino, Earl King, and Snooks Eaglin from New Orleans. From St. Louis, Albert King and Robert Lockwood Jr.; and from Houston, Bobby Blue Bland, Barbara Lynn, Clarence "Gatemouth" Brown, and—by way of California—the "Iceman," Albert Collins. The word brought them to Austin, but what they found brought them squarely into what was musically coming to pass in the Texas capital.

Initially they were expecting to find what they had always found as working musicians in many of the blues venues of the nation—double-dealing, short door, and expenses on the cuff. But at Antone's they found in the proprietor a man who in his heart was a bluesman himself, a coterie of passionate and serious young hometown musicians, and a growing community of genuine blues fans. Here was a room and a town that had come to love, respect, and value who they were and what they did. When they knocked on the door of Austin's Home of the Blues, they found a family within.

Clifford did not just invite the big names who had established, electrified, and recorded the blues in postwar America; he also called for the musicians in their bands. He cherished the name performers really more than anything, but his passion carried him all the way into the music,

Right: Antone's Twelfth Anniversary, Antone's, 1987

The twelfth anniversary show honored the great Eddie Taylor, lead guitarist and boyhood friend of Jimmy Reed. Eddie, who died on Christmas Day, 1985, had also played lead for John Lee Hooker and Big Walter Horton. This poster, which was printed on heavy card stock, features Eddie in a filigreed leaded-glass frame, set against a red marbled background. Keeping up the playing card motif, I show a spread of four jacks beneath his name—one for him, and the other three for the blues greats whose music was made richer by virtue of Eddie being there.

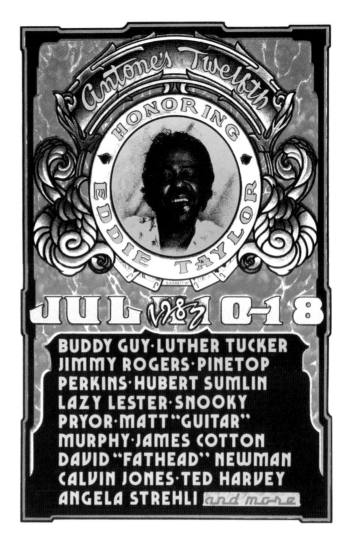

and his devotion to it insured recognition of all those sidemen who contributed so much. That's why Eddie Taylor was offered an immediate gig when he got wind of what was happening down in Austin. In short order Hubert Sumlin, Wayne Bennett, Matt "Guitar" Murphy, and Pinetop Perkins followed him there.

The fact was that Antone's was a place that welcomed any musician connected with the blues. This policy led to musical reunions in short order. Eddie Taylor and Jimmy Reed were reunited after a decade-long estrangement—though Clifford had to call and get permission from Eddie's wife to make it so. Eddie had also played with John Lee Hooker on his VJ Records sessions. When Clifford first booked John Lee, he also called down Big Walter Horton and the three of them, along with Hubert Sumlin who was also in town, had a long overdue reunion on the purple-draped Antone stage. Hooker was not only impressed by the arrival of his old Chicago bandmates showing up in Austin, but also by the quality of the local musicians who were there to open for him as well. It would be the mingling of these two groups, the older black masters and the young white Texas blues players, that would provide the real magic at Antone's Number One on Sixth and Brazos.

An old Buddhist saw allows that "the teacher and the taught together create the teaching." Austin's blues home was about to become a school, with the faculty now acquiring tenure. The blues greats kept arriving, along with their sidemen. They were forming up to teach. Whatever contention there was out of town found little purchase here. The opportunity for work, the fair shake, simple respect, and genuine love for the musicians and the music prevailed. It was a familial trust that won over these men and women who had spent their lives working probably the hardest arena of the music business. Based on this trust, invaluable musical knowledge and experience was set to pass from this group to another.

On the other side of the educational equation the pupils were also assembling. The word got out early on to Austin's young players. All the blues groups began playing there. Bill Campbell and the House Rockers were the first to mount the stage as regulars. It was the Fabulous Thunderbirds, however—Jimmie Vaughan, Kim Wilson, Keith Ferguson, and Mike Buck, plus "Thunderbroad," Lou Ann Barton—that became the club's first real house band. Others joined in as well. They started to back up the older guys when they arrived for gigs at the club. It was a great honor—and an even greater privilege—for these young musicians to provide a musical backing for their idols.

With everything in place, the sessions informally turned to lessons. A connection emerged between the visiting greats and the young musicians who had come of age in the clubs of Austin. From the beginning there were special liaisons and personal relationships that formed between the teachers and those they taught on the boards of Antone's stage. These were not arranged relationships, though many were years in the making. It was a pleasure to see the genuine affection between two musicians shine from a shared love for the music. For the young white ones, this love started years ago in a darkened bedroom with a radio. Those seductive and distant sounds past midnight had now become the flesh and blood that stood upon the stage beside them.

Here the power of the music could literally be seen to pass from one generation and race to another. Again and again over the next four years, the mixture of blues masters and passionate young blues musicians would pour out this magic over the stage at the corner of Brazos and old Pecan Street. The little storefront that Clifford and Angela checked out on a balmy spring day would transform the fabric of Austin music, reinvigorate and redefine a unique Texas blues sound, and breathe new life into this most American of musical forms.

Clifford had always intended to bring down the blues greats and provide a place for them to play alongside the Austin talent that had frequented his import and sandwich businesses. Perhaps no one, not even him, could have seen where these notions would eventually lead. From regular Monday night sessions, through weekday gigs, to the fabulous weekends and the performances of the masters who came in from Chicago and elsewhere, the blues matriculations continued.

The local scene benefited the most from these arrangements, and the number of blues musicians and bands continued to increase throughout the last half of the seventies. Although

Right: **John Lee Hooker, Antone's, 1985**

John Lee Hooker. The phonetics in the name itself just evokes the blues. John Lee had a real affection for Clifford Antone. He had played numerous times at the club's first incarnation at Sixth and Brazos, and I had been fortunate enough to do one poster of him there. John Lee Hooker was one of the giants of the blues and it was inspiring to watch him pass some of his musical heritage and power to the young white blues players at the original Sixth Street locale. While much of that interaction was largely conducted with individual pairings, with John Lee it seemed that all the Antone's house players enjoyed a rapport with the great bluesman. As you can see, he signed the original artwork for me. While the limits of his literacy may be revealed by the track of his hand, so too, these marks show the beating heart of one who feels deeply about what he does. I treasure this as much as I do the living music that the same hand had conjured forth so many times to my hungry ears.

It was a special honor to do this one for his last appearance at Antone's, and his only one at the Guadalupe location. Here you see the original art in tandem with the finished piece. The gray tone is the pen-and-ink rendering that I did of John Lee on cold press illustration board. "Antone's" and the date are raw board with ink surrounding the lettering. There is also a film applique of fine parallel line work that is cut to fit and burnished over the lettering, giving it a toned texture. Because the letters are "beveled," I have had to pencil in where the beveling begins. This is done with a nonphoto blue pencil. You can easily see the pencil marks on the original art. The preparation and printing of this piece yielded to the necessities of the old analog printing technology that was available at the time. This technology involved shooting the piece with a copy camera that took the image under a flood of intense light. The nonphoto blue would not show up as the camera was only interested in black and white; hence the guiding lines for the applique did not appear in the printed image. "John Lee Hooker" was hand painted upon the ink using gesso, a priming ground, as a substitute for white ink or paint—it is super opaque and ideal for such things. Notice the hook on the "J". There is no color in the printed piece, the cream color you see is the color of the paper stock.

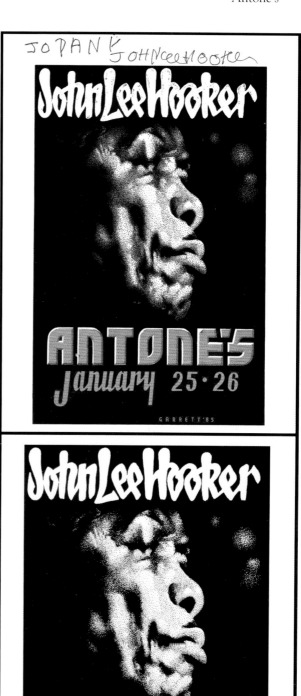

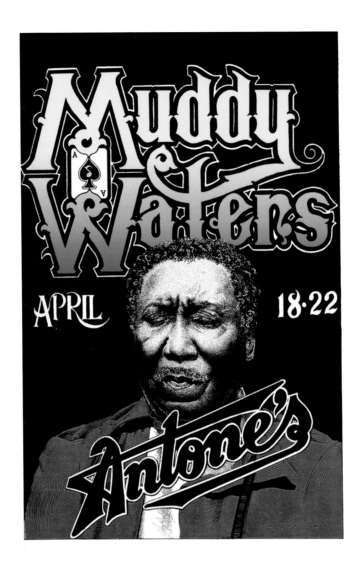

Above: **Muddy Waters, Antone's, 1978**

When Antone's opened it changed everything in my musical world. I had heard the blues, of course, but I didn't know the blues. It is simply impossible to experience Texas music and not be aware of the blues. Growing up near Houston, I absorbed that particular regional flavor. Mance Lipscomb, Lightnin' Hopkins, Albert Collins, and the odd bit or two floating in from Louisiana over AM radio were all quite familiar. But it was Bobby Blue Bland that first cast an indigo spell over me. He was the coin of the realm during my high school and early college years. All the local bands south of Houston covered him, including those of B. J. Thomas and Roy Head. His was the velvet sound of my youth. But I knew nothing of the Mississippi Delta, Chicago, St. Louis, or Memphis and the many drivers of the music in those locales. Clifford and the bluesmen that he brought to town enlightened me, and none so more than Muddy Waters. So when I first had the opportunity to do a poster of him, I wanted to put my revelations into the image. The title lettering speaks to my newfound knowledge of this music. I wanted to capture the expanded horizons I felt and the primal power of its sound in this promotion of one of its greatest creators. This may be the best poster that I ever did for Antone's, and one of my best overall. Certainly, the stippled image that I did of Muddy counts as one of my finest pieces of portraiture.

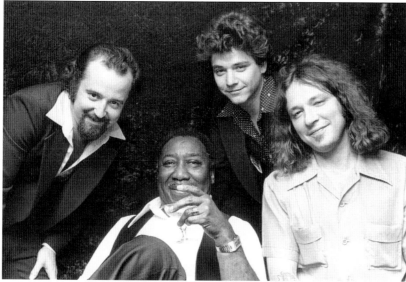

Top: **Clifford Antone paying Muddy Waters at Antone's, upstairs on Sixth Street, mid-1970s**

Captured here is the holy moment of the payoff. Muse, men, and endeavor brought to an inevitable financial communion. Following one of his first performances at Antone's, Muddy Waters is being paid, in cash, by Clifford Antone. Between Muddy and Clifford, Junior Wells nods in approval with his forefinger, while in the dim background a young lady with enough pull to access the upstairs inner sanctum views the scene. *Photograph by Bob Margolin*

Above: **Kim Wilson, Muddy Waters, Jimmie Vaughan, and Keith Ferguson, Antone's, 1980**

Four of a kind. I call this the "Tao of Muddy." It shows Muddy Waters surrounded by the original core of the Fabulous Thunderbirds—Kim Wilson, Jimmie Vaughan, and Keith Ferguson. The remarkable thing about this image is that they all have the exact same expression on their faces. It's a beatific blues countenance. Looking directly at the camera, they seem to share a secret. Whatever it was, it fully informed the moment. *Photograph by Watt Casey Jr.*

the club struggled to find its footing during those years, that was when the magic was well and truly laid down. A world-class blues club had been born. In an *Austin Chronicle* article in 2000 concerning "Blue Monday," an institution at Antone's that grew from musical moments like these, Derek O'Brien told Margaret Moser, "There's no way to really discuss the Monday Night Blues Party without bringing Clifford Antone into the picture. He always gave younger players the chance to play with the authentic bluesmen, and that's the greatest gift."

The magic was real, but like all things, it could not last. The street itself was changing. Other clubs, bars, and restaurants had followed Antone's down to Sixth Street and were beginning to nestle in between the conjunto bars, loan shops, and repair garages that lined Sixth from Congress Avenue to I-35. As the new businesses moved in, the old ones departed. Sixth Street insinuated itself as the entertainment district that had eluded Austin since the music began. Antone's, along with Toad Hall and the Ritz Theater, had paved the way, and many clubs followed them down that seven-block stretch. A few were even blues clubs.

When the music scene exploded in the early seventies, the venues were mainly scattered from the university to south of the river to the wild woods stretching west along Bee Caves Road. The conversion of Sixth Street from skid row to an entertainment district dovetailed nicely with Austin's growing reputation as a live music center. Behind these successes in Austin music, however, forces that would threaten it started to appear. And so it was with Antone's first location. Business interests saw the potential of what was happening on the street, and the owners of the building sought to expel the club in pursuit of greater income. The place soon lay in its grave, with a parking garage as a headstone. After a soulful four-year run, Austin's Home of the Blues was evicted in 1979.

Opposite: **B. B. King and Bobby Blue Bland, Antone's, 1976**
A pair of kings. Less than a year after the club opened, it put on a very big blues show, featuring two of the music's giants back in the day. It signaled an enhanced presence of the blues in Austin for that bicentennial year. Because of its importance, Clifford went large on the poster—17"×22". No extra colors though, so I engineered a split-fount background with the spot color. In the base image, I employed a gradient in a different way, fading dark to light using quarter notes. Here, the gradient is valued by size and space—falling in a descending fashion, much like a musical rain, over a more circumspect Austin skyline. Connecting the portrait frames, I used a new image convention regarding my Antone's bills—playing cards.

Above: **B. B. King, drawing, 2003**

Sometimes you just do a drawing because you want to. That's the case here. I was listening to some B. B. King and was just taken away by that smooth hand of his and its deft touch. I looked at the album art and was captured by the set of his mouth. I started a drawing of him and a few days later, this is what I had. Just needed to do it.

Antone's II:
Great Northern Boulevard

Nobody wanted it to be over, and so Clifford and staff started to look around for another location. It was important not to lose momentum. The Austin music scene had only grown since the doors had first opened in 1975, and many prime locations had been taken up by newer venues. Options on or near Sixth Street itself were particularly poor, owing to the sheer number of clubs, restaurants, and bars crowding to open there and the higher rents that followed in their wake. Searches around the university or south of the river proved similarly fruitless. Finally

Above: **Tanya Tucker, Antone's, 1980**
Another Nashville talent to make the Antone's stage in 1980 was Tanya Tucker, then near the top of her professional game. With Marcia Ball opening for her, she put on quite a show. Clifford, always appreciative of lovely women, was particularly taken with her—and it showed throughout the performance. Here I have rendered her in oil crayon on cold press illustration board. The lettering is pen-and-ink. For no particular reason, I thought to give her a 1930s look, complete with deco polygons floating behind.

Allen "Sugar Bear" Black came up with an out-of-the-way vacant furniture store in what was then far north Austin. Sugar Bear had become the de facto handler of musicians and master of ceremonies for the club since he walked through the doors in 1976 trying to secure a gig for Johnnie Taylor. He would remain so for nearly a quarter of a century, and three more locations.

The space itself was comfortably roomy. Spaciousness was about the only asset to recommend it, however. A former furniture showroom, it was located in an obscure but newish strip mall a block off Anderson Lane and just east of the new MoPac freeway. Large plate-glass windows provided the exterior walls that corralled vast flat spaces of soulless linoleum, metal pillars, and plasterboard that constituted the new room. This was a soundman's nightmare. The place would only have good sound when it was packed and humanity itself cushioned the music, which otherwise ricocheted over long stretches of faceted surface. But the worst thing about the new location was that it was too far north. It seemed light-years away from the action. That could spell real trouble for a music-consuming culture that was already taking advantage of the magnitude of talent in the city by hopping from one venue to another on any given night.

At first the bookings at the new location were a continuation of what had happened downtown. Antone's was still the city's blues home, and it continued to be Clifford's passion to provide Austin with the best of that music that he could. But more often now money matters were affecting current affairs and future plans. While attendance had, in the end, been dodgy downtown, it was positively dire now that Antone's fans had to travel many more miles to get to the club. Overhead at Great Northern was also much more than that which had floated the original location. Despite the fact that it was a love affair with the blues that caused the venue to be, the club could not continue to rely on blues alone as long as outgo constantly challenged income.

Clifford had to face the fact that producing blues shows might have to take second consideration to merely keeping the doors open. He supplemented by buying into the music that was driving Austin's reputation—and door receipts. He began to book a bit of the Austin Sound. Among the first was Asleep at the Wheel. The group had polished its reputation on the Armadillo and Opry House stages, among others—venues that had been in competition with Antone's. Now, progressive country began to fill the hall. It was only a change of booking though, and not attitude. Besides, Clifford had always respected that music and was very happy to invite it into his club.

It wasn't progressive country that distinguished the club's play dates, however. Clifford didn't want to compete with the many rooms that featured that music and set out to distinguish the venue by booking many mainline and classic C&W musicians. The size of the club and its generous parking variance now allowed for booking much bigger musical acts. Among these was George Jones, then a country colossus, as well as a Golden Triangle neighbor of Clifford's. However, it took two bookings before George actually mounted the stage. Not for nothing was he called "No Show" Jones, and on one unfortunate occasion, patrons were handed their money back at the door. To make amends, the second time he played for free. The Orange native's

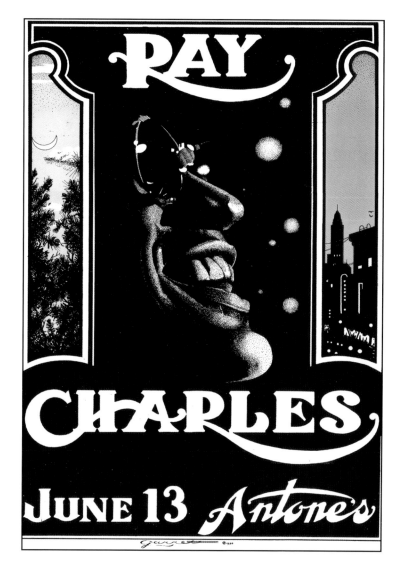

Above: **Ray Charles, Antone's, 1980**

Ray Charles was the first big-name act that I ever saw; I was 13. Ray was hot in '58 and still was in '80. It was at Antone's second location and the place was jam-packed. That was a very good thing, because a large audience insured good sound. The music came through loud and clear—carrying you across familiar piano riffs and that voice, right into the soul of the man. In this image I tried to capture two realms of that soul in the pale blue and peach "windows." They stand for the rural roots of the man and the urban arenas where his music took hold. In between these elements is the high-contrast profile of the great musician, whose strong chin mimics the thrust of the two R's in his name.

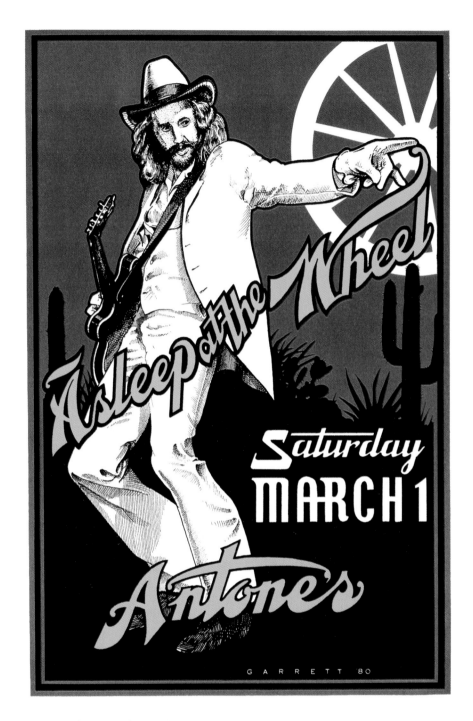

Asleep at the Wheel, Antone's, 1980

In the beginning, Antone's booked blues, rhythm and blues, and zydeco almost exclusively. That changed when the club moved to a new location. At the second club, Clifford began to add country and progressive country to his shows. Asleep at the Wheel was one of the first such groups, and this bill marks their initial appearance at Antone's. This is also one of my best pieces. Here, against a southwestern silhouetted background and vermillion sky, Ray Benson bends his towering frame to spark a spoked-wheel glyph as he touches the extended wing of a W. How he might play guitar in white gloves is something I didn't fully consider.

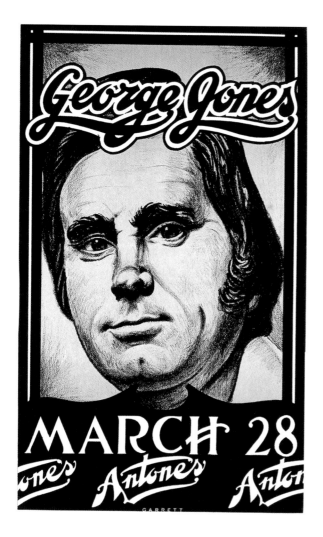
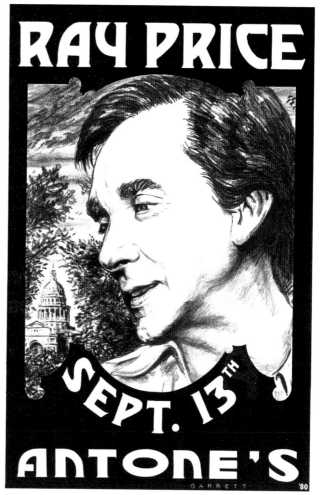

Above left: George Jones, Antone's, 1980

He has been called "No Show" Jones. In point of fact, he missed a previous booking at the club, but he scheduled a second show, and for this one, he showed up. And what a show it was. He did not disappoint, even adding a half hour to his 90-minute set. That mailed-fist-in-velvet-glove voice filled the sold-out room. Though sometimes the big country acts that were booked in this blues club seemed out of place, that was not true for this one. Maybe it was because Clifford and George hailed from the same place.

Above right: Ray Price, Antone's, 1980

Appearing at Antone's second location as one in a string of topnotch Nashville country players, Ray put in this performance near the ides of September. This man, who once employed Willie Nelson as a bass player in his band, had a voice as smooth and golden as honey. The place was sold out, which thankfully guaranteed that voice would be appreciated. Here is the bill I created for that show, with Ray in a pencil sketch before the state capitol. The white lettering on a black field fulfills the dictum of a poster: who, when, and where.

performance that night was inspired and well worth the previous misfire. The acts out of Nashville just kept on coming—Ray Price, Tanya Tucker, Jerry Lee Lewis, and Lacy J. Dalton were only a few who tapped into the Tennessee/Texas connection. This kind of setup couldn't last though; it was just too expensive to book these kinds of acts. The place was starting to lose serious money.

The primal passion for the blues, R&B, and zydeco that drove the venue was still there. And it wasn't as if those acts weren't booked—Ray Charles, James Brown, and Muddy Waters all played there. But less than two years after moving up north, Clifford realized he needed to look for another location. The growing sophistication and newfound success of local blues groups such as the Fabulous Thunderbirds, the Cobras, and Triple Threat Revue provided another and compelling motivation to move on. This factor would prove to be the charm. The blues in Austin was poised to take off, and the club that was going to be its launching pad was off to its third location in as many years.

Antone's III: 29th and Guadalupe

A. J.'s Roadhouse was a relatively new music venue located in a former Shakey's Pizza Parlor at 2915 Guadalupe. The club was a fair-sized one that mainly showcased Austin Sound acts. Tastes were changing, and the room had fallen on hard times. The proprietor was more than happy to turn the keys over to Clifford when he came calling in the summer of 1982. The deal happened so quickly that I was called in to help Dale Wilkins with sign painting the night of that same day. One day it was "A.J.'s," the next it was "Antone's"—only the A remained the same. The building itself was squarish and nondescript, and afflicted with a miniscule parking variance. It was surrounded on all sides by Guadalupe, a Rexall drug store, one great Austin alley, and Milto's Pizza, which perched upon the corner at 29th Street. Just a block west was the great Rome Inn, a pithy blues joint run by "C-Boy" Parks, which Stevie Vaughan generally called home. It also served pizza—pizza being a big thing in areas around the university.

The basic structure of the new site itself was Shakey's corporate formulaic. This setup would have implications for the layout of the club's interior and the way that performances would be viewed—and experienced. The entire place was literally built around a huge walk-in freezer that segregated about a fifth of the total space behind walls that bisected it. The bar wrapped around the front of the freezer, affecting line of sight to the stage. This setup divorced a fair-sized backstage and office area from the main hall. The space thus created was quite eclectic. Forbidden to the general public, in that arena things could get very interesting during—and between—performances, as musicians milled and waited to go on. The club's big room with the stage and bar area was intimately spacious, with enough room for a small dance floor and a good-sized area with tables and chairs surrounding it, and copious standing room behind that. The main entrance was relocated from the front to the north end, where tickets were taken and swag sold.

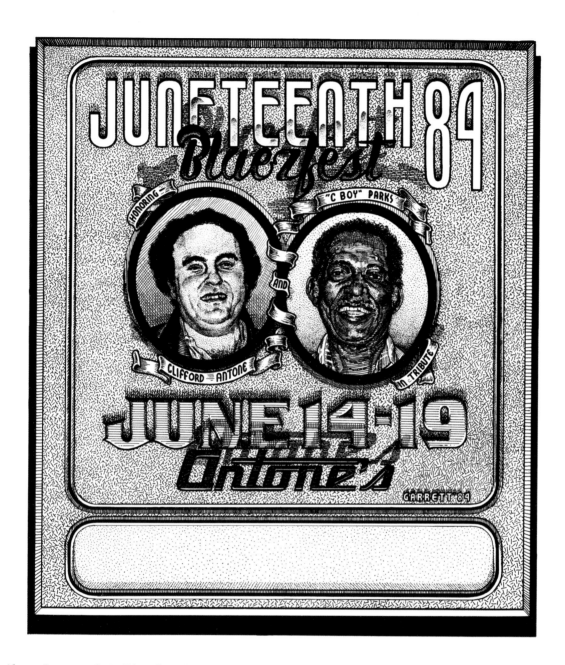

Above: **Juneteenth 84 Bluezfest, Antone's, 1984**

In 1984, Clifford held a five-day celebration of Juneteenth, the date (June 19) black Texans celebrate their emancipation from slavery, and dedicated it to "C-Boy" Parks. C-Boy and a few others had been running blues clubs for years. As the blues ginned up, these joints were jumping. C-Boy cooked in, and ran, the Rome Inn, a little pizza joint around the corner from Antone's III. Blues there every night of the week—SRV on Sundays, Thunderbirds on Monday, and Cobras on Tuesday was a standing three-day threat that people took seriously. And C-Boy was responsible. This is the cover that I did for the *Austin Chronicle* documenting the occasion dedicated to these two Austin blues providers.

Above: **The Fabulous Thunderbirds, Antone's, 1982**

Antone's was moving to its third location, and it was only fitting that the Fabulous Thunderbirds should open the room—they were the hottest blues act in town and were on their way to success beyond the city limits. I chose a classic 1950s color scheme of pink and black for this bill. I titled it a grand reopening because at the new spot, Antone's was once more a solid blues room. To many who had not known the Sixth Street location, this would be the definitive location for the venue. The show that night was hot, with Keith Ferguson playing the bass like I had never seen him play before. Hubert Sumlin came to town for it, representing the past and Antone's first location on Sixth. Stevie was also there, representing what was to come.

In that area was also a black hole. Its position in the shadow of the freezer and its bar blocked any view of the stage. Food was concessioned here on occasion, kicked off by the famous "Stubb's Bar-B-Q," handcrafted by C. B. Stubblefield, his own self. Stubb, who moved here from Lubbock, worked the stand personally, long before his namesake venue on Red River was even conceived. Robbie Greig sold his Louisiana cooking after Stubb left. When food wasn't offered, the spot housed a shoeshine stand, which was a feature, at some point, of every Antone's location. Even constrained by the Shakey's template, the place was very much Antone's, and a genuine blues room once more. It had the feel of the original location, and for many who would initially access Austin blues at this location, it would be the definitive incarnation of the club.

It was only appropriate that the Fabulous Thunderbirds kicked off the grand reopening in 1982. They were one of the fastest-rising Austin musical groups that year, Christopher Cross notwithstanding. They were certainly the premier Austin blues band at the time and had the widest notice—though the Cobras and Stevie's bands were producing significant heat and light of their own. Not only that, but a newer generation of blues musicians such as Charlie Sexton, David Murray, and Jake Andrews came of age—and took the stage—there. The rise of these guitarists demonstrated just how far the blues had come in a few short years. When the club on Guadalupe opened, it was a genuine homecoming. It was almost as if Antone's had been absent for two years, and in some ways, it had. Now, however, it was Austin's homegrown blues that was poised to become the next "big thing" in River City.

Even with the demise of blues-friendly rooms like the Armadillo, Castle Creek, and Soap Creek, there were a number of venues that had, for some time, been booking the music, such as the Austex Lounge, a reinvigorated Continental Club, Alexander's out in the country on Brodie Lane, 311 Club on Sixth Street, and Rome Inn. But it was Antone's that was the music's real home. The eighties were going to be heady times for the blues in Austin, and ground zero was Antone's, where some old, establishing forms soon came back into play.

The repainting and bar stocking had hardly finished before Clifford was again dispatching Junior to pick up the Chicago guys from the airport. The greats started coming back, and in no time there were overdue reunions between them and the Austin blues players they had once mentored. Some like Jimmy Reed wouldn't be returning, and neither would Muddy Waters. Others such as B. B. King had gotten so big that Clifford could no longer afford to book them. But many, like Buddy Guy, would sometimes take a pay cut and appear without their bands. The greats and their sidemen were aging, and their numbers were thinning. But most who could make it back did so just as soon as they were able. It wouldn't be long before Clifford would greatly expand the anniversary shows, just so he would have an excuse to have them play again and reunite them with the local talent.

Things started taking off. Besides the Thunderbirds' national recognition, Lou Ann Barton had signed a record deal, and Stevie Ray Vaughan and Double Trouble were coming up very fast on the inside. The Cobras, with Paul Ray, Denny Freeman, Alex Napier, and Rodney Craig,

still topped the local blues scene and were pushing for larger recognition as well. Clifford had started the groundwork for a record label, while management and touring structures were beginning to take shape. It helped that these efforts were now headquartered out of a solid showcase venue—one that looked and felt like a blues hall.

It was a heady mix: the proliferation of new blues venues, overdue respect for the music, and new bands and new musicians. Record companies and A-string musicians were starting to pay attention—and money. Most of all, some of these Austin world-class blues players were poised on the threshold of success. The club sailed along just fine in the months after the opening. It was booking practically every blues band in town, and now there were several. Some, such as Bill Carter and the Blame, held forth regular gigs on irregular dates, while others, like the Angela Strehli Band, held the same time slot every week. The word went out that Antone's was back, and musicians came in from all over. Things were really looking up, but in order to continue, money—and more of it than ever—was required.

Something was about to happen in that regard that would shortly change things. In November of 1982, Clifford and his cousin were arrested for selling marijuana. They were indicted along with a few others. In March 1984 they pleaded guilty, and in the summer of the following year Clifford entered the federal prison in Big Spring, Texas. This was a bombshell for the venue, for the Antone's music family and the Austin blues community at large. Susan Antone, Clifford's sister, moved from Los Angeles to run the club. As pertinent documents were placed in her name, the new location got a second chance at life. Every one chipped in effort, time, and money to make sure it all stayed alive. This was especially true of the legendary club "angels," those blues lovers with a bit of money who had, for nearly a decade now, helped keep the doors open. Still, it was going to be a tough slog without Clifford's energy and unwavering vision.

The bust and subsequent prison sentence illustrate just how fervently Clifford Antone wanted his efforts with the blues and the musicians that played them to succeed. Money had been the persistent problem, and marijuana was perceived as an answer. It wasn't the first time that a music venue had been sustained by commerce in pot or other contraband, and Clifford was hardly the first music entrepreneur to go that route. That was just the way things worked in the music business sometimes, especially in the seventies and eighties. Kim Wilson would say over a decade later, "When you get off the plane [at Austin's new airport], and it says, 'Live Music Capital of the World,' they should have a picture of Clifford there. Austin needs to get its priorities straight as to who the criminals are, and who the heroes are."

Now, however, Clifford had to hurry. There would be nearly three years between the bust, trial, and incarceration, and in that time there was much to do. First and foremost was the big dream—establishing the label of Antone's Records. Angela Strehli was called in to head up that operation. Personnel and money were found, and a small storefront across the street from the club was leased. Antone's Records was born. In practically no time the retail selling of records

Above left: **Albert Collins and Albert King, Antone's, 1984**

The night of the Alberts! What a show. One of the best two consecutive nights of the blues that I've ever seen anywhere. One night one opened for the other, and the next night that was reversed. And of course at the end they played together for one blistering set, backed by the Antone's house band, who were designed from the DNA up to do just such a thing. This piece also marks a departure point for me, artistically—as I moved into oil crayon/coquille in addition to pen/ink and acrylic paint.

Above right: **Albert Collins, Antone's, 1985**

The iceman. A performance by Albert Collins was always an occasion at Antone's. He loved to play there. In the 1980s, he often left tours, other schedulings, and his band for a one- or two-night spot at the club. The highlight of a Collins show was when he spooled out his guitar cord and moved out from the stage across the dance floor, beyond the tables and out the front door into the parking lot, patrons in tow. Here, I have rendered him in oil crayon on coquille, approximating a stippled effect.

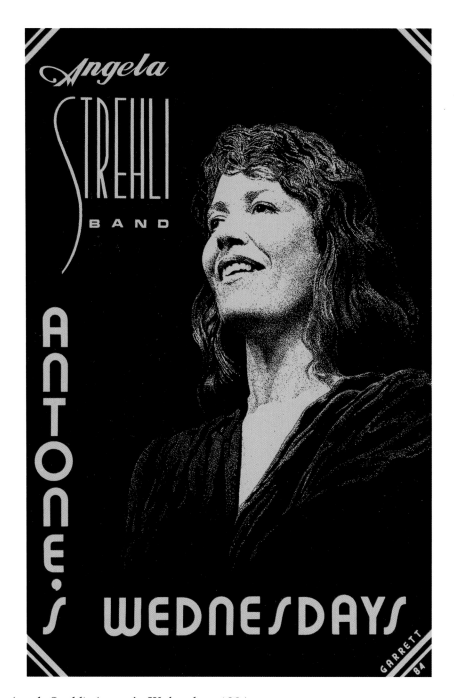

Above: **Angela Strehli, Antone's, Wednesdays, 1984**

Angela Strehli was central to Antone's and its success from the very beginning. After all, it was she and Clifford Antone who found the very first location of the club downtown on east Sixth Street. She was also instrumental in the founding of the record label the following decade, and later became head of that label. Here I created a bill promoting the regular Wednesday gig that she held for several years at the Guadalupe location. I crafted it from a wonderful photograph that looked up into her classically beautiful face. It is one of the best pen-and-ink portraits that I have ever done.

was established in 60 percent of the space, while the incipient record company occupied the other 40 percent behind the back wall. The first albums were by Strehli, Memphis Slim, Denny Freeman, and Ronnie Earl. However, Clifford's aim always included getting as many of the now-elderly blues greats recorded as quickly and as often as possible. He really wanted both on vinyl—the Chicago as well as the Austin players. To this end, the anniversary shows would prove to be the key.

The anniversaries had always been celebrated at Antone's. In the beginning they were mostly low-key affairs that were greeted mainly with relief and happiness that the club had survived another lap around the sun. That changed at the new location. Now it was to be a celebration of what had informed the first location with such spirit and power—the pairing of the reigning greats with the local blues musicians. These anniversaries would serve as a vehicle to let everyone experience just how special such occasions were. The first one that I did was the ninth anniversary in 1984. This was followed with the milestone year of 1985, signaling the passage of not just another year, but of an entire decade. There were already matchups inherent in the lineup: Jimmy Rogers and Jimmie Vaughan, Albert Collins and Derek O'Brien, Otis Rush and Denny Freeman, James Cotton and Kim Wilson, and Buddy Guy breaking it down with Stevie Vaughan to see who could play the quietest—just as they'd done on Sixth Street.

These were pairings that had sparked over the years and were still vital and transforming even after a decade. But these were just the classic couplings that had become such a pleasure to witness. The anniversary gatherings offered so much more. The jams between the musicians were free-form and open to all. Eclectic and quite often magical duets and ensembles swept over the Antone's stage constantly and spontaneously. The changing combinations electrified the room with sound for a week. The tenth anniversary may have contained more of them than any before or since. It was just a solid week of blues that stretched from one Blue Monday to the next in that stifling July heat.

The roster of musicians was nothing short of phenomenal: Buddy Guy, Jimmy Rogers, Albert Collins, James Cotton, Pinetop Perkins, Otis Rush, Junior Wells, Eddie Taylor, Hubert Sumlin, Sunnyland Slim, Luther Tucker, Denny Freeman, Derek O'Brien, Jimmie Vaughan, Stevie Vaughan, Kim Wilson, Keith Ferguson, Angela Strehli, Chris Layton, Tommy Shannon, Bill Campbell, Wayne Bennett, Mel Brown, Paul Ray, John Littlejohn, Snooky Pryor, Matt "Guitar" Murphy, Alex Napier, Mark "Kaz" Kazanoff, Jon Blondell, Lou Ann Barton, Marcia Ball, Sarah Brown, George Rains, Doyle Bramhall, Fran Christina, Lucky Peterson, Smokey Smothers, and Wild Child Butler, to name but a few. The lineup and the music from it was so rich and unique that the record label quickly put out a pair of live LPs around the tenth-anniversary shows. From this the Antone's record label would receive its first Grammy nomination. Clifford's intention was to record these performances and make them available to blues fans everywhere. The discs reprising the legendary tenth anniversary were exactly what he had in mind when he set out to create his label.

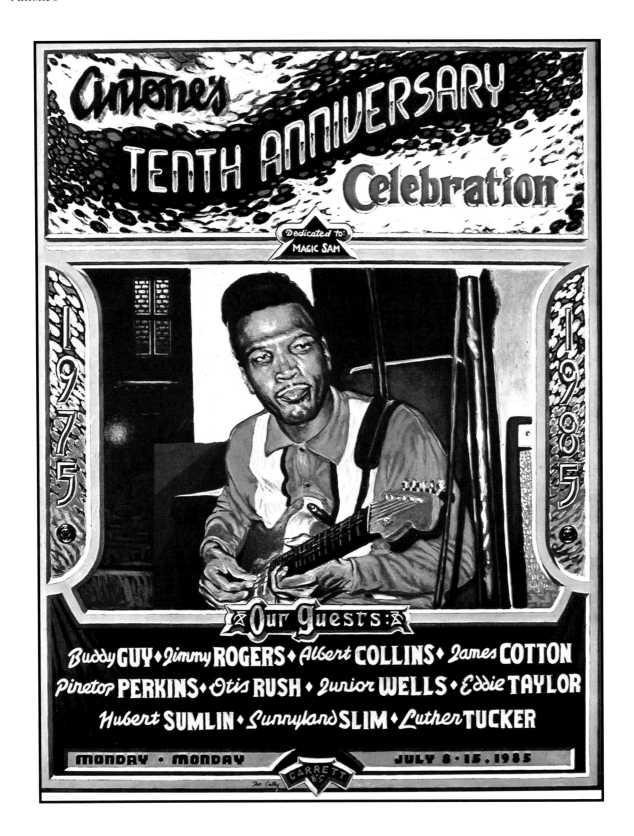

The anniversary had been a triumph, and everything just kept moving onward and upward in the Austin blues world. The Cobras were at the top of an expanding and very hot local blues scene. Lou Ann Barton had changed labels, moving over to Spindletop Records. The Fabulous Thunderbirds signed to a label again after a four-year hiatus. The band reconstituted one more time as Preston Hubbard replaced Keith Ferguson on bass behind a shift in drummers from Mike Buck to Fran Christina that had occurred earlier. Of the original group, only Kim Wilson and Jimmie Vaughan remained. The career of Jimmie's brother Stevie broke out with the release of *Soul to Soul*, his third album, just two months after the anniversary show. All in all the midyear of the decade was a very good year for the blues. And Antone's.

For Clifford, however, 1985 was only half good. In the summer of that year he entered federal prison. But as he left, he did so with pride. In a later interview he allowed "between '75 and '85, I don't think there's any question we were the best blues club in the world." While in the minimum-security facility at Big Spring, he would organize a series of concerts for the inmates, bringing up musicians from the club. He also formed an alliance with a city councilman and began to put much energy into community projects for the municipality. I was approached to do two posters for benefits that Clifford had organized for the restoration of Comanche Trail Park, a beautiful Depression-era amphitheater that was in dire need of restoration. One poster was for a joint concert by the Thunderbirds with Stevie Ray Vaughan and Double Trouble. The other was for a special performance donated by Willie Nelson in support of Clifford's public service and restoration efforts. This was a real solid by Willie out of respect for Clifford and what he had accomplished. It was also the beginning of a warm relationship between two of my biggest clients, Clifford Antone and Willie Nelson.

Opposite: **Antone's Tenth Anniversary, Antone's, 1985**

There was no anniversary like the tenth. None. On this occasion the club found itself in its third location—the one many tout as its classic one, near the corner of 29th and Guadalupe. And what an anniversary it was. Many of the blues greats were still alive; Muddy Waters had died two years earlier, but most of his contemporaries and the sidemen were still around and making music. Joining them were the younger Austin blues players who had remained in town over that decade, turning the music blue as the cosmic cowboys ambled off into the sunset. Some, such as Lou Ann Barton, the Fabulous Thunderbirds, and Stevie Ray Vaughan were moving into the national spotlight and beyond. Once again they made music with the old timers who had inspired and mentored them on that first stage at Sixth and Brazos. There were similar reunions at previous and subsequent anniversaries, but this one was special. The combinations and permutations that crossed and recrossed the stage were just a delight to watch and hear. The tenth was eight intense evenings of blues that often continued way past the wee hours and almost to dawn. The shows were dedicated to Magic Sam, and here I placed him in a sepia duotone within an indigo one. This is a tricky bit of printing, and there were few at the time who could do such a thing other than Terry Raines, Austin's preeminent poster printer.

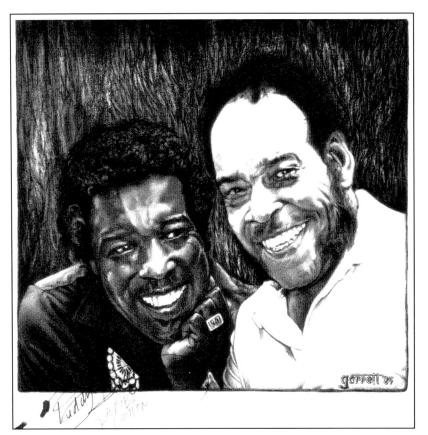

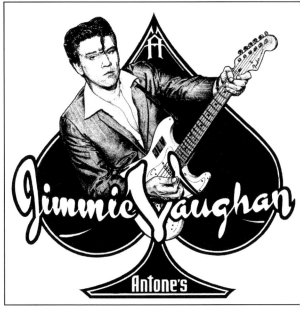

Above left: **Buddy Guy and James Cotton, drawing, 1985**

This piece was just a drawing that I wanted to do. The image itself is taken from a Susan Antone photo of Buddy Guy and James Cotton. It was shot down the alley behind the club, at Ruby's Barbeque during the tenth anniversary festivities. The tenth was really the best anniversary of them all and this is reflected in the expressions on their faces. The piece is signed by the two Chicago bluesmen, complete with ink smear, on the lower left side. These guys and others represented the Chicago blues contingent—that supremely powerful professional blues community that was really elemental to the Antone's brand. They were there when it all started in 1975. Cotton later became an Austin resident due to Clifford's efforts, and remains so to this day.

Above right: **Jimmie Vaughan, Antone's, 1990**

Susan Antone ordered up a T-shirt design for Jimmie Vaughan. I sought a playing card reference, and immediately came up with a spade—to signature Jimmie's muscular guitar playing. Here is the result. I used an earlier shot of Jimmie in a sharkskin coat, with a lock of loose hair falling on his forehead. The brush script lettering stretches neatly across the bottom of the spade, and where the "V" appears, Jimmie's picking hand falls squarely into its groove. What really worked design-wise, though, is how the torque of this pose echoed that V, forming an inverse complement to the upward thrust of the spade.

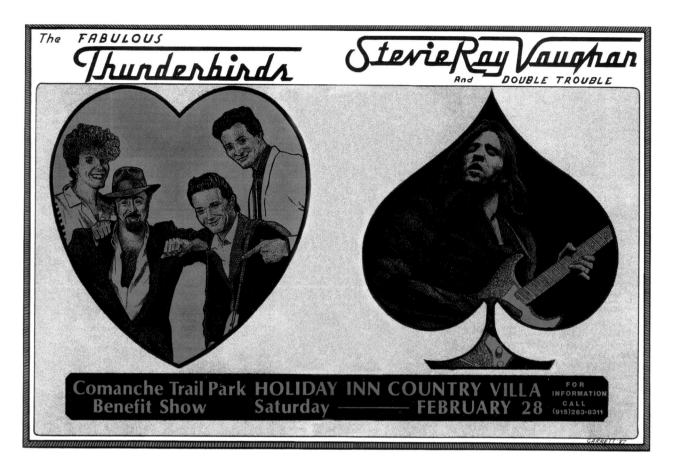

Above: **Thunderbirds and Stevie Ray Vaughan, Big Spring, Texas, 1987**

This was one of two posters that I did for Clifford Antone while he was incarcerated in Big Spring. Both events took place in that city. Here the Fabulous Thunderbirds teamed up with SRV and Double Trouble for a fundraiser benefiting the Comanche Trail Park amphitheater. This and other efforts by Clifford were part of his community service endeavors. This version of the Thunderbirds features Preston Hubbard on bass and Fran Christina on drums. In a simple landscape (horizontal bias) orientation, I chose to place the different groups within a heart and a spade, keeping with an Antone's graphic tradition.

The genuine affection between Clifford and Willie was exemplary of one positive aspect of the period up on Great Northern that carried over to the Guadalupe location. Because Antone's had decided to book country acts out of Nashville and progressive country acts out of Austin, any perception that the club was exclusively a blues venue had been cast aside. The initial booking of Asleep at the Wheel was very important in that regard. Just as Sunnyland Slim had informed Muddy and the gang about what was happening on Sixth Street, so too did Ray Benson inform Willie and the others about the new regime on Great Northern Boulevard. The result was a stream of successful survivors in and around progressive country that periodically mounted the stage at the new spot on Guadalupe. Doug Sahm was one of the first to do so, furthering an already deep affection between him and Clifford that would last as long as they lived. Clifford had long been

Above: Willie Nelson/Family, Big Spring, Texas, 1987

There was someone else who took it upon himself to pitch in with Clifford's community service efforts—Willie Nelson. This gesture of support and recognition, done by Willie, was completely his own idea and effort. He has always been selfless and respectful in this way. It was so heartening to see one Austin music founder come to the aid of another. But with Willie it was not surprising. In this piece I honor two of my biggest clients. I also honor Quanah Parker, the last great chief of the Comanche people, for whom the Depression-era amphitheater was named—a view of which is seen at the bottom. A very rare poster that was never seen in Austin, it is among my favorites.

Right: **C. J. Chenier and the Red Hot Louisiana Band, Antone's, 1989**
Although this is a bill for C. J. Chenier's band, the portrait is of his father, Clifton Chenier. He had passed away almost exactly two years before the play date. This is my homage to the great accordionist. It is one of my best pen-and-ink pieces and follows a familiar two-color approach of red and black—the colors of the suits in a deck of cards. Clifton's squeezebox playing was just phenomenal; he really was the king of zydeco. If there is any doubt, just examine the countenance on his face.

aware that the San Antonio sound that informed Doug's music was spot-on with the music of south Louisiana that he grew up with. He also remarked, "One of the things that brought us together was the love of the Louisiana swamp pop music."

However, Antone's was still dedicated to the blues. And zydeco. Clifton Chenier, after all, did open up the club. His Red Hot Louisiana Band played the club many, many times, and after Clifton died on December 12, 1987, the leadership of the band passed to his son C. J., who kept that tradition going into the twenty-first century. Other Louisiana practitioners soon followed—notable among these was Stanley Dural Jr., the Lafayette accordionist who formed up Buckwheat Zydeco. In that same vein Esteban "Steve" Jordan, a conjunto and Tejano accordion player, entered the club in 1986. His Anglo counterpart, Ponty Bone, did the same. The accordion, along with the harmonica, held a special place in Clifford's heart. In fact, there seemed to be two additional chambers in that heart—one to pump the blues through his veins, the other to do the same for zydeco.

There was something else that dwelled close to his heart—women. Clifford Antone loved women both personally and professionally. As the owner and operator of the "best blues club in the world," he went out of his way to make it easy for the female professional musicians to further

their craft and their personal passion for the music. The number and quality of the female musicians that mounted the Antone's stage is remarkable. Here are just a few: Angela Strehli, Lou Ann Barton, Marcia Ball, Sarah Brown, Barbara Lynn, Sue Foley, Eve Monsees, Susan Tedeschi, Carolyn Wonderland, Irma Thomas, Bonnie Raitt, Bonnie Bramlett, Elouise Burrell, Miss Lavelle White, Lacy J. Dalton, Tanya Tucker, Meg Driscoll, Texana Dames (Charlene, Conni, and Traci), Millie Jackson, Sister Sledge, Karen Kraft, Kathy (Murray) and the Kilowatts, Mandy Mercier, Tracy Nelson, Toni Price, Martha Reeves, Katie Webster, and the legendary Koko Taylor. Clifford's regard for women was genuine, and extended to the executive realm—prior to his stay in Big Spring and all during it, Susan Antone had taken over the helm at the club, Laura Hibbits managed it, and Angela Strehli ran affairs at the record label.

But of the female performers, it was the first four—Angela, Lou Ann, Marcia, and Sarah—who were really the dearest to Clifford. It was his intention, almost from the get-go, to put out an album by these women on the Antone's label. It probably would have been done after the tenth anniversary, had Clifford been there. As it was, it was on and off again and again until *Dreams Come True* was finally released in 1990—only by this time Sarah Brown had left the lineup. Dr. John led the band on the album, which included David "Fathead" Newman and Jimmie Vaughan. It was a solid slice of R&B in the gritty Texas roadhouse style and really tailored to the common denominator of three very distinctive voices and musical stylings. It remains a remarkable record to this day and an homage to Antone's and the women that played there.

Clifford Antone was released late in 1986 and returned to Austin. When he did return he stayed away from the club and the label. Because of legal constraints he could have no active participation in the affairs of either, and for a while could not even be on the premises. He mostly confined his activities to the record store and the baseball card shop that he ran just around the corner from the club, within earshot of the music that he so loved. It was really a low point for the man who had raised the profile of the blues so high in both Austin and Texas music.

The club itself was on a roll, and many consider these years to be the some of the greatest that the location enjoyed, while many more consider the location itself to be the greatest that the club enjoyed. Though the ranks of the aging blues greats were noticeably thinning, those that remained came to the club as often as they could, and showed up for the anniversary shows year after year. Other blues performers such as Albert Collins seemed to play the club more and more in the late eighties and early nineties. Maceo Parker, James Brown's saxophonist, started scheduling tour dates at the club, and the place just exploded when he played there. Varied acts such as Jr. Walker & the All Stars, West Side Horns, the Paris ex-pat Luther Allison, and Roy Rogers, the Bay Area Delta slide guitarist mounted the stage regularly. Local established bands such as Bill Carter and the Blame and Omar and the Howlers constantly honed their skills there. The profusion of newly minted blues performers played their own shows during the week and opened for touring acts on the weekends. The Blue Monday tradition that had begun on Sixth Street con-

Lou Ann Barton
Mel Brown
Albert Collins
Ted Harvey
Calvin Jones
Pinetop Perkins
Snooky Pryor
Jimmy Rogers
Otis Rush

Doug Sahm
Willie Smith
Angela Strehli
Bob Strogher
Hubert Sumlin
Luther Tucker
Lavelle White
Kim Wilson
...and more

BIG WALTER HORTON

July 9·15

Garrett 89

Above: **Antone's Fourteenth Anniversary, Antone's, 1989**

The last anniversary of the eighties, this one celebrates the blues of Big Walter Horton, who had passed away at the beginning of the decade. The incredible harpist from Horn Lake, Mississippi, was honored for the occasion. I chose to create a circular frame for his portrait—constituted with upside and downside wrap-around harmonicas containing the name of the club and the number of the anniversary; all against a tortoise-shell background. The spades lock in the playing card motif and the sevens add up to four-teen—I deliberately reversed the '7' within the spade glyph on the right, making it resemble a musical quarter-note. As the '80s progressed, fewer and fewer of the old time greats were around, so I began to mingle their names with Austin players. One particular addition to this roster of performers is the inim-itable Doug Sahm. Doug and Clifford had an intense friendship that would last throughout their lives.

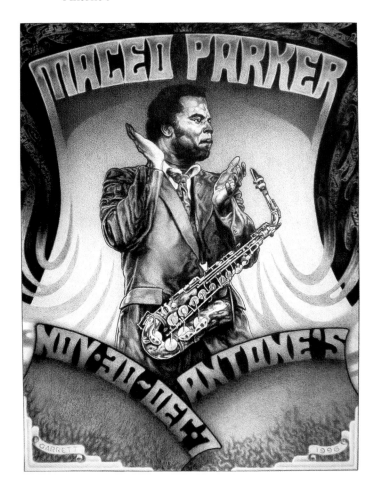

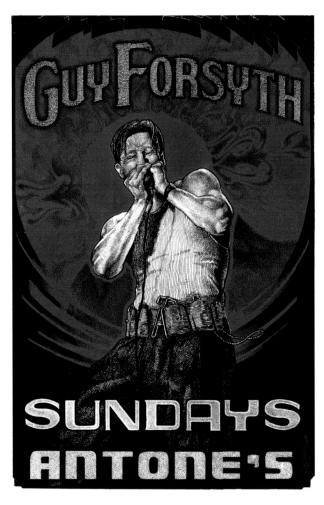

Above left: Maceo Parker, Antone's, 1996

Austin is a guitar town, full of six-string gunslingers. But while a guitar is muscular and demanding, nothing fills a room with sound like a horn. Enter Maceo Parker. Playing off and on with James Brown, and after a brief stint with George Clinton, Maceo went solo in front of his own band in 1988. Touring through Antone's once or twice a year, his arrival was greeted with great expectation. The doors just came off the place when he played. His single two-hour set got the joint jumping, with women inevitably atop the bar, dancing. Here is my homage to the man and those magic nights. In an Antone's purple duotone, I have lettering monoliths crowding the stage proclaiming "who, where, when," flames licking at their bases. Tight streams of saxaphone sound sweep away and behind, turning into ribbons of glyphic music, while Maceo just stands there in midclap. The quarter note that appears on his tie is one of my graphic "Easter eggs."

Above right: Guy Forsyth, Sundays, 1996

Like Angela Strehli, Guy Forsyth had a weekly gig at Antone's. For over half a decade he played every Sunday—mostly at the Guadalupe location, but also downtown on Fifth Street. Reverently, we attended faithfully, and referred to it as 'church.' Here I have rendered him as he appeared then—tank top, cargo pants, with an army-issue .45 ammo belt to hold his harmonicas. Behind him, in this image, is the best attempt I'd made up to this point to capture the music as a visual form. Depicted here is a full-on pen-and-ink rendering of sound itself. The two key forms outside the circle are meant to capture a harp note split in two and held.

tinued, featuring mainstays like Derek O'Brien, Denny Freeman, George Rains, Roscoe Beck, Mel Brown and Riley Osborn that provided first-day-of-the-week relief for decades. Single performers staked out particular days as their very own at the club—Angela Strehli had Wednesdays the whole second half of the eighties, while Guy Forsyth held forth on Sundays in the nineties.

The ongoing success of the venue, the dedication of its returning performers, the national recognition of first the Fabulous Thunderbirds and then Stevie Ray Vaughan and Double Trouble, and the growing prowess of the record label prompted the management to support and launch a tour out west. In 1988 Antone's took it all on the road with "Antone's West 88 Blues Cruise." It was a genuine effort to project the blues-regeneration success that the club had enjoyed in Austin and Texas to national and, hopefully, international arenas. The tour succeeded in promoting the blues, Antone's club, and its new record label. This was followed up a few months later with a swing up the East Coast that also showcased Austin blues. However successful these road trips were, they failed to reach the critical mass for recognition that Clifford had hoped for, and although the tours and this particular year were not the apex of Antone's fortunes, they represented the most powerful projection and recognition of the club, the label, and the blues family that sustained both.

The eighties gave way to the nineties and the blues den near Twenty-ninth and Guadalupe was still going strong. The year 1989 had been great for the club and the label as the decade played out, and 1990 seemed to offer more of the same. The label looked particularly strong when the long-awaited *Dreams Come True* was released in 1991 and sold nearly fifty thousand copies. This was followed by an exceptional Doyle Bramhall release that rolled twice that number. All in all and despite Clifford's legal problems, the club, the record label, and the record store, along with the tours, seemed to have put Antone's and the blues on a solid footing for the coming decade. The ongoing success of the venue's alumni, including the Fabulous Thunderbirds, Lou Ann Barton, Stevie Ray Vaughan and Double Trouble, as well as the budding careers of second-generation musicians such as the Sexton brothers, Ian Moore, and Doyle Bramhall II seemed to indicate that these accomplishments would not only continue, but increase, in the last decade of the twentieth century. All of that potential however, would be fatally compromised by an event mere miles from the blues' sweet home of Chicago.

On August 26, 1990, Stevie Ray Vaughan was on the Alpine Valley stage in East Troy, Wisconsin, just across the Illinois state line. He had just finished a memorable performance with many of his blues peers, including Eric Clapton, Buddy Guy, Robert Cray, and his brother Jimmie. Leaving for the Windy City by helicopter, Stevie Ray was killed instantly when the aircraft plowed into an artificial ski slope in dense fog. The Austin music community experienced a loss like none other, before or since. The whole city, it seemed, went into mourning, with Stevie's music playing on practically every radio station and in every music hall. A massive candlelight vigil more or less spontaneously commenced at Zilker Park, and everywhere throughout the community people viscerally felt his absence.

99

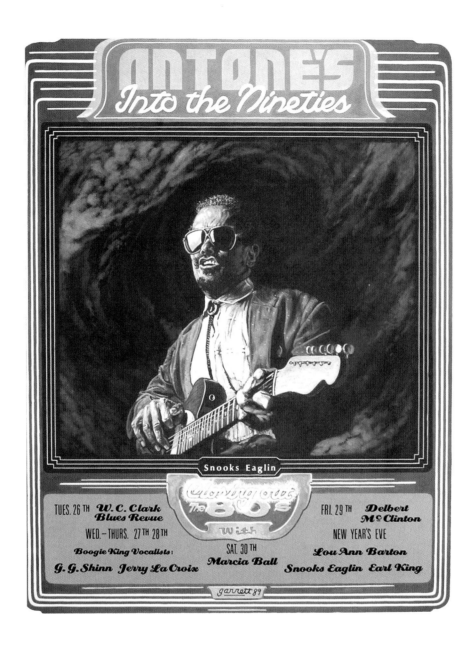

Above: Into the Nineties, Antone's, 1989

The 1980s were Austin's decade for the blues, and it was coming to an end. To shore up 1989's December bookings, this bill was commissioned. As you can see, it was made to order for a blues lover: W. C. Clark, the Boogie Kings' vocalists G. G. Shinn and Jerry LaCroix, Marcia Ball, Delbert McClinton, and on New Year's Eve, Lou Ann Barton and Earl King. In addition to King, another musician from New Orleans, Snooks Eaglin, was appearing with Lou Ann. It is his image that is pictured here. In this 1940s Deco-inspired motif, I have attempted once again to draw the music. Here you see a hurricane of it swirling about Snooks's head.

For Antone's the significance of Stevie's death was profound and profoundly personal. He was, in one person, what the club had been all about. He was "the kid" when the place opened on Sixth Street. His session with Albert King was both typical and the most extraordinary example of the magic that had happened between the black blues greats and the white Texas blues musicians that came together there. His professional and critical success, following on the heels of that of his brother Jimmie and his bandmate Lou Ann, was the greatest of all the Antone's alumni and second only to Willie Nelson as the top performer to come out of the city. Stevie's trajectory almost exactly tracked that of the blues club. With Stevie's death the aspirations that Clifford had maintained for the club when it moved locations in 1982 seemed to slowly evaporate.

Even tragedy can't keep the mundane at bay for long. Always a problem, money flow started to hit the club hard as the nineties continued. Financial angels like T. O. "Tonky" Murphey Jr. consistently helped out and sought out others to provide the venue with the funds to continue. But that only covered part of the freight. Numerous benefit shows helped to shore up the constantly sliding bottom line. The responses to these situations were always heartening. People both in and out of the music industry consistently wanted the venue and its associated businesses to continue—they instinctively understood what the place meant to Austin and its music. A couple of wealthy investors, one from Austin and another from Fort Worth, joined with Murphey to save the club and the label from a particularly vicious time in 1993. This, along with the increased presence of such musical biggies as Doug Sahm and Joe Ely, kept the hall's heart beating. A deal with Discovery Records/Warner Music Group breathed new life into the label.

It wasn't to last. By 1995 the label was in trouble again. This time it was the old, seemingly terminal, bugaboo of distribution. "The distribution did us in," said Clifford, "there's no question. It was hard then for independents. It's twice as hard now." This perennial choke point for the marketing of artistic endeavors was now being squeezed by something far more lethal—digital technology. The Internet, digital streaming, and musical pirating combined to spell the end of the music business model upon which the success of the label depended. This trend was threatening the entire recording industry, and at that time there was no way to offset it. The numbers needed just weren't there.

The fortunes of the label were reflected in those of the venue. Despite all the efforts of the various angels, the dedicated benefit performances of Austin musicians, and the affection and determination of the fans that were attending, fundamental problems plagued the club. Though near the university, most students preferred to get their music—and blues fix—downtown on Sixth Street or in the newly energized "Warehouse District" rather than at 29th and Guadalupe. On top of that, the physical circumstances at the location were reaching a serious

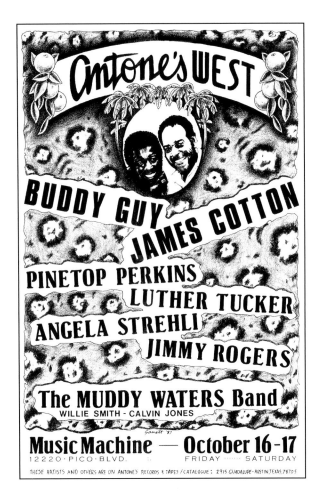

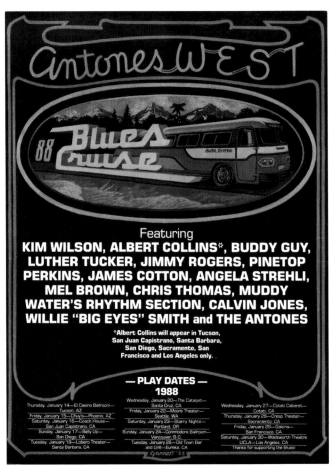

Above left: Antone's West, Antone's, 1987

In the late 1980s Antone's was on the move. West. It was a year before the Blues Cruise bus would roll along the Pacific shore, and the club dispatched an advance party to establish a beachhead in Los Angeles. Here is the bill that announces that show. Since it is So Cal, I topped the piece with a cameo shot of Buddy Guy and James Cotton, the headliners, in an oval frame crowned with palm trees—while oranges flank the titling. A stretched leopard skin peels away to reveal the blues cornucopia headed for the Golden State.

Above right: 88 Blues Cruise, Antone's West, 1988

All through the 1980s Antone's was on a roll. By the end of the decade, the musicianship of Austin's bluesmen and blueswomen, the reinvigorated venue on Guadalupe, and the growing success of the record label saw to that. At the crest of this success, I was tasked to create a poster for the first tour out west. Here is that poster. Nearly twenty performers were playing thirteen lucky play dates up and down the Pacific coast. The roster of players is mixed evenly with the greats as well as practically all the local musicians in the Antone's stable. In the poster, the main title mimics the piping of neon tubing. The image itself shows the Austin Express trucking down a western highway—mountains, pines, and palms poke up in the distance, while Pacific waters wash toward it.

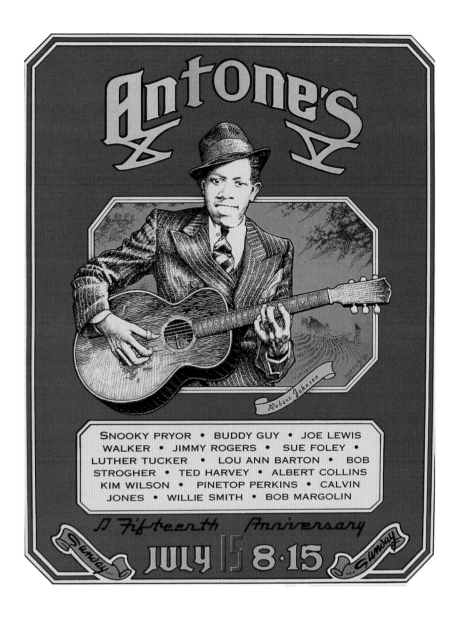

Above: **Antone's Fifteenth Anniversary, Antone's, 1990**

At last an anniversary poster that honored the mythic blues musician, Robert Johnson. It was a great privilege to render his image and I chose a southern rural scene to back up that portrait. Here you can see oaks and Spanish moss hovering over a plowman, his team, and rows of earth contoured. Like the tenth, this anniversary ran a full week. Of note on this bill is Snooky Prior from New Orleans and the white blues guitarist, Bob Margolin—"Steady Rollin'." Joe Louis, the great Kansas City bluesman, also first appeared on the Antone's stage. Indicative of the changing times, I was given the list of musicians to be included on the poster as a computer printout for the very first time, and, in a hurry to meet deadline, I dutifully turned it over to be typeset. Joe's name was misspelled and by not doublechecking, I completely missed it. When I explained to him what had happened as he got in my face over it, he rolled his eyes and started to speak, then just walked away, shaking his head.

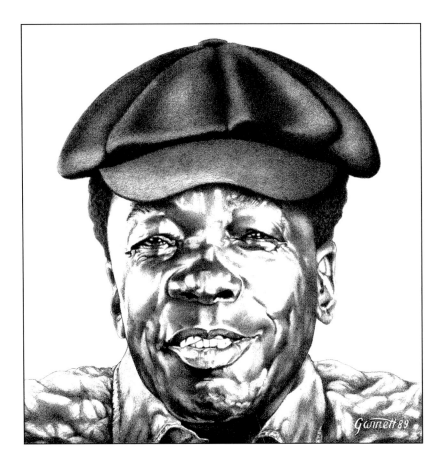

***Above:* John Lee Hooker, cover design—Antone's Records, 1989**
I got the commission for this piece from my good friend, mentor, and colleague, Bill Narum, who was art director for the label. It was for a live album, and the photos that went with the liner notes showed John Lee in a soft cap. Because the image I chose to render did not have a soft cap, for the sake of continuity, I placed one on his head in this oil crayon/coquille drawing. Such combining of image parts is referred to as "frankensteining" in illustration palaver. The advantage, to me, of coquille paper stock is that you can pass a dry medium over its surface and have it come out looking like more work-intensive stippling

state of decline. The place was just wearing out. From the carpets to the stage, the extended, perpetual, and modified use of the facilities had just about run its course. As great as the third incarnation of the club had been, the feeling could not be escaped that the club was fiscally and physically on its last legs.

Antone's IV:
Back Downtown at Fifth and Lavaca

The twenty-first anniversary came and went at the Guadalupe location. It was another memorable affair with a number of the few remaining older musicians in attendance, along with an expanded list of local bluesmen and blueswomen. The rest of the year played itself out with performances by Doug Sahm, Albert Collins, Maceo Parker, Bill Carter, and the brothers' acts—Sextons, Moellers, and Kellers. The following year brought more of the same—great music, less and less of it blues, and a perceptible decline in both the quality of the venue and attendance therein.

Too much was eventually enough, and in March of 1997 a new location for the club was chosen by Clifford and Susan on the southeast corner of the intersection of Fifth Street and Lavaca. After eighteen years Antone's was again downtown, back where it all began. The location was on the edge of the newly forming Warehouse District. Like Sixth Street before, Antone's was pioneering a new entertainment arena in a derelict precinct. Many bars, restaurants, brew pubs, theaters, and music venues were cuing up to locate there, with Antone's its northern gateway. Another grand reopening was announced for June 17 of that year. Unfortunately, other precedents would also kick in, harking back to the venue's harder times.

In 1996, federal drug agents came up with Clifford Antone's name in connection with marijuana distribution activities out of town. Subsequent investigations, including a search of Clifford's condominium on Town Lake in April of that year, resulted in charges being referred to a federal grand jury. Adding insult to indictment, the charges were filed by the feds on June 16, 1997—one day before the opening of the Fifth Street location. In January 1999 he pleaded guilty to two counts, and after many delays he was finally sentenced to serve four years in the federal facility in Bastrop on May 27, 2000. He was released two-and-a-half years later, in December of 2002.

When he was able to return to the club, he maintained a physical connection with the room and the music that he had not felt able to when the probationary period ended for him in the 1980s. Times and tastes had changed though, and once again the club only booked a small percentage of its play dates to the blues and zydeco. Other genres, especially funk, took the lion's share of bookings. No mistake though, this place was still Austin's home of the blues. Though their ranks were severely decimated, there were still aging blues greats and they still played the club. Soon after the location opened, James Cotton and Pinetop Perkins had taken up residency in Austin, and Clifford looked after them—especially Pinetop—with the love and respect that had always characterized his relationships with the elder bluesmen. And for a time he did the same with Hubert Sumlin, as well.

Derek O'Brien and the Antone's house band cohort still played Blue Mondays, while family members such as Jimmie Vaughan and Lou Ann Barton played frequent but irregular dates.

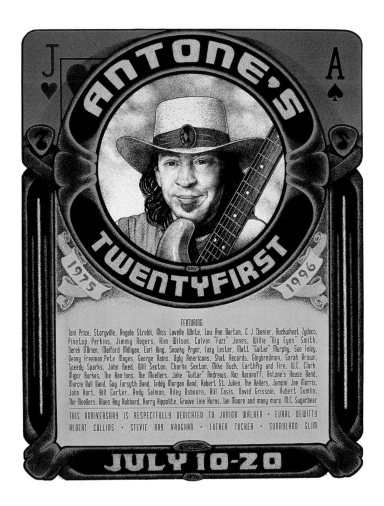

Above: Antone's Twenty-first Anniversary, Antone's, 1996

Clifford Antone wanted Albert Collins—an excellent choice. In keeping with his own tradition, the man the club was named for insisted that the anniversary poster be dedicated to a deceased musician. There certainly were many candidates: Jr. Walker, Luther Tucker, Sunnyland Slim, and Eural Dewitty, to name a few. All but Albert and Luther had died the previous year. However, it was once again hard times for the Guadalupe location, and as things were shaping up, it looked like this one just might be the last anniversary show that Antone's would ever have. Given this, I had another blues musician in mind. He was the one that most represented what the club had been all about; one who had been there from the start; the one musician who was the full incarnation of the Austin blues scene—and sadly, one that was deceased. If this was the last anniversary of the club, and if this was to be the last anniversary poster that I ever did, then there was only one person's image that could be on that poster, and one person only: Stevie Ray Vaughan. Clifford balked; he had wanted Albert Collins to be so honored since he had passed three years before. I pressed and pleaded, which was unusual for me, and Clifford resisted, but in the end I was able to persuade him. Here is that poster. For a bordering motif, I chose to riff off of the shape of a guitar pick. Nestled at the top of the two vertical arms of the border sit two of them, branded with quarter notes. Completing the background is my traditional Antone's playing card imagery—a jack and an ace, which add up to twenty-one. I chose the suits of hearts and spades to represent, in turn, both love and power. I then rendered what is probably my best drawing of Stevie, endowing him with a beatific countenance. Once again, though, the club endured, and made its way to a fourth location—back downtown at Fifth and Lavaca. At I write this, Antone's is homeless again, but hopefully not for long. The blues home that Clifford founded, and Stevie's spirit informs, I feel, will open its doors—and its heart—again.

106

From time to time headliners like Bobby Bland or Luther Allison would come through, though old friends like B. B. King and Buddy Guy were priced out of reach for the medium-sized room. Antone's was still the place for the local blues musicians as new and not-so-new players like Eve Monsees, Gary Clark Jr., Nick Curran, Doyle Bramhall II, and a few new others frequently mounted the stage. Though the family was both diminished and extended, and the house wasn't what it used to be, it was still a home to Austin's blues.

And so it was into the new millennium—good music in the hall and great blues there every chance it got. Though sometimes Antone's in name only, the spirit that informed the hall was purely Clifford and Susan. The dedication to the music, blues or not, was Clifford-inspired as well. The venue benefited enormously from his presence, but the musicians and the patrons

Below: Albert Collins Tribute, Antone's, 1994
On January 16, 1994, Antone's held a tribute to Albert Collins, who had died less than two months earlier in Las Vegas; he was 61. Born of African American/Native American parentage in Leona, Texas, he was the cousin of Lightnin' Hopkins, his family vector to the blues. He first mounted the Antone's stage in 1976, where in those days of musical matriculation, he became a friend and mentor to house guitarist Derek O'Brien. Here is the color drawing from which the black and white poster was made. Once again I attempted to draw the music. I tried to capture the essence of his cool sound by corralling fire in ice-strictured, self-contained diamonds of sound.

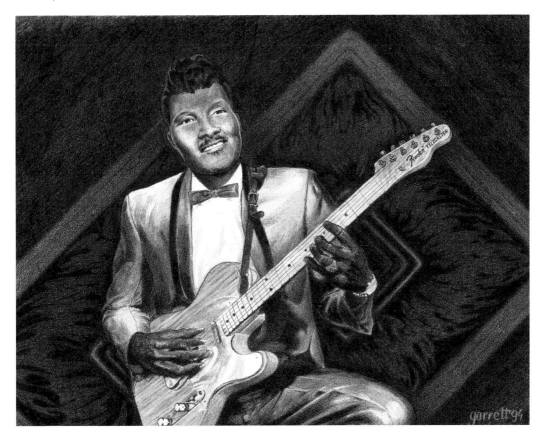

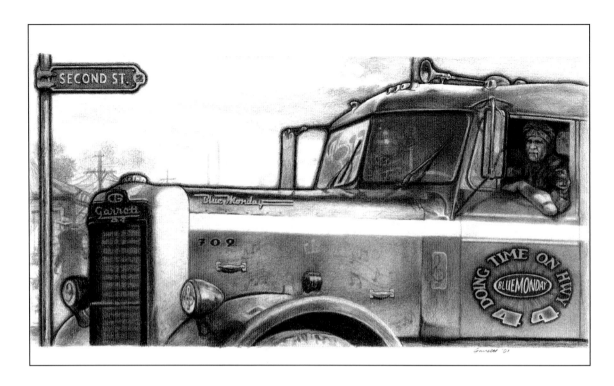

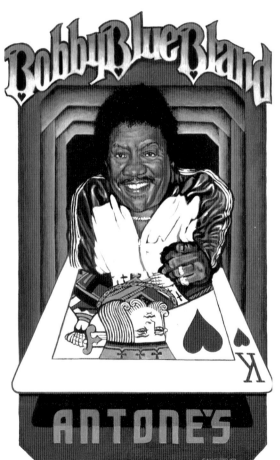

Above: **Doing Time on Highway 44/ Blue Monday, CD cover for Dutch blues band, 2001**

Record covers are another form of music ephemera. This is an album cover for a Dutch blues band called Blue Monday. I've never met them, but they admired my Antone's work, so we collaborated on this cover over the Internet; a first for me. This is a wrap-around, and the name of the album and the band are contained in the logo on the truck's door. The lead singer is driving. Second Street is the record label. My name and the date of the drawing appear on the front of the radiator. Music glyphs abound upon the truck, as well as the Austin number for weird: 709. The piece is a visual semiotic stew.

Left: **Bobby Blue Bland, T-shirt design, 1987**

"Music ephemera" is the term applied to the creation of materials for short-term use relative to the performance or in the normal conduct of the business of music. T-shirt designs qualify as such. Here is a T-shirt design commissioned by Susan Antone. Once again riffing off of playing card imagery, I've drawn Bobby emerging from a king of hearts. I echoed the suit graphically at the base of each "B" in his name. Hearts really suit his style. Bobby still had a youthful demeanor in 1987. He left this world near the summer solstice of 2013.

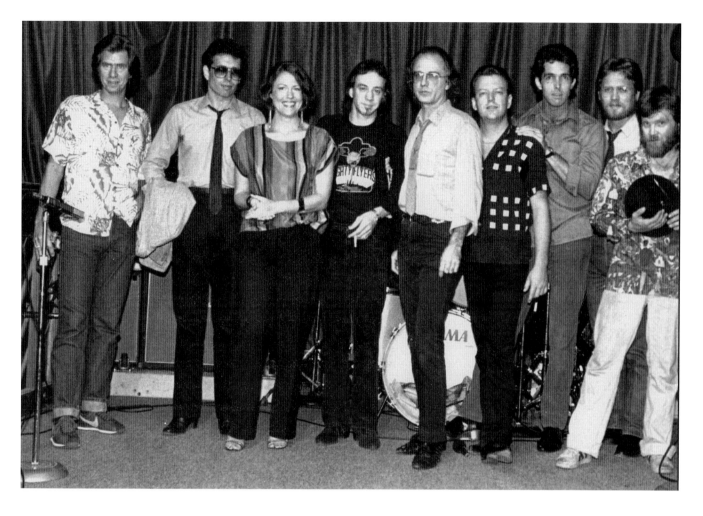

Above: **Antone's players stage shot, Antone's on Guadalupe, mid-1980s**
This photograph, possibly shot for an article or in some other publicity context, shows some of the Austin
musicians that played the Antone's stage and moved the Antone's brand forward. From left to right:
Larry Lange, bassist; Derek O'Brien, guitarist; Angela Strehli, singer; Stevie Ray Vaughan, guitarist;
Denny Freeman, guitarist; Alex Napier, bassist; Rodney Craig, drummer; Pat Whitefield, bassist; and Jeff
Barnes, saxophonist.
Photograph by Dennie Turner

benefited far more. He never failed to inspire through his passion for the music. Once again he was one with the club. And then he was gone. On Tuesday, May 23, 2006, Clifford Antone suffered a fatal heart attack. He was fifty-six years old.

The dreams of the 1980s, when the Fabulous Thunderbirds, Lou Ann Barton, and Stevie Ray Vaughan were polishing national reputations and the club was garnering international acclaim, had finally hit the wall. Terminal money woes, and the deaths of Stevie and Clifford had done in many of those dreams. In a convolution involving Don Walser, of all people, the record label went down. The retail record store itself was sold to Mike Buck and Eve Monsees, who maintain the spirit and dedication to the music and the records that are its beating heart.

Before his death, Clifford had reinvented himself beyond all that had happened. He had become a revered figure in the local music community and a godfather to blues musicians and devotees worldwide. He was given a class to teach the music under his own name at the University of Texas, where he had earlier failed to complete even his freshman year. He supported the careers of young musicians and took care of aged bluesmen. He sponsored the cultural and educational aspirations of children and students throughout the community, and became a cultural and community force for the entire city.

Yet it was his passion for the blues and American roots music, an abiding respect and caring for its unsung creators, and a burning desire to see that the music was made known and available to all, that really informed and illuminated his life. That light became a beacon that drew many to this music who otherwise would be ignorant of its power and significance. He brought the blues to Austin and made of it a gift to its people. And of the musicians and their audiences, he said, "They got to watch people grow through their whole career at our club. Things like that. I think that's what people think about when they say 'Antone's,' the nightclub or me. We represent the real working musicians."

5

Sheauxnough Studios

Art is the lie that shows us the truth.
—Pablo Picasso

It was eclectic; it was nonusual; and artistically, it was somewhat magical. It was Sheauxnough Studios. And it sought to do for the eye exactly what Austin music was doing for the ear.

Sheauxnough (pronounced sho-nuff) was Micael Priest's baby. It seems like from the beginning, Micael had a unique, broader view of the art that was being made around the music, and wanted to be a driving force for it. He had been the creative director at Directions Company, as well as the art director and art sergeant at the Armadillo. As the music scene matured, and music

Left: **Warren, Sheauxnough Studios, 1981**
Warren was the custodian for the Bolm Building. As such, he was also the gatekeeper to Sheauxnough Studios, as well as checker player extraordinaire. He was a rich source of inspiration during long stretches of production and perspiration. Warren was definitely one of the things that made Sheauxnough such an interesting destination. Here he is, on a winter's day, relaxing in the *living* room.
Photograph by Danny Garrett

111

art along with it, many of us felt the need for a space to seriously create. There were some attempts to find such space, but they mostly yielded nothing. Along with Sam Yeates, Micael located a sweet spot in an old building—the Bolm—at Sixteenth and Lavaca. He then raised the money, built out the space, and populated it with an Artograph overhead projector and a Robertson copy camera. When the dust settled, that singular edifice of art, absurdity, and Austin—Sheauxnough Studios—was born.

It lasted less than a decade, yet in those years much of the art that would come to be associated with the rise of Austin music was created there. Many people, almost all artists, sublet its space, with the ultimate tenant, the *Austin Chronicle*, setting up shop there between 1977 and 1985. Mostly though, it was the hard core of Micael Priest, Guy Juke, Dale Wilkins, Bill Narum, and myself—all Austin music artists—that covered rent and utilities every month. Other artists/creative souls came and went, notable among them Kerry Awn, Scout Stormcloud, and Robert Ekstrom. These and others created and contributed to the visual side of Austin—and its music—within those walls.

Back way before the day, the Bolm Building housed the old state laundry. Two stories tall with ample roof accoutrements, it came to occupy one half an entire city block, practically within the shadow of the state capitol building. In addition to a few of acres of floor space, it also contained a sizable fur storage vault and a huge steel boiler beneath a brick chimney that challenged that same capitol building for height. It was the kind of place, in the kind of location, with the kind of rent that was readily available in Austin during those early days when the music came to town.

The laundry went away midcentury and the place sat mostly derelict for a good while. By the 1970s, the building had become a maze of large and small spaces, mostly rented out to art and music types. It was a tight little community—jewelry makers, luthiers, seamstresses, potters, and creative denizens of all flavors, including music artists. For a while, the place even enjoyed the aroma of sourdough bread when Schlotzsky's Bakery was resident. The fur storage vault became a practice space for musicians and the odd but fairly frequent concert/party. The boiler, so huge that the building had to be constructed around it, had been cut up, and much of it secreted away in the nooks and crannies abounding in that ghost of industrialized space. In its absence a two-story void appeared, dead center in the building, large enough to stand a locomotive on its head, with room to spare.

Besides the creative warrens, the biggest renter in the Bolm was the main site of Half Price Books in Austin. We were very good friends with the guys that ran it, and there was even a secret second-floor doorway where access to both bookstore and studio, as well as the sharing of joints, was possible. Half Price was our library, eclectic record store, and image morgue. In the fast-paced world of music art, access to a wide and varied trove of images was not just a boon, but pretty much a vital necessity. Hard-copy pictures of the world and its contents were one of the wheels that made Sheauxnough roll. Images at the behest of a keystroke would not exist for nearly

another quarter century, but the studio had discovered a paleo-Internet within the walls of Half Price Books.

Once up and running, Sheauxnough began rapidly acquiring stuff, and corrals magically formed to contain it. A music room arose next to the overhead projector booth, and albums floated in from everywhere—ourselves, our friends, and Half Price Books, as well as from mystery donations. We had everything from Bach through Spike Jones to Hank Williams and beyond—all meant to conspire to inspire. This feedstock was continuously enhanced by the visiting Austin musicians for whom we created album covers and such. The music wafted around the various studios constructed by individual artists in their own spaces. Some were simple, direct, and functional, such as the one created by Dale Wilkins. Others were elaborate, maze-like fortifications like Micael's, with sanctums both inner and outer.

Besides the sequence of hot summers and cold winters that were the norms for the studio interior, there was also freakish indoor human weather, some of which materially altered the landscape. Here and there, but especially in the studio's foyer, eclectic items gathered themselves forth. Over the years, this stuff organized itself into evolving sculpture involving a heartbeat. In fact, said foyer was at some point rechristened "the *living* room," in order to better describe just exactly what was taking place there. Within this lair resided a wall of TVs—variously filled or painted upon with scenes and dioramas perceived to be culturally swell by resident Sheauxnoughians. A smattering of furniture, liberated or graciously donated—including at least one antique Edison gramophone—splayed out before the television shrine. Pretty pictures adorned tastefully wallpapered, portable movie-set "walls," and throws of lobby carpet rounded out and gilded a *sanctum sanctorum Americana*. It was this uber-domestic parlor that first greeted those who pushed open Sheauxnough's substantial door.

Beyond the foyer, the rest of the studio unfolded into individual and communal arenas. Micael's art fort appeared immediately to the left—a wall of various materials punctuated by portholes and pay-windows. Hard in front of that was a semifunctioning Frigidaire held together by bumper stickers. My space faced Micael's along a western wall shared with a neighboring art den, and to my back ranged the casement windows punched in the outer wall overlooking Sixteenth Street. Guy Juke's shoes filled the square feet east of me, with his faceted space running all the way to the front of the building, and other casement windows peeking out onto Lavaca. Dale Wilkins's studiette, across the trail from Micael, faced Juke's and mine. Between Juke Corner and the projector booth, hard against the music room, was a space variously occupied over the seasons. It was most notably held by painter and photographer Robert Ekstrom for a few significant years. Beyond the music room was the crammed but tidy arena where Bill Narum conjured his considerable magic. The rest of the space, to the Half Price south interior wall, was occasionally employed for large projects, temporary studios, and storage. This vast back space was notably populated with the Robertson copy camera—a rather large honey trap of photons and negative plates that lured in other artists, and eventually the *Austin Chronicle*, its own self.

Above: **Micael Priest and I and some business with the phone, Sheauxnough Studios, 1970s or 1980s**
Can't recall what this scene was all about, but Micael is either coming or going and I'm engaged in some pithy moment concerning a phone call. Above my head is the Texas flag that I solicited from then-Governor Preston Smith when I was in Vietnam. Other than that, the rest of the place is fairly colorless. Outside of the *living* room, that was pretty much the case. It was an industrial setting, but it was fun. Like the musicians that we labored for, we were mostly working stiffs.
Photograph by Robert Ekstrom

Sheauxnough and Me

I learned art here. That is no small fact for me. Sheauxnough, and the artists that I worked with, essentially taught me to be an artist. I had some native talent via genetics, but had never taken an art class and had no idea how to put it to real use. These guys were my art education and Sheauxnough the scholarship. An examination of the arc of my work—even a surface one— would quickly confirm that truth. It can be easily seen that the quality of art that I produced quickly improved once I joined the studio. And it's not that it just got better, but remarkably so.

My colleagues at Sheauxnough and I were part of a migration of artists that closely paralleled that of the musicians into Austin. Both were part of a larger population shift that was essentially culturally driven. Exactly because of that, creative types of all stripes came to town. A

114

Right: **D. G. at the drawing board, Sheaux-
nough Studios, the 1970s**
Here I am actually producing work at my desk,
in my space. I have no idea when this picture
was taken, or by whom. My best guess is that it
was taken in the 1970s, from the cut of my
hair. My little work area occupied about fifty to
sixty square feet in the extreme northwest cor-
ner of the studio, and the light you see is from
the casement window behind me and the fluo-
rescent fixture above.
Photographer unknown

remarkably talented cadre of artists was coming in all through the early seventies. Some came
fresh from high school or college graduations; some had followed their buddies here; some had
already established art careers; a few came hungry for a more stimulating environment, seeking
inspiration; while others just came. As for me, I was at loose ends, looking for something mean-
ingful after doing a year in Houston that followed two in the army. My misty plan to create an
underground comic and publish it in San Francisco evaporated once I hit Austin. Home had
found me.

One by one, we all made it down Texas highways to the state capital. The common de-
nominator for us all was our desire to be where the action was, and that action was essentially
musical and countercultural in nature. We settled in as individuals and began to seek out work
on a freelance basis. The work was mostly easy to come by, though the pay was pretty thin.
Nonetheless, Austin music art was at the dawn of its most fruitful period. It was a living thing,

Above: **Relaxing, Sheauxnough Studios, the 1980s**
Somehow, I have found my way over to Juke's couch. Those are his keyboards and pedal steel in front of me, and some of his flyers on the walls behind. Perhaps I was meditating, but more likely I was sound asleep—probably after a head-on collision with a deadline. Nevertheless, another helpful artist—probably the one who took this picture—has seen fit to place a sawing-log balloon on the couch beside me.
Photograph by Robert Ekstrom

already brought into being by those who had come before us. Music art had existed in this town since its inception; born the moment musician, venue, artist, and printing press first pulled it out of a hat. But it was especially vibrant in the 1970s. That was due to the groundbreaking efforts in the previous decade of individuals like Gilbert Shelton, Tony Bell, Jack Jackson, and Jim Franklin. If Priest, Juke, Narum and Wilkins "fathered" my artistic growth, then these guys were my godfathers.

We came here as individuals, but swiftly became aware of one another, met, and congregated. The Armadillo had an irresistible mass that drew many of us into its considerable orbit. I shared a communion with those artists that were a part of its family. Jim Franklin, Micael Priest, Ken Featherston, Guy Juke, Sam Yeates, Henry Gonzalez, Gary McIlheney, Kerry Awn, and Bill Narum were all employed there, creating while also contributing their labor to other tasks. Brothers in art, they welcomed me into their midst. I think it was that nexus which was so fundamental to

the development of Austin music imaging. It marked, as well, the beginning of a remarkable bond between and among us. That connection drew in most all the Austin music artists, whether they drew a paycheck from AWHQ or not. The Armadillo became the beating heart of a creative cultural center for Austin. Something it had always aspired to be.

Sheauxnough was, in many ways, an extension of that situation and sentiment as well as the next logical step for a handful of us in pursuit of a career in art. It also provided an intensified and continuing focus on the music art, important since we necessarily had to choose work in other arenas in order to make a living. Much of that was also cultural in nature and often complemented the music, as in the work we did for publications, apparel design, and radio stations. It also provided entree into other forms entirely such as cinema, TV, and computer gaming as those endeavors existed, or came to exist, alongside the piping of the music into town. Of course, some of the work wasn't so stimulating, and much time was spent in signage, production art, advertising, and other straight-out commercial work. Nonetheless it was mostly a joy to do the labor, and a positive, if mitigated, pleasure to do so at Sheauxnough.

Sheauxnough, in the Rough

From the beginning, Sheauxnough was more than the sum of its parts. Much more. It was more than the artists or the art created. It was more than the exotic material that filled the place, or the evolving sculptures that recombining that stuff brought to life. It was more than the promise of the new alternative weekly abiding within its walls. It was more even than the musicians, the venue owners, and other creative/producing types that braved its heat and cold to hatch art schemes around their efforts. Sheauxnough was a cultural entity in and of itself.

In a phrase, it was inspiration on the hoof. It was an exotic jungle of visions; a tossing ocean of memes; a maze of visual notions. It was all of this and more. The air itself seemed ripe with creativity, even in the weest hours of the morning, when shadows filled all the spaces and deadlines loomed like vultures. There was an energy that seemed to permeate the place.

There was also a liveliness to it all, something not always apparent to those of us who worked and—as often as not—lived there. If it's true that you can't read the label once you're inside the bottle, we weren't even aware of the glass. Spinning our art from our individual spaces or within the gears of the studio itself, we were usually so caught up in the process of it all that we were ignorant of just how special a time we were having. That didn't seem to be the case with our clients or visitors. People wanted to be there. It was the creativity to be sure, but as much as that, it was the weird process of that creativity that they sought out as well. But the process, like the installation sculptures, was a living deal and—as often as not—something we made up as we went along.

For instance, drawing and painting required an intensity around the interaction of the eye and the hand. That meant that speaking and listening were free to have lives of their own. Guy

Above: **Portrayt, 1984**

This is the serigraph, or screen-printed image, that Guy Juke created for Portrayt, our joint show on portraiture in the Orwellian year of 1984. Juke, whose given name is DeForest White, appears above his signature. In his faceted style, he has depicted us in profile, rendering one another—he with brush and me with pencil. We worked side by side at Sheauxnough Studios, and our close proximity enhanced both our work and our accompanying banter. Though I learned art and the absurd from many of my colleagues, it was my interaction with him that was the most profound and profun. The interaction between us greatly enriched my ability to conjure up the zeitgeist of Austin in the 1970s and 1980s.

Juke and I worked so close to one another that we were able to conjure up our own language—English to be sure, but a patois of our own device built around word associations so bizarre and subjective as to be almost opaque to others within earshot. Almost. There were occasions when someone might be waiting for Micael. Being polite, they would amuse themselves, usually in the *living* room, while we attended to our work. We would soon begin to talk openly about the person as they thusly occupied themselves. Half listening to our palaver, they almost always knew something was up, but could never quite decrypt just what was being said. Which of course prompted us to talk about that. At such a point, things could really get interesting.

People actively sought to hang out there, and that made it one of the few cultural touchstones left as the city changed. It was one of those places where the hometown music community at

large still came together. Sheauxnough was a nexus in that community, and as such it invariably drew in those who wanted a cultural fix of the visual variety. The notion was that, somehow, we were on to something.

We seemed to have more visits as the eighties subsumed the seventies. This was especially true as the first of the groundbreaking music venues began to close or relocate. Those visits seemed like pilgrimages driven by the thin hope that we might know something about what was happening. We didn't, of course. The community felt the losses and was concerned about how to move ahead. As the 1980s dawned, gone was our main fixed point, Armadillo World Headquarters. Antone's had relocated in the remote north of the city, as had Soap Creek Saloon. The great radio stations K98 and KOKE FM had vanished. Townsend Miller, the local journalist who had heralded the emerging scene in his spare time, was suddenly gone as well, and tragically so. The *Austin Sun* had ceased publication, setting somewhere over the horizon. Touchstones, indeed, were becoming dear.

Sheauxnough soldiered on, at least for a while. But the writing was on the wall for the studio, as well. As the new decade progressed, it became clearer that what had begun ten years before was vanishing, or at least changing enough to challenge recognition. This is the way of things, of course. All things. They have their moments in the sun, and then their day is done.

For Sheauxnough Studios that day came in 1985—far too soon, it seemed at the time. No matter, the bulldozers and the real estate minions were waiting. The artists, both within and beyond the studio doors; the other denizens of the Bolm; Warren, its custodian/caretaker and checkers player extraordinaire; and even the building itself, with its creaks and crevices—all conspired to make the studio's lifespan memorable. It had been a good run, in which many, if not most, of the classic Austin music images were coaxed into being.

It was a magical convergence in time and space. It was a place where the muse stopped off for a joint and a nap. It was a cultural refuge from the commercial storm. It was where art played to the music. It was Sheauxnough Studios.

6

Beyond the Clubs

Outdoor Festivals, Independent Concerts,
and Free-Range Music

Most of the music that has been performed in the Live Music Capital of the World was performed within the walls, and under the roof, of a club such as the Continental or a music hall like the Armadillo World Headquarters. But in a city such as Austin, which enjoys a lovely urban environment nested within a pleasant natural one, the impulse to stage music performances out of doors just sort of manifested itself, well, naturally. Beginning in the sixties and continuing into the next millennium, much of the best music was made al fresco. At about the same time, the general performance environment was such that individuals, on their own, could put together musical events, either in public arenas or private ones, indoors or out.

America's modern love affair with large outdoor musical concerts arguably began with the Beatles performance at Shea Stadium in August of 1965. This was possibly the first time that a crowd of such a magnitude—fifty-five thousand—required a large outdoor space as the only way to accommodate everyone who wanted to see the performance. To be sure, such gatherings for the purpose of hearing music had been held for quite a while—usually as annual festivals. Perhaps the best known of these at the time was the Newport Jazz Festival, held each year since 1954, but that popular event only drew around eleven thousand over two days. At the time, the Shea Stadium performance, like the Beatles' US tour itself, was simply considered a one-off event. With the possible exception of 1967's Monterey Pop Festival, it would be four years (and a cultural upheaval) later before another such event occurred.

But that one would be, and still is, the mother of all outdoor festivals—Woodstock. This salient event would produce an audience four times greater than Shea and establish the outdoor concert as a fixture in the music industry. The impact of the social and cultural phenomenon occurring over those three days of music outside of Woodstock, New York, and the mythology that arose around it was such that it would be put forth that a counterculture "nation" had come into being because of it. Such a proposition is debatable, but it was a galvanizing moment, and a powerful meme was established.

That was in August of 1969. By December of the same year the Rolling Stones-sponsored Altamont Speedway Free Festival in California had blown away that notion, as well as any illusion of no-fault mass musical gatherings, in a murderous blur of beer, blood, and Hells Angels' colors. The question mark raised by Woodstock concerning large outdoor concerts was answered by the exclamation point of Altamont fairly decisively. At the time, it seemed that the appetite for large and iconic outdoor music concerts had been stanched at almost the instant it arose.

Outdoor Festivals in Texas

Before such trepidation set in however, Texas was to have a Woodstock of its very own. Only two weeks after the affair at Yasgur's farm in upstate New York, crowds that would be estimated at 150,000 began streaming into Lewisville, north of Dallas, for a Labor Day blowout that would last for three days in the intense Texas heat. The Texas International Pop Festival would showcase some of the best musicians in the country—Janis Joplin, B. B. King, Led Zeppelin, Herbie Mann, Santana, and Johnny Winter—along with twenty other known acts of the day. As it was at Woodstock, there would be no violence to speak of, and the three days would pass pretty much without incident. Nonetheless, a few months after the multitudes had dispersed to their various communities around the state, the occasion of Altamont discouraged such events from happening for another three years—and no such attendance numbers for the rest of the century.

When outdoor music concerts did resume, they tended to be staged in established or makeshift arenas that provided infrastructure, reasonable access, and parking/camping for multiple days. The massive 1974 Willie Nelson Fourth of July Picnic was held, like the pop festival in Lewisville, in the middle of a huge motor raceway, just outside of Bryan. When ZZ Top brought its "First Annual Texas Size Rompin' Stompin' Barndance and Bar B.Q." to Austin on Labor Day of that same year, they played UT's Memorial Stadium. Many music stars such as the Grateful Dead, Johnny Winter, and the Allman Brothers would later play gigs at Manor Downs, a horse racetrack just east of Austin.

There was more to come. In the three decades between the 1972 Dripping Springs Reunion and the 2002 inaugural Austin City Limits Music Festival there were a goodly number of outdoor music events in and around Austin, with some of those projected around the state. A few were so successful that they became legendary and so iconic that they generated (mostly) annual sequels of themselves. Many were so ill conceived and marginal in scope, or victims of fate, that they arrived nearly or already dead on arrival.

Some, however, while musically significant, were just plain silly. In the summer of 1974 a very talented but eccentric violinist haunted the clubs of Austin. Joshua Ives had been drawn into town from the Left Coast by the buzz around the music scene. He played a few clubs and started attracting a bit of a following. After Christmas of that year, I was approached by Joshua

Above left: Joshua Ives/Festival of Love, Philip Menn Arena, 1974

One of the most unusual clients that I ever had was Joshua Ives. A serious hippie and excellent violinist, he approached me to do a poster for a large festival. It was to take place around Valentine's Day, and despite its being winter, in an unheated rodeo arena. Forty bands were to play, including Mike Bloomfield, Booker T., and Link Wray. Taken by a piece of art that I had done, he wanted the poster to be imbued with love and cosmic themes, including quotes from Nostradamus as well as prose of his own. It also contained the names of girlfriends and such peppered throughout the piece. I shouldn't have been surprised when he offered to pay me in hits of LSD. I declined, accepting filthy lucre instead.

Above right: Uranium Savage Festival of Lust, 1974, by Kerry Awn

A mere fortnight after the Joshua Ives festival, the Uranium Savages decided to do one of their regular gigs at Soap Creek and pay homage to Mr. Ives's event. Calling it "A Festival of Lust" and a "Celebration in Search of the Big Taste," it was typical of their irreverent approach to all things highfalutin. Kerry Awn, founding member, resident artist of the group, and long-time friend and colleague, came up with this parody of my recent creation. As a devout believer in the absurd, I was honored and consider this a worthy companion to my Joshua-directed piece.

and a group of friends to produce a poster for an upcoming outdoor concert—the Joshua Ives Festival of Love, to be staged on Valentine's Day, 1975. The group had been drawn to me on the strength of a sort of cosmic pen-and-ink piece that I had produced a couple of years earlier, and they wanted to use it as a centerpiece for the poster. I proceeded to produce the poster along with the art direction that this group deemed necessary. The event went forward in an unheated rodeo arena, and sure enough was torpedoed by a particularly nasty bout of mid-February weather. Kerry Awn promptly produced a parody of the poster as a promotional piece for an upcoming Uranium Savages show.

There was a hunger for al fresco music, however, and the times seemed ripe for music events of this nature. I created a T-shirt design for one such event. The bicentennial year of 1976 would see both the yin and yang of putting on such spectacles incarnate in two separate events under the same name. As winter yielded to spring, an outfit called Mayday Productions conceived of having a massive outdoor concert not in an arena or in some remote rural location, or even on the outskirts of town, but rather smack dab in the middle of Austin itself. It was to take place the second weekend of May.

Sunday Break was audacious and brilliant as far as these things go. Access, egress, and parking for tens of thousands of attendees are among the first problems encountered in trying to pull off such an endeavor. That was solved by staging the event at the juncture of I-35 and Highway 290, at a large patch of scraped earth prepped for the construction of a high-rise hotel. Deals were made, money changed hands, and in no time at all chain-link fencing, stages, portable toilets, and backstage trailers popped up like magic mushrooms in springtime cow patties. The site was bordered on all sides by roads, so getting there and leaving was a breeze. Parking was ample. One of the top acts of the day, Peter Frampton, along with America and Santana, entertained a crowd of 56,000 without a hitch; the weather perfect. A good time was had by all, piles of money were made, and no sooner had the dust settled than they decided to turn around and do it again.

This time it would be even bigger and even better with the hottest band in the nation at the time, Fleetwood Mac, headlining the show. But this would be no repeat of an in-town, no-fault, easy-access gig. Mayday honchos instead chose a beautiful bucolic setting on a remote piece of the Steiner Ranch just below Mansfield Dam and Lake Travis, some twenty miles or so west of Austin. The Steiner was a massive affair which at that time was still a family-owned working ranch that occupied hundreds of acres of open range. Cutting through the land was Quinlan Park Road, a two-lane roadway that ran from RR 620, the main highway, to a park, a private spa, and a small community of residents who lived among the giant pecans and cypress that lined the north bank of the Colorado River. It was here that Sunday Break II was to take place.

Down that road came the equipment and supply trucks that would bring the rigging, stage, fencing, vendors' booths, and consumables for the September 5 show. The musicians, VIPs, and other swells would arrive by boat and dock at the spa after a leisurely cruise up the river from Austin. The day dawned beautiful, and thousands upon thousands of people headed out to the

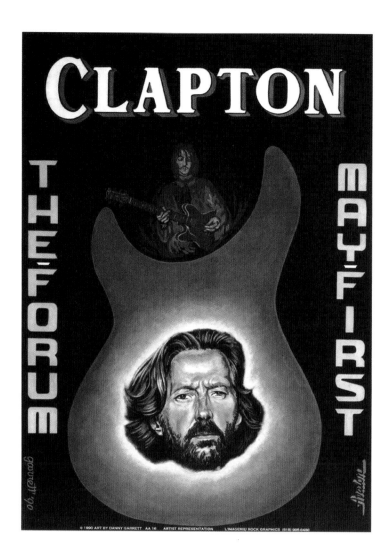

Above: **Eric Clapton, The L. A. Forum, 1990**

Around about the end of the 1980s, my fellow Austin poster artist colleagues and I were "discovered" by a gallery out of Sherman Oaks, California: L'Imagerie. They came in and bought up lots of our posters at prices that we had never seen before. Shortly after, they began commissioning posters for concerts in and around Los Angeles. Here is one of my first, and best, of that series—an Eric Clapton show on May Day of 1990. Bordering the main graphic with lettering, I chose to just use "Clapton" as the title lettering in deference to the tremendous reputation of this iconic musician. On the body of a Gibson Telecaster, I have placed his portrait. In the cusp of that shape I positioned another image of Clapton, much younger, with flames shooting up the arc of the curve. Wanting to enhance the design strength of that insert, I placed the guitar pointing outward from the curve. I was only half clever though, as I inadvertently made him left handed.

Left: **Sunday Break I, 1976**

This is the T-shirt logo that I did for the initial Sunday Break. The show was exceptional in all respects, and along with Willie's picnics and Rod Kennedy's Kerrville festivals, helped bring back the large outdoor concert after a short hiatus. The May show was a spectacular success, but a following concert in September, under the same name, was much less so. No matter, Austin music was in the midst of a remarkable roll. Here, I've placed bluebonnets under and above informational banners. The state flowers, with their lone star leaves, flank an oval containing a monumental treble clef that dominates a fantasy landscape. It was an exceptional show occurring in an exceptional spring.

festival. Shortly before noon, however, fate scratched an itch, and traffic on the small road became snarled. The available parking had overflowed. Also, a beer truck broke down, and blocked the park road a few miles shy of the highway. Access to the concert was baffled without remedy, and the festival grounds became a distant goal as concert goers hiked several miles to get there. A relatively small number had made it in before—or around—the problems, while tens of thousand were stuck in a stitch of vehicles almost all the way back to Austin. When the dust settled, Sunday Break II was a bigger bust than Sunday Break I was a success.

While the success and failure of the Sunday Break shows can be both credited and blamed on the critical factor of access, the story of these two shows is a wider cautionary tale about the risks and dramatic shifts of fortune that can be associated with organizing, promoting, and producing such events. The failure or even compromise of any element in these endeavors can bring the whole enterprise to ruin. Had Quinlan Park Road remained viable and money made, there might have been a whole series of Sunday Breaks, not unlike the Fourth of July Picnics—but that was not to be. Many such shows—though most were much more modest in scale—shared this same fate. Usually weather was the element to blame. Even though these concerts occurred at the height of Austin's wide-open music scene, such maverick entrepreneurial endeavors were generally on the way out, even at that early date. Independent outdoor promoters for big events

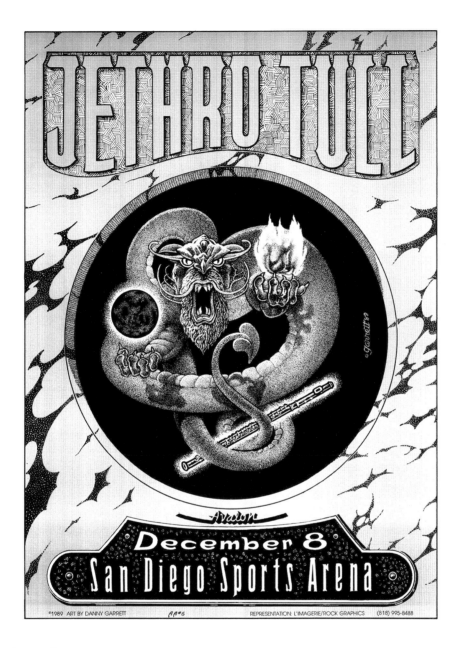

Above: **Jethro Tull, San Diego Sports Arena, 1989**

Another of the Avalon Rock series of posters from L'Imagerie. Here it's Jethro Tull, and they are appearing in San Diego. The background is a slab of marble, into which is carved the title lettering. The venue and date are placed on a plaque that is affixed to the stone by four bolts. In the center is a circular cutout. Within that cutout is a creature consisting of a torqued and eclectically coiled dragon with a heart-shaped tail and the head of Ian Anderson, the group's lead singer and flautist. His claws hold spheres of both light and darkness while a glowing flute nestles in the nether reaches of his body. His gaze and countenance say it all.

became rarer and rarer. As time went by, the big outdoor music experience increasingly became the bailiwick of local government concert series, serial events attached to big-name performers, corporate-sponsored shindigs, or those of successful broadcast entities.

This trend would eventually culminate in a festival of almost Woodstock-like proportions in the twenty-first century. In 2002, *Austin City Limits,* the highly successful PBS performance program that had put Austin music before the whole world, inaugurated a series of concerts in Zilker Park, the crown jewel of the city's parks and recreation system. The Austin City Limits Music Festival would feature the biggest acts in contemporary music as well as legendary performers in shows that would, by decade's end, set attendance records of over 200,000 in two- to three-day events.

However, it was to be another series of outdoor gigs that would be the most legendary of them all.

Right: **Willie Nelson's Second Annual Fourth of July Picnic, College Station, 1974**

This was my very first Willie Nelson Fourth of July Picnic poster. It was the second picnic and the second poster—Jim Franklin had done the first. The main graphic here is riffing off that poster. In it, Jim had an armadillo crawling out from under an American flag, with a small Texas flag in his mouth. Here I had Willie doing the same thing, but holding a can of beer—Tree Frog Beer, but that's another story. I was still learning my licks—especially when they involved cutting manual overlays for printing. I'm starting to get it down, but there's way too much white space here.

Willie Nelson's Fourth of July Picnics

Right: **Willie Nelson's Ninth Fourth of July Picnic, Southpark Meadows, 1985**
The ninth Willie picnic reprised again the art that I did for him in 1983. That was my only contribution to this poster. The image itself has been cropped, while the poster has been lengthened along the vertical axis. There were other occasions where this—or something like it—was done, but I wanted to include this one, because of the photographs. Neil Young, Kris Kristofferson, Johnny Cash, and Waylon Jennings are hard-to-beat images.

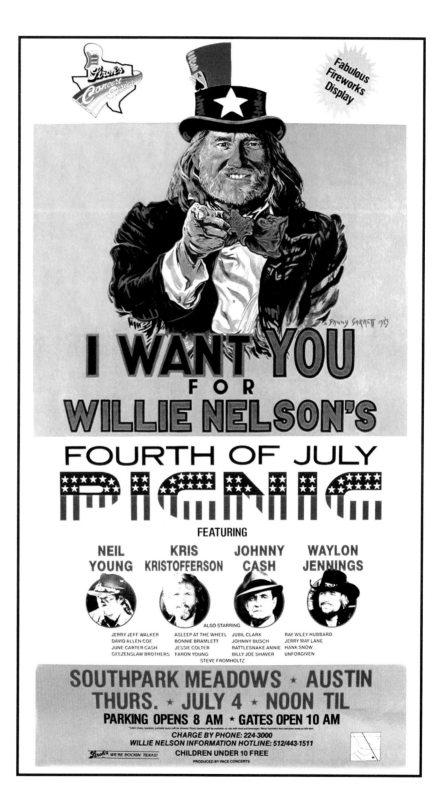

Whatever the state of outdoor performances, a series of them that began in the early 1970s would forever signature one performer and associate him with his new hometown. The Willie Nelson Fourth of July Picnics were an outgrowth of the Dripping Springs Reunion of 1972. A year later, the first picnic, essentially a clone of that show, took place at the very same spot, with many of the same performers and once again produced by Eddie Wilson and the Armadillo crew. The most notable aspect of the first picnic, as compared to the reunion, was the diminished presence of Nashville players. Willie was shifting his attention away from Music City to River City. This show included a brace of Austin talent while mostly restricting the Nashville side to the outlaw elements thereof.

The 1974 version was a three-day extravaganza at College Station, and was really the first of the classic picnic form and the very first to garner significant national attention. This picnic was to be very different than the first one—for one thing, it grew from a one-day event to a three-day one, which changed logistics exponentially. The change in the musical lineup was more dramatic—Nashville was out, Austin was in. Leon Russell and Waylon Jennings, outlaw veterans from the Reunion, were there. This time, however, Willie filled the stage with singer-songwriters and a herd of progressive country performers such as Jerry Jeff Walker, Michael Murphey, B. W. Stevenson, Ray Wylie Hubbard, and the eclectic country-rock stylings of the Lost Gonzo Band. Also included were the Cajun fiddler Doug Kershaw, rocker Rick Nelson and a relative newcomer from Alabama named Jimmy Buffett. The College Station gathering was the real kickoff to the series of picnics to follow. It also provided a cosmic occasion for Robert Earl Keen's car to be burned up by patriotic but misguided fireworks.

The 1975 picnic was on the flip side, with its locale being northwest of Austin instead of northeast. Liberty Hill at that time was a sleepy little village about thirty-five miles from the capital city, and the event would bring ninety thousand fans to its gates. However, just prior to Independence Day, the powers that be sent mixed signals about the whole affair. On the one hand, there was the Texas Mass Gathering Act, passed in response to problems that had initially arisen at the Lewisville festival, as well as at some past picnics and other outdoor events. It provided an excuse that Williamson County would use to try to stop the show. On the other hand, the Texas Senate had declared July 4 as Willie Nelson Day. Regardless of both proclamations, and depending on neither, Willie, along with Charlie Daniels, the Pointer Sisters, Delbert McClinton and, again, Kris Kristofferson, put on a great show with few hassles.

The year 1976 saw the event take place in Gonzales. This was the darkest picnic of all, with poor access, a miserable location, lost funds, a bit of violence, and just generally Altamont-quality sensibilities permeating the whole event. Weather was another negative factor. A huge thunderstorm had broken the baking heat and caused the place to become a quagmire. Famously, Paul English, Willie's longtime compadre and drummer, fired a pistol onstage to release the water trapped in the overhead tarp. That action pretty much characterized the whole show.

The picnic was canceled for 1977. There was a compelling need to rejig the vibes. Two of the three last picnics were flawed but successful shows, but the Gonzales one was so plagued

Above: **Willie Nelson, Fourth of July Picnic, Austin, 1978**

This is a pen-and-ink based on an idea I had of Willie as Uncle Sam. It was very quickly crafted. It's billed as the sixth and seventh annual picnic, to fill in for the lack of one the previous year. However, in fact, it was the sixth only; the seventh would get its own poster. The show was tight and featured many of the artists that Willie had signed to his Lone Star Records label. It was a hell of a show by Willie and the family. I would elaborate on this image in 1983 to produce a painting that would become my best-known version of Willie as Uncle Sam.

and unwieldy that it was decided to hold it in a more controlled setting. In 1978 a belated and hastily summoned picnic moved for the first time onto Willie's turf and for the first time indoors. Always a big draw, Waylon Jennings again joined Willie for the show, along with Doug Sahm and Emmylou Harris. It was staged at the Austin Opry House. The decision to have it at all was made at the last possible minute, and I was given a poster commission on very short notice. The result was a standard two-color, eleven-by-seventeen-inch bill for the occasion. I had something of an insight, and produced a quick pen-and-ink, cartoon-like sketch of Willie Hugh as Uncle Sam.

The following year the outdoor show was back, with Leon Russell, Willie, and Ernest Tubb as the headliners. Don Bowman, Ray Wylie Hubbard, and practically the entire stable of Willie's label, Lone Star Records, were there as well. This picnic marked the end of the seventies and the very first time that the event moved out to the Pedernales River and the incipient Willie World forming there, out west of Austin. In 1980 Merle Haggard, Johnny Paycheck, Ray Price, and Asleep at the Wheel performed at the Pedernales Country Club. During the show Willie announced that the picnics were ending along with the decade.

And for a couple of years they did. But in the early 1980s, Willie was getting big. Really big. In the spring of 1983, I was approached to do another picnic poster, a very special one. For the first time, the Willie Nelson Fourth of July Picnic was going to be held outside of Texas. A three-day East Coast extravaganza, it was to be held in Atlanta, in Washington, DC, on the fourth, and then in New York City. I revived the "Uncle Willie" concept that I had done for the Opry House five years earlier, and did a one-sheet size, full-color painted send-up of James Montgomery Flagg's iconic 1917 recruiting poster. Only this time, the idea was to recruit attendees to the eighth picnic. The result was probably the best piece of Willie Nelson art that I have done. In addition to the 1983 series of picnics, it was relicensed for the promotion of four more such events, two of which were held at Southpark Meadows, a huge open concert site in extreme South Austin, alongside the interstate and north of Onion Creek.

This would be the last poster that I would do for the Willie Nelson Picnics. In October of 2001, I was commissioned by the Austin Chamber of Commerce to reprise the image and rework it for a public service piece that promoted the hiring of Austin musicians. Willie donated his name and image, and I contributed my art in support of this effort.

The picnics would go on—occasionally morphing with and into Farm Aid events—throughout the rest of the century and into the next. Such was the case in 1986 when the picnic/Farm Aid concert was held at Manor Downs, just east of Austin. In addition to Julio Iglesias, the Beach Boys, and George Jones, the stage was mounted by Stevie Ray Vaughan, who was following Willie's lead to the cusp of superstardom. Like what had transpired at the Armadillo, these shows were great leveling and inclusion events. They didn't just bring the rednecks and the hippies together; they also connected all Texans in a series of musical events that were a very real statewide cultural communion.

Above: **Willie Nelson, Chamber of Commerce flyer, 2004**

On a spring day in 2004, I was contacted by the Austin Chamber of Commerce. They wanted to use an image I'd created for the Willie Nelson picnics in order to promote the hiring of local musicians. I said I would agree if they got Willie's permission. They did and I did. Here is the result of Willie's and my contribution. It is obviously a riff off my 1983 "Uncle Willie" piece. The record of support for Austin's unique musical culture by the Austin Chamber of Commerce has been spotty at best. When the music started up, the chamber seemed kind of ashamed of the scene here, but when it suited their fancy and it came at no or low cost, a modicum of enthusiasm could be mustered. Nevertheless, this was a genuine effort by them in support of the music.

By the dawn of the eighties, the picnics, along with the Armadillo World Headquarters and *Austin City Limits,* constituted a trinity of elements that both made and secured the city's music reputation.

The Kerrville Folk Festival

Above: **Bandanna, Kerrville Music Festivals, 1979**
Once the Kerrville Folk Festival was up and running, Rod Kennedy expanded his operations to include Bluegrass, Gospel, and Country and Western events as well. Having done many T-shirts for various musicians, venues, and performances, I hit upon the idea of doing bandannas. This is the bandanna I produced for the Kerrville series of festivals. The logos for each festival are in the corner, with "Texas Music" bracketing them, and "Kerrville" in the arcing field between them. In the center on a black field is a mandala made up of intertwining music notes.

This premier Texas music festival takes place each year at the Quiet Valley Ranch nine miles south of Kerrville on Texas Highway 16, at the gateway to the lower end of the Texas Hill Country. Starting on the Thursday before Memorial Day and now lasting eighteen days, it is the longest continuously running such music festival in North America.

Started by Rod Kennedy, the very first Kerrville Folk Festival was held June 1-3, 1972, in the twelve-hundred-seat Kerrville Municipal Auditorium. From the beginning, the festival down in Kerrville owed its inspiration and incarnation to the Austin folk scene of the 1960s. It grew directly out of that time. But a special point of genesis was the Chequered Flag, the legendary Austin folk-music club run by Kennedy from 1967 to 1970. As the music scene in Austin changed and increasingly left the folk-music tradition of the sixties behind, Kennedy sought a place and event that would preserve that special cultural contribution. The first concert featured many of the Austin musicians who would go on to make the Austin Sound, especially creators of original material. Such performers included Allen Damron, Willis Alan Ramsey, Jerry Jeff Walker, Kenneth Threadgill, Carolyn Hester, Frummox (Steven Fromholz, Dan McCrimmon), Rusty Wier, and a fixture for many years at Kerrville, the blind singers from New Mexico, Bill and Bonnie Hearne. Also appearing onstage in 1972 was Peter Yarrow of Peter, Paul and Mary, who became somewhat of a permanent fixture in subsequent gatherings.

In 1981 the festival celebrated a decade of performances. This was an occasion that I commemorated with a tenth-anniversary poster. It had been a remarkable decade. In that span of years it had achieved broad acclaim, with attendance from all quarters increasing each year. The first audiences had tended to be local and regional folk enthusiasts and singer-songwriters practicing a variety of musical forms. Later, the attendees themselves tended to come from greater demographic mixes while at the same time coalescing into a cadre of devotees returning year after year with greater enthusiasm and fresh converts. This marathon of shows, musical workshops, and camping occurs every year around Memorial Day. Impromptu musical gatherings fill the evenings and late-night hours spent around campfires that dot the hills and line the limestone-bottomed streambeds. Kerrville is more than an event; its occasion creates in its attendees a real sense of spiritual optimism through music. It is that special sense that I tried to capture in the poster.

After the first decade, the festival only grew larger and its contribution to Texas music only became greater—with Austin, and Austin musicians, increasingly lit by the glow that these occasions generated. In 1986, Texas's Sesquicentennial year, the fifteen-year-old festival celebrated with a documentary album and a musicians' tour of nine states on behalf of the Lone Star one. The next year saw the event expand to its present format of eighteen days, with eleven six-hour evening concerts. In 2000, attendance at the festival topped thirty thousand. On April 17, 2014, Rod Kennedy died at the age of 84. The festival, however, continues: the 2015 Kerrville Folk Festival was the forty-third.

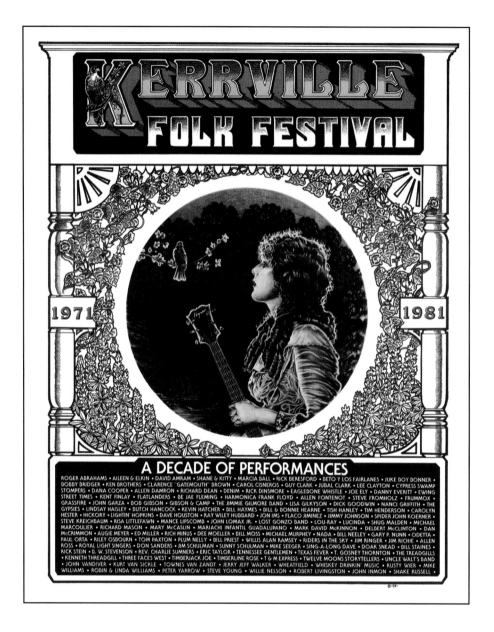

Above: Kerrville Folk Festival, Tenth Anniversary, 1981
This is a poster that I did after attending the festival for a half-dozen years or so in the 1970s, and in it I tried to capture the spirit of the Kerrville festival experience. Within the body of the K in the title, a red-tailed hawk stares out at the viewer. Bowers of morning glory and bluebonnet fill the space between the porch poles and the central graphic. Below these images is a partial listing of the many performers who appeared onstage during that first decade of the festivals. A cursory reading of the names will give some idea of the talent pulled in from across the state and the nation. The central graphic itself embodies the spirit of the event and the natural context in which it has its being. In it an aspiring songwriter (a riff off Mary Pickford) finds inspiration for her craft in the lilt of a songbird on a springtime branch.

Indoor Concerts

The 1970s were a freewheeling time in Austin.

All the elements were in place to make it so. Most of all, the city was imminently afford-able, especially in living and workspaces. It was a pleasant, physically beautiful, intelligent, and cultured community, and the traffic so moderate that it decreased citywide when UT let out for the summer. In general it was an exciting place to conduct a young life. That is why many who had come to study at the university had simply stayed on—ensconced in the paradise of a well-kept secret.

As it ginned up, the music was in an increasing search simply for somewhere to be. The music halls such as the Armadillo, the Texas Opry House, and the Creeks (Castle and Soap) were just getting up on their collective legs and still had to figure out how to do it right without going broke. Start-up and other establishing costs were high. The outdoor concerts were largely in a bust season, in the hands of training-wheel promoters, or hostages to the whims of plan and fate. At the same time, the scene was expanding, and a growing demand for the opportunity to hear a bit of live music—and to make a bit of money doing so—was making its presence known.

The cityscape of Austin in 1970 was essentially a few tall, boxy bank buildings poking above a grid of smaller commercial structures that were in turn surrounded by a sea of leafy neigh-borhoods. Significantly, there were two iconic buildings that could still be seen from any point in and around the city. The Texas Capitol Building and the University of Texas Tower not only dom-inated this skyline but also the viability of the city itself. These buildings represented the two chief economic engines that drove the wheels of commerce in Austin—the government and the uni-versity. Other than these, essentially only commercial retail, the professional realm, construction, or the service industries offered work opportunities. Outside of these traditional realms of em-ployment, there was little to generate lucre in the sleepy, compact, and affordable community—with one exception: drugs.

To put it in software terms, it should be established that drugs were a feature of the coun-terculture, not a bug. At the outset though, drug use was essentially benign, even altruistic. Pot was smoked to relax, without the side effects of addictive alcohol such as fighting, falling down, and wrecking vehicles. Consciousness, expanded through LSD, mushrooms, and peyote, enhanced sensory perception, while mental landscapes were made explorable. Such substances gained strong purchase among the countercultural communities. Speed and heroin, which had always been present, for the most part were used by few. Other street drugs were available, but they too were used by only a very few. Dangerous prescription drugs were the same—around, but unlike today, fairly rare.

The big game changer was cocaine. It mutated the vibe, harshed the buzz, and generally replaced communality with selfishness. Nonetheless, drugs and their users and dealers were an

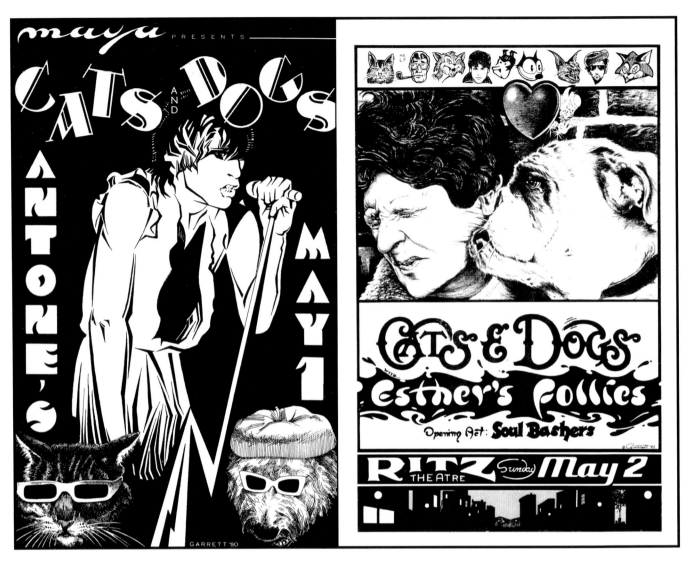

Above: Cats and Dogs, combined images, 1980,1982

Cats and Dogs was an annual affair, performed and hosted by Ty Gavin. Every year it appeared at a different venue; in 1980 that was Antone's. Here, Ty appears in house dress and holding a very electric microphone, all above a cat and a dog that just want to remain incognito. Another Cats and Dogs, two years later and now at the Ritz. This time Ty is joined by Esther's Follies and the Soul Bashers. At the top one can observe a series of cool cats, including Ty. The frame below is a black and white of my drawing, "Coy and Kissed". The next two frames contain the lettering. And the bottom frame is a look west down Sixth Street.

integral feature of the Austin of the early 1970s. They also had a material impact on the music, and in a left-handed way, how some of it was presented.

Marijuana was the main product delivered by this black market. Individuals in the trade, steeped in the American entrepreneurial tradition, were often very successful at what they did. Tons of weed were flown in by small aircraft or trucked up I-35 from the border. Because of Austin's geographical location, distribution to the rest of the nation emanated from many, mostly rural, locations around the city; especially those near the lakes. Precisely because the counterculture

138

Above: **Coy and Kissed, a drawing, 1981**

This is the drawing that was incorporated into my second Dogs and Cats poster. It is my homage to the dogs. Here we have true, if almost forbidden, love. Two countenances prevail—that of the terminally coy, and that of the compulsive kisser. Our canine friend is nothing if not all passion and weepy zeal, while m'lady shrinks from such intense ardor. Above, the Coke imp, whose bottlecap hat reiterates prohibition, steals out from behind a throbbing heart to perform a hand-sign that speaks directly to what must be, and remain, forbidden.

was a redheaded stepchild of the general culture, the people that supplied the product necessarily did so out of sight. Illegality, of course, being another good reason. These dealers developed their own entrepreneurial practices and, under the radar, did so with some alacrity and skill. Money from this black market began to accumulate here and there, outside of the shadows of the Capitol and the UT Tower. And some of it shortly percolated into the Austin music scene.

To be sure, much of the money would find its way into the venues, the recording studios, the record labels, the management operations and even to the musicians and the bands themselves. A significant amount of that early money and effort found its way into shows that were conceived of and executed by groups and individuals who were essentially wildcatters, in the best Texas sense of that term. These guys just sallied forth and got it done. It was the brief day in the sun of the independents—the small-time, sometimes casual concert promoters.

It really didn't take all that much to promote or produce a show when the Austin music scene was just in the process of establishing itself. The usual routine was quite simple. Once a performance was conceived and a date settled upon, inquiries were sent out to the prospective entertainer as well as to the prospective public (sometimes private) venue. Once confirmation

from the performer was secured, along with contract, down payment, expense and payment terms, the venue was booked and paid for. The show was then promoted and held. The booking of the musicians was fairly straightforward and pretty easy, as it was almost always done with cash. It was the securing of an adequate stage that proved to be more problematic.

And that was because, like the clubs and halls, there just weren't very many of them. In Austin, there were essentially four good-sized indoor arenas—two provided by the city and two that were available on campus at the University of Texas. The City Coliseum, originally an aircraft hangar, had been around since the 1940s, with the Palmer Municipal Auditorium (later renamed the Long Center after a twenty-first-century makeover) opening in 1959. These were the two main public-events venues that were available from the city for bookings. The rooms available at UT were the old Bass Concert Hall and the venerable Bates Recital Hall; both then ensconced in long-established classroom buildings. When there were no university functions trumping, these could be acquired by a member of the public at reasonable prices. Once word got out, they started to be booked. These four venues couldn't meet demand, and often events were held in dried-in spaces such as exhibition halls, athletic facilities, and rodeo arenas.

Opening acts were easily booked from the pool of talent increasingly resident in the local community. Promotion then kicked in. This period was critical. Hopefully there would be a good lead time. Such was usually restricted to between ten and fourteen days; three weeks at most. Once these things were done, monies paid and contracts signed, the go-ahead was given and the clock started running. Usually this meant that the functional promotional time could be as short as a week—sometimes less.

The promotional process was much more basic in those days. An advertisement in the city's daily newspaper was usually not an option because of cost and time, but ads might be placed in the campus paper and/or the alternative weekly. At this time that meant the *Rag* (1966-1977) or the *Austin Sun* (1974-1978). The real promotional vehicle that was cost effective, however, was the hand-drawn and offset-printed A3 music poster. This was where I came in. The drill, from my perspective, was the same as if it had been a club, hall, or outdoor event—the clock was running and it was up to me, the printers, and the hands hired by the promoters to get the bill out of the studio and press shop and onto telephone poles and storefront windows as quickly as possible. I did a number of such posters in the first half of the seventies.

Endeavors around such events could be unorthodox. Producers enjoyed general anonymity then and offered up counterculturally pertinent monikers for their production out-fits—usually one-shot deals. Entities such as JackPot Productions, the Ganja Group, or La Paz Productions promoted a number of these indoor concerts. After the creation of a poster for one such group, I was asked to do a personal print identity for one of its honchos and his alternative business. The business was an international jewelry concern, with offices listed as "New York - Austin - Bogotá." I was actually paid for the job with a couple of Andean emeralds pulled from a glass vial in a corner of Soap Creek Saloon.

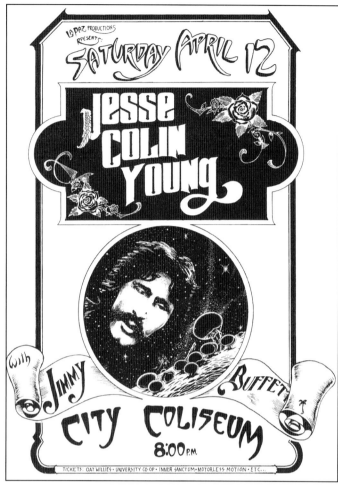

Above left: **Jerry Jeff Walker/Milton Carroll, Strahan Auditorium, 1973**

Here is another independent production poster. In this case it was Albatross Productions, the very brief independent production company of Tim O'Connor, who kept his hand in the game as he transitioned from Castle Creek to the Austin Opry House. The venue for this particular show was Strahan Auditorium, the then-new indoor sports arena at Southwest Texas State University (now Texas State) in San Marcos. Jerry Jeff of course was the main draw with Milton Carroll, an up-and-comer back then, as his opening act. The other two groups were one of the many progressive country bands out there looking for a break.

Above right: **Jesse Colin Young/Jimmy Buffett, City Coliseum, 1977**

This was also an independently produced show. This time the production company was called La Paz Productions, a moniker that referred to the capital of Bolivia and was a dog-whistle reference to the cocaine trade that may or may not have been germane to the financing of this endeavor. My own drug reference in this piece was the mushrooms that Jesse is eying. It was a spring show and it was then still possible to pluck psychedelic mushrooms from cow patties found in rural areas around the Austin area after a seasonal rain. It wasn't to last. Word got out and it wasn't very long before feed companies put fungicide in their grain.

Many times I was offered remuneration in some such contraband or another. For obvious reasons—and the demands of rent—I usually declined. Some of these productions made a bit of money; sometimes a tidy bit. Most just barely paid for the effort, or lost money big-time. As with so much that was happening with Austin music in that era, no one was seriously in it for the money—especially when it was easy money. Some of the promoters, however, did manage to acquire a bit of business acumen and sometimes a bit of geld, which enabled the more serious among them to move over into the legit side of music promotion when inevitably things began to change.

And change they did. As the decade wore on and the music caught fire, the whole public-events-venue scene shifted. A godsend to the situation occurred on February 2, 1975, when a wonderful old venue became available as a newly renovated Paramount Theatre opened with a performance by Dave Brubeck. In 1970, Frank Erwin was the head of the UT Board of Regents and the bane of countercultural types, gleefully breaking up their antiwar marches. In 1977, the Frank Erwin was a brand-new world-class sports and events arena that welcomed these same types off the street to hear their music being played there. Across campus and two years later, the Cactus Cafe opened its doors in the UT Student Union for the first time. It would become one of the best listening rooms in the city, and valued enough by the community to be saved from closure in the next century. To some degree, it was those early independent productions and the demand for music that they represented that spurred on the creation of such facilities.

An ancient pattern concerning almost all human endeavor inevitably kicked in. As time went by and the situation successfully matured, the independents were forced from the scene. The big boys took control. Music industry touring, always married to record sales, became lucrative on its own. The larger and better-known acts began to be either handled by the record labels themselves or organized through professional touring entities that operated from the coasts or out of industry centers like Nashville. There were now also many more private venues. A few new ones such as the One World Theatre opened, which allowed midsized acts to be experienced intimately, eliminating one of the last niches of the independents. It had been a very good, but brief, run for them. But the time when an individual with a bit of money, a bit of promotion, the booking of an act, and a public stage could make it happen were pretty much gone forever.

Opposite: **Spamarama '99, 1999**
Apparently the Spamaramas, as of 1999, are now designated by date as opposed to being dated by number. No matter. This is another example of working in art production with another artist, in this case, Micael Priest. This is Micael's design/concept, and my rendering. Here we have "Swine Lake." A delightful Priestian sow pirouettes upon a can of Spam, within a view looking north over Lady Bird Lake. Look closely and you can see another of my palm trees as part of the dated skyline. As this was a collaboration, I signed it "Bimby Dado," with a nod towards Walt Disney's signature signature.

Free-Range Music

There has long been a tradition of just plain folks putting on music shows for the just plain fun of it. Some of the time, the music was put on for its own sake alone. In other situations it was just part of a package in support of endeavors that had some other intent entirely. But either way there is a rich history in the city of folks just wanting to gather together for a good time and to hear some good music.

Austin likes to get outdoors and it also likes to have a good time when it does. And since music holds the place that it does in this town, it is certainly not unusual to find that it is an integral part of many of its outdoor events. From the earliest days when the community was known as Waterloo and itinerant fiddlers roused revelers down by the riverside, to the twenty-first century when high-tech companies would hire seasoned acts for promotional rollouts, Austin has gotten quite used to music being a familiar companion at most get-togethers. Here are just a few of the classic ones:

Eeyore's Birthday Party. When they held the first Eeyore's Birthday Party, John F. Kennedy was president. The year was 1963, and the place was Eastwoods Park, just north of the UT campus. It was held as a picnic and party for students of English professor Lloyd W. Birdwell Jr., and featured honey sandwiches, a big tub of lemonade, and a live donkey festooned with garlands of flowers. Held at Pease District Park since 1974, the occasion has become an Austin tradition, especially for the hippies still in town, and is an excuse to just become a kid again, suit up—or down—in costume, make music, and revel in the park on the last Saturday in April. While local acts are booked for the event, it is really the eclectic acoustic instruments, their equally eclectic players, and the huge drum circles that fill the place with sound. It is an extremely Austin rite of spring.

The Hill on the Moon Concerts: These were a series of performances that were put on by Crady Bond, starting in 1968. They were conducted on a makeshift stage located on the land that had been in Crady's family for years. That land was on lonely City Park Road, then quite remote, connecting Ranch Road 2222 to Emma Long Park on the banks of the Colorado River. The spot was a spread of acreage not that far off the highway, and just east of the park road. It consisted of a large modern limestone house, a bit of woods, and a compound with a spacious A-frame, a barn, and a number of outbuildings and sheds. Out in a high field was an old weathered stage with lighting consisting of strung light bulbs atop poles situated at the four corners of the platform. Crady had a lengthy power cord that was wrapped around a cable spool attached to a cart that he had rigged up in order to quickly and efficiently run power from the big house to the stage. Many concerts were held there throughout the sixties and into the seventies. Many of the hot local bands and ad hoc groups played there, including Conqueroo, Krackerjack, Greezy Wheels and Texas Storm. Shortly after Doug Sahm returned to Texas from California, he held a huge show there. As did Willie Nelson. Crady, indulging a strong pyro-preference, staged fireworks shows that included dynamite, functional homemade cannons, and more. He once filmed the exploding of a derelict Corvair, late of an absent concertgoer. This was accomplished with eight sticks of dynamite and a bleeding container of gasoline. It was often seen on a famous piece of 16mm footage that made the rounds back in the day, including screenings at some concerts. Freewheeling does not quite fully nor adequately describe a Hill on the Moon show, though all of them were, indeed, free. They wound down and completely ended in 1977, when the land was sold.

Above: **Willie Nelson, Hill on the Moon, 1973**

Willie is onstage, second from right. Behind him, looking almost due east, you can see the limestone hills between this location and the city of Austin, which lies just beyond. You can even see the cuts in the limestone faces as RR 2222 snakes out of Austin toward Lake Travis. Notice that there are no developments, just wilderness, in this shot. This was a fair sized crowd on the hillside. The fact that Willie had moved to Austin brought out ever more fans to see him. In turn, Willie cranked out many more performances.
Photograph by Sue Spicer

The Full Moon Barn Dances. These private concerts take place on select full moons during the year. They occur at the South Austin residence of Leeann Atherton, Austin musician, music teacher, South Austin booster, and mom. Located in the prestigious 78704 zip code, these barn dances have been held since 1993. The official pronouncement goes like this: "This community and family-orientated event celebrates the fine original music of Austin, Texas, and the world beyond; with friends, dancing, and a potluck dinner to share. The special guest artists and the full moon make for a howlin' good time." And that does pretty much sum it up. It's musical and cultural; it's eclectic; it's South Austin. Shindigs are held on occasional full-moon Sundays as well as some holiday Sundays, and each has its own personality. There is a monetary donation as well as suggested potluck food to share. Volunteers are encouraged, as are musicians, novice or otherwise, with open mics provided before the main shows. It is a hoot that has been vocal for

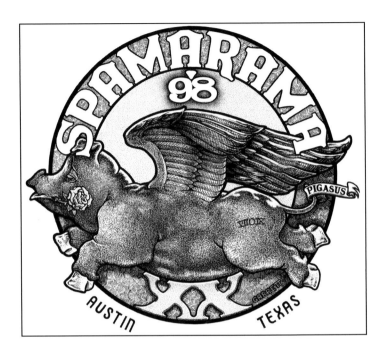

Above left: **Spamarama Five, Scholz Garten, 1982**

This is my first offering for Spamarama, the simpering soiree-promoting potted-pork this and that. I chose a familiar graphic vector and an easy Spamatarget. I reprised my often-used Uncle Sam/Montgomery Flagg image and imported into it the face of David Arnsberger, the dude most responsible for it all. Here's his visage, beneath a Spam-ifyed top hat. This piece was done when "Spamorama" was spelled with an 'o.'

Above right: **Spamarama Twenty, Austin, 1998**

Pigasus. A tribute to the flying porcine by virtue of parodying a flying equine. Anyway, this is it. Two features, beyond the wings and the sublime countenance, are the rose-in-mouth confidence and the requisite "709" appearing in the likeness of a brand. For perhaps the very first time ever, the three-digit cosmic cypher is presented in a mock Roman-numeral form.

over two decades. If you really want to know what Austin—and its music—is all about, you need to attend.

Spamarama. These spectaculars got their start in 1978 as the consummate anti-chili-cook-off. Officially, the moniker reads as: the Pandemonious Potted Pork Festival, Spamarama. The event has run intermittently from that year and into the new millennium. Ostensibly, the idea was to build haute (and other) cuisine models around the humble Hormel meat product, Spam. Unofficially it is just another excuse to have a good time. In that regard it invokes the spiritual power of Austin's trinity of food, fun, and music. The brainchild of David Arnsberger and his buddy, Dick Terry, the annual celebration grew into a significant cultural event, loosely occasioned around April Fool's Day. Besides the actual food events themselves, other festivities include Spam Toss, Spam Relay, and the Spamalympics. In all such matters, but especially those cuisinesque, celebrity judges were acquired to mount the stage and render potted-pork judgment. Many musicians have also mounted the stage over the years, and include Joe Ely, Doug Sahm, Austin Lounge Lizards, Steven Fromholz, and of course the Uranium Savages. Spamarama, now in a state of suspended animation, has established itself as an Austin icon, and one that stretches back over four decades and bridges two millennia. It came into existence within the city's generous reverence for fun, and so it remains. It is true to the Austin tradition of strong absurdist leanings, and as an event that has endured essentially in its original form, it humbly upholds the sentiment "Keep Austin Weird."

Outside of the clubs, there's been laid down another rich stream of Austin music. From the outdoor festivals, through the independent productions, to the grassroots production of the music, there's a constancy in seeing that the music continued to ring out in the city. We all knew at the time that we were privileged to have had our fun, and our being, within a matrix of sound, and we also knew that it couldn't last. On that last point we were, happily, wrong.

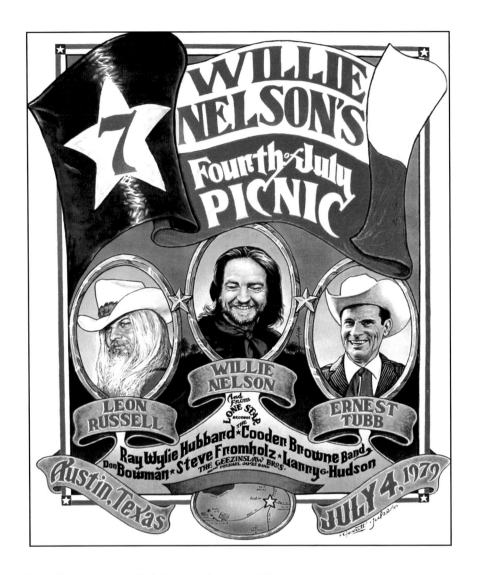

Above: Willie Nelson, Fourth of July Picnic, Austin, 1979

This was Willie's first picnic at his growing compound out where the Pedernales River meets the Colorado River, west of Austin. Somewhat of a circumscribed affair, especially if you compared it to the second one at College Station, it still contained a formidable lineup. In addition to Willie, Leon Russell, who had been at most of the previous ones, was headlining. Appearing as well was Ernest Tubb, one of the country masters from Nashville, and a true Texas treasure. There was also the entire Lone Star Records stable. Here is the 17"x22" poster. I had help on the portraits from my friend and colleague Guy Juke.

7

Willie Nelson and Stevie Ray Vaughan

By the end of the eighties, it was clear that Austin had become the hub of the big wheel that is Texas music. Many musicians that had called the city home by the end of that decade had gone on to national and international acclaim. Some achieved success as individuals or groups, such as Joe Ely or the Fabulous Thunderbirds. Many like Roky Erickson and Townes Van Zandt would overcome adverse circumstances and personal demons to become living legends, while others like Christopher Cross would go supernova stellar and then fade away, leaving barely a trace of their passage. In the decades that followed, others would lend their considerable talent to other considerable talents. Such was the case with Denny Freeman, who left Austin at the decade's end and surfaced as lead guitarist for Taj Mahal and then Bob Dylan. Roscoe Beck, part of Eric Johnson's Austin power rock trio of the late 1980s to early 1990s, did much the same thing. He played bass for the Dixie Chicks on their infamous 2003 tour and then returned to his seventies and eighties musical cohort Leonard Cohen and his tour in 2009, as both band mate and musical director.

A few were destined for super stardom. Three stand out as a trinity of sorts in this regard—Janis Joplin, Willie Nelson, and Stevie Ray Vaughan. All three were Texans from out of town, all three reached remarkable heights in their careers, and all became icons among the musicians and the musical community of the city. Within Austin's city limits they also were associated with, or arose from, a trio of venues—Janis from the original Threadgill's, Willie from the Armadillo, and Stevie from Antone's.

Willie Nelson was reborn professionally when he relocated to Austin from Nashville. Janis Joplin and Stevie Ray Vaughan shared the date of October 3 as literally vital to them both—for Stevie, in 1954, it was the day he entered the world at Dallas Methodist Hospital; for Janis in 1970 it would be the night she left it in room 105 of the Landmark Motor Hotel in Los Angeles. These three would leave professional and personal imprints on the music that was made in this city. At the end of the summer of 1972, Janis represented the folk and rock past, Willie was the cosmic cowboy present, and Stevie the white bluesman future.

I'd never met Janis Joplin. But I've known Willie and Stevie personally, counted them as friends, and produced some of my very best work on their behalf.

Willie Nelson

*There's a freedom you begin to feel the closer
you get to Austin, Texas.*
—Willie Nelson

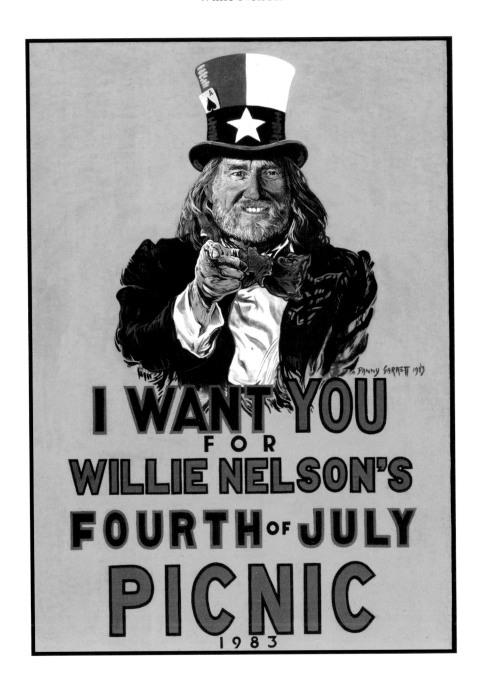

My uncle had grown up with Willie Nelson in the 1930s. According to him, Willie was an outlaw even then—though the setting might be a baseball diamond, not a stage. Hiding in the tall grass near the outfield, Willie the kid would nick any ball hit his way. The game would come to a halt as he was chased down and the baseball retrieved. This was all up around Abbott and Hillsboro, about as "deep in the heart of Texas" as it gets.

In 1970, after it all burned down in Tennessee, Willie Nelson returned to the state of his birth. Eventually, he relocated to Austin, where fate and a booking guided him to the stage at Armadillo World Headquarters. Though he had been a renowned songwriter for years, that show added new depth to his reputation as a performer, and he took this pairing to a whole new level. It also introduced him to a new generation and a new take on the world. Willie became the acknowledged leader of the crosscultural music that gained new form in the wake of that introduction. With his solid country reputation, his long hair and unapologetic inclination to smoke pot, the image thus projected was perfect for the new sound. He made the "outlaw" concept iconic and married it to the city, helping to pave the way for scores of nonusual musicians of all stripes to come to Austin and make music there as well.

Willie had mounted another stage earlier in 1972. This particular one was at the Dripping Springs Reunion. The reunion was an endeavor by a group of Dallas promoters to have an outdoor concert—a sort of "redneck Woodstock" that would capitalize on Willie's Nashville credentials as well as the emerging new genre. Even though it featured the likes of Kris Kristofferson, Tom T. Hall, Loretta Lynn, and especially Leon Russell, it was a commercial failure. But it laid the groundwork for the first Fourth of July Picnic. On a side note, two other Texans would meet there—Waylon Jennings and Billy Joe Shaver. They met only, but their subsequent collaboration would be large for both—and for country music outlaws everywhere.

Sixteen months later, on July 4, 1973, Willie would return to Dripping Springs for the very first Willie Nelson Picnic. Leon Russell wouldn't be there, nor Loretta Lynn, but Kris would be back, along with Waylon and Tom T. Hall. In addition there would be Kristofferson's wife Rita Coolidge, Charlie Rich, and Doug Sahm. The Armadillo production crew, captained by Eddie

Opposite: **Willie Nelson, Fourth of July Picnic, July 3-5, 1983**
This is one of my best-known pieces. Commissioned in 1983 for a series of three picnic concerts on the East Coast—Atlanta on July 3, Washington, DC, on Independence Day, July 4, and New York City on July 5. It garnered the Willie Picnics their first big national recognition. That is precisely the reason that I put the "redheaded stranger" in Uncle Sam garb. A design derived from James Montgomery Flagg's famous World War I recruiting poster, I added a couple of Lone Star touches. The top hat is the Texas state flag, with an ace of spades in the hatband for good measure, Antone's notwithstanding. And if you look closely, you will see, in the knot of the tie, a quite familiar shape. When such things are placed in an image, to be discovered on later examination, they are usually referred to as "Easter eggs."

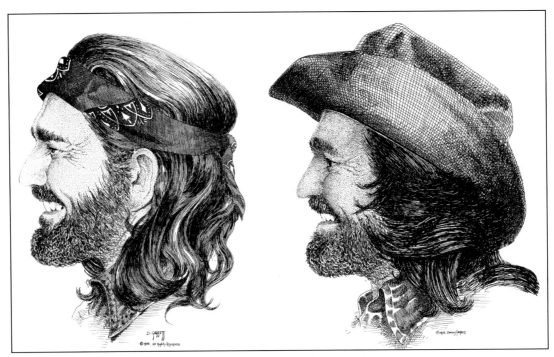

Above: **Willie Nelson, drawn as a hippie, drawn as a cowboy, 1975**
Two profiles of the cosmic cowboy, Willie Nelson. The one on the left, of course, is the cosmic, with his long hair, beard, and bandanna; the one on the right the cowboy, decked out in the same profile pose, with cowboy hat taking the field for bandanna. Both of course are Willie, the man and the musician. And they both went on to become integral parts of Willie, the bandanna. I had the idea of creating one back in 1975 and produced these two profile images of him to go on it. The project never panned out, and I eventually gave the original drawings to Willie as a birthday gift. Imagine my surprise when they appeared on Willie's own inhouse bandanna. He wears that bandanna a lot, and if you look closely you can see these portraits upon it.

Wilson, was fiscally, physically, and psychologically unprepared for the thirty thousand to fifty thousand fans that would show up for the one-day event, but it came off in a spectacular, if not spectacularly profitable, fashion.

Back in Austin, Willie cranked it up a notch. Following the musical success of his second Fourth of July Picnic in College Station, he forged a much stronger bond with Tim O'Connor, who produced the show. Shortly after their initial meeting when Willie first hit town, Tim became an integral part of Willie's Austin operations. He knew the local music turf, helping the redheaded stranger integrate into the music scene. Their relationship would continue to produce much music over many decades. Years later, when Willie was asked about O'Connor, he said, "Tim's a funny bunch of guys." And if anyone would know, it would be Willie.

In 1974 a golden opportunity presented itself when the Texas Opry House closed its doors. Tim stepped in, doing what he does best—building a viable venue by coupling an uncanny vision

***Above:* Willie Nelson, Hill on the Moon, 1973**
Many musicians performed at Hill on the Moon, a private residence and stage off City Park Road, in the early 1970s. When Willie settled on Austin as his new home, he quickly became one of them. This was one of his earliest performances there in the spring of 1973. Here is a close up of him and "Trigger," his guitar and long time companion. His hair, longish when he came to town, is now onto his shoulders and still heading south. And the full beard is new.
Photograph by Sue Spicer

Above: Willie Nelson, Bull Creek Party Barn, 1975

This was another independently produced show by Tim O'Connor—this time under the auspices of Robin Productions, yet another avian moniker. Bull Creek Party Barn was a collaboration between O'Connor and Willie Nelson; they were already partners in the Austin Opera House and had staged a couple of picnics together. The outdoor venue was a test run by O'Connor for his later al fresco effort at the Backyard. Located on RR 2222 where Bull Creek meets the Colorado River, the space was formerly a fishing and vacation lodge built during the 1950s. Subsequently it became the second County Line barbeque location.

Above: **Willie Nelson, Austin Opry House, 1979**

I've always called this piece "Schoolgirl Willie." I do so because the Texas flag banner forms a bow directly above Willie in pigtail regalia. This is another product of Calico Press and longtime poster printer Benny Binford. There was a mix-up in the commissioning of this promotional piece, and Dale Wilkins produced another full-color version—which also included a portrait of a long-haired Willie in addition to my own; the first and only time I am aware of that such a thing happened.

Above: **Willie Nelson, Canyon Amphitheater, Lubbock, 2003**
Commissioned by Doug Moyes when he briefly ran this venue in Lubbock, Texas. It is one of my first digital posters. Constructed in Photoshop, it is more a manipulation of images rather than the raw creation of them. The only things I really created in this piece are the wallpaper background and the shapes, containing images or text. The wallpaper is a mixture of a lone star and a quarter note, separated by banding. Willie's image is grabbed, copied, and pasted, while the lettering was created and deformed using the program. Digital graphic programs look to be the main tool of the twenty-first-century music poster artist.

with raw—sometimes creative—opportunity. Teaming up with Willie and Paul English, Willie's drummer and long-time compadre, the three formed Southern Commotion and picked up the place for ten large down. It was rechristened the Austin Opry House, later the Austin Opera House.

The partnership also converted a number of the many rooms and spaces into a music center, with rehearsal halls and business offices. The crowning touch was Arlyn Studios, an excellent recording facility run by Freddie Fletcher, Willie's nephew. With such infrastructure, Willie was able to launch a record label, Lone Star Records. It could all be done on the premises—recording, showcasing, and housing many of its artists on site. The complex turned into a major

Austin venue for over a decade, and was riding high as the biggest private hall in town when the Armadillo closed on the eve of the eighties. At least one of Willie's picnics was held there.

But Willie had another vision and was looking at more expansive spaces out west of town. Even before the Austin Opry House opened, he was in the process of purchasing a bankrupt resort at Briarcliff on Lake Travis, near the junction of the Pedernales and Colorado Rivers. It was to be a headquarters, haven, and series of domestic and commercial compounds carved out of, and added to, the resort infrastructure. And, it had a golf course. Arlyn Studios also went on to establish a state-of-the-art recording facility at Briarcliff. *Stardust* would be recorded there, as well as *The Outlaws* LP, the first country album certified platinum.

It would all expand beyond the recording studio, offices, residences, and golf course to include a movie/video ghost town called Luck. When the Austin Opera House closed in 1990, Tim O'Connor followed Willie out west and started up another venue. The Backyard opened halfway between Briarcliff (now Willie World) and Austin, in the then-small village of Bee Caves. It all seemed to be headed out west. Even Willie's legendary jefe of the roadies, Poodie Locke, would establish his own venue. Poodie's Hilltop Roadhousel is located on Highway 71, just up the road a piece from the turnoff to Willie World.

The work that I did for Willie Nelson spanned four decades. The first commissioned pieces were the poster and T-shirt design for Willie's second picnic. There were other picnic posters to come, as well as stand-alone designs for apparel that were derived from those bills. There were a number of posters that I did for performances at the Austin Opera House, and a couple of small flyers that I did for him at the very excellent Bull Creek Party Barn. This was a sweet, but short-lived, indoor-outdoor venue, out RR 2222, where Bull Creek enters the Colorado River. The last poster I did was a digital piece for a Canyon Amphitheater show in Lubbock.

Working for Willie has been an honor. Perhaps no other Texas musician has come to be as universally loved and respected by others as Willie Nelson. I think that this is because the work of the man, and the man himself, is so honest and real. I think this is why he left Nashville and its sound, and helped establish one for Austin. It is this genuineness that shines through and makes him personally accessible and appealing. Willie was at home the moment he came to town, and it is hard to conceive of an Austin without him in it. The music he made was for one and all. He is a quintessential Texan—maybe the greatest example of the form. As the *Dallas Morning News* said in an editorial on his seventy-fifth birthday: "Willie Nelson is Texas. With his old, battered heart and Trigger, his old, battered guitar, he makes all us rednecks, hippies, and the whole Lone Star lot proud to be from here. Good Texans honor Willie Nelson on this milestone because he has honored them with his music and with his life."

Stevie Ray Vaughan

I'm just doing the best I can now to keep this going . . .
trying to grow up and remain young at the same time.
—Stevie Ray Vaughan

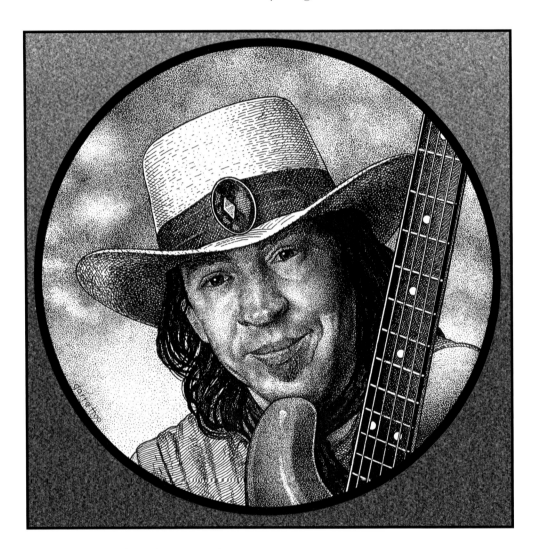

Above: **Stevie Ray Vaughan, drawing, 1990**
This is the drawing I did of Stevie for my initial idea for a T-shirt design. I did use it later in the Antone's twenty-first anniversary poster. It is one of my best pen-and-ink pieces. In it, I used two different techniques for valuing—lines and dots. To value with lines is generally referred to as "cross-hatching," and here I have employed it in creating tones for his hat/band/jewel/guitar neck as well as his shirt. Cross-hatching is more appropriate for coarse or hard surfaces. Dot work, or "stippling," is mostly used for softer surfaces. Here I've used it for his skin, guitar body, and the clouds.

One of the first and most lingering memories that I have of Stevie was of a weekday night in the bicentennial year of 1976. It was a rainy and dreary late fall evening on Sixth Street. A reflected and broken image of the Driskill Hotel lit up the rain-soaked pavement in front of Antone's first location, perturbed by a passing car every now and then. Occasionally a burst of cold wind would throw water across the old storefront window; the doorway beside it had hardly opened all night. As was sometimes the case, employees outnumbered patrons. On stage a slight figure, barely more than a gathering of shadows, played long and slow, but precise, licks in front of a drummer and beside a bassplayer. Framed by the heavy purple drapery that hugged the platform, the three were performing for about as many people. I sat at a table just a few feet from its edge and marveled at the sounds that I was hearing. Stevie just stood there, eyes closed and head lowered, completely immersed in the music he was making. It wasn't the first time that I had seen him, but it was the first time that I had fully appreciated just what it was that I was seeing.

Since the late sixties there has been a powerful presence in Austin of a dedicated group of blues musicians who had moved down from Dallas. Blues history there is rich and deep. Indeed, Dallas can rightfully be considered to be among the few seminal homes of the musical form—right up there with Chicago, Kansas City, Memphis, and New Orleans. In fact, there's a contention that "Dallas Blues," penned there under the city's very name, was the first blues song ever published.

Oak Cliff is not very far from Deep Ellum. Stevie and his older brother Jimmie could almost hear the blues drift up from Commerce Street. No matter if the brothers heard or not, their DNA picked up such vibrations on a much deeper level. Whether from Deep Ellum or midnight radio, the blues was a part of Stevie's and Jimmie's very being. And so it was with others as well. For some reason Dallas had produced an inordinate number of very talented blues musicians—especially of the blue-eyed variety. As the sixties closed, many of these chose to relocate down I-35 to Austin.

Stevie had watched them go, one by one. He stayed on, practiced his guitar, and sat in with a few bands until he formed his own—Blackbird. At loose ends, he also got a job at a burger joint, the Dairy Mart. Of a moment one night, the finger of fate pushed down. He later described it: "Part of my job was to clean out the trash bins. One night, I was standing on top of a barrel, the top caved in, I fell in grease up to [my chest], and right then I decided I'm not gonna do this anymore. I'm gonna play guitar." And with that, he dropped out of high school over the semester break, and followed his brother, his friends, and his fortune down the interstate to Austin.

At seventeen, he shortly found himself on the couch circuit and looking for slots in local groups. He fell into the Austin pick-up routine, eventually settling into lengthy gigs with groups like Krackerjack (where he first played with Tommy Shannon) and the Nightcrawlers over the next couple of years. He was even playing bass for a while in his brother's band, Texas Storm. In 1973, Ray Hennig sold him a 1959 Stratocaster, which he christened "Number One." A year later Stevie joined his homies Doyle, Denny, Alex, and Paul in one of Austin's all-time great blues

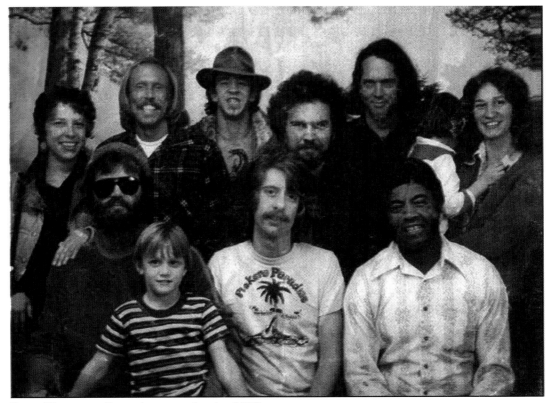

***Above:* Hyampom Records group, Austin, 1980**
Here is a group shot of people that constituted Hyampom Records, a typical independent record label back in the day. The family-owned label, located in the basement of a former church, was the very first to record Stevie Ray Vaughan. You can see Stevie, left of center on the back row, with a grimace and beneath the fedora. That's Charlie Prichard of Conqueroo, to the lower right of Stevie, and W. C. Clark, to the lower right of Charlie. Both were also recording on Hyampom at the time.
Photographer unknown

bands, the Cobras. These players and others constituted a significant cohort of blues musicians who had been forming up various groups since the 1960s.

By 1972, a year after Stevie moved to Austin, progressive country tended to rule the roost. Although the number of venues was increasing, the popularity and publicity around this music—along with the influx of new and established musicians seeking to capitalize—was forcing groups in all genres to seek play dates where and when they could find them. Gig slots were dear, and while the white blues groups had been playing around town for a while, there was little focus on this music at that time.

When Clifford Antone brought his club to life, it fired up this incipient blues scene. The opening of Antone's pretty much coincided with the opening of Sixth Street. But pioneering music real estate wasn't his intent—Clifford wanted to create a world-class venue for the blues

in Austin, a place dedicated to the music. And that is just what he did.

He created a space for the Austin blues musicians where they could interact and grow. The new club truly was a home for both its working musicians and the growing audiences that came to hear them. It was a viable performance venue for those of national repute as well. At Antone's something quite vital took shape—the passing parade of legendary greats, the talented locals, and the communion between the two. Over time, this trinity formed up an Austin Sound for the blues.

Almost immediately upon contact between the two groups, an interaction took place that elevated this union to something greater than the sum of its parts. And although every player in the local blues community would benefit tremendously from such cultural alchemy, none would be so transformed by the experience as Stevie. None would take it as deeply to heart.

He had picked up and used the stylings of all the great blues guitarists, focusing on Dallas heroes such as T-Bone Walker, Freddie King, and especially Johnny "Guitar" Watson. He absorbed their riffs and phrasing like a sponge, torqued them to his bent, and set them loose among the frets and strings—living ghosts within his guitar. But it was the stylings of Albert King that would

Above: **Stevie Ray Vaughan, T-shirt design, 311 Club, 1981**
A T-shirt design for the grand opening of another club on Sixth Street. This was the first blues club on the street since Antone's had left its corner at Brazos a few years earlier. This was a first class blues joint, and it went on for many years before the last notes faded out. The portrait of Stevie was drawn from an memorable photo by Ken Hoge. Sticking to my usual motifs and filigree, I inserted a diamond (the card suit equivalent of fortune) on the upper banner. A great club and one of my best images of Stevie.

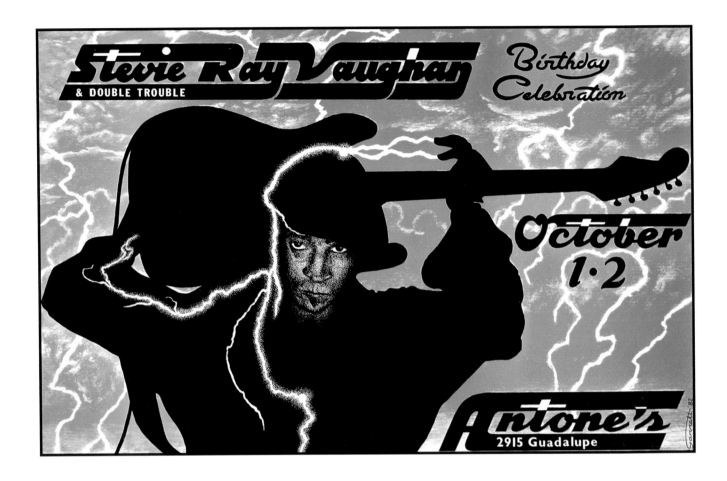

Above: **Stevie Ray Vaughan, Birthday Celebration, 1982**

Approaching his twenty-eighth birthday Stevie stood poised on the threshold of success, but in 1982 he still belonged to Austin. That summer was a particularly brutal one for the city. As October dawned, the Autumnal Equinox had passed, but the heat endured. On the first night of this weekend birthday show, a massive line of thunderstorms was rolling in from the west. Stevie took to the stage around 10:30 to an overflow crowd at the club's third location. About the time he began his lead-in to "Texas Flood," the squall line broke upon the city, and as if on cue lightning danced across the sky. What unfolded that night was a performance as tempestuous as the weather. Stevie's hands flickered over the Stratocaster like a flame, and he was in total control of the music. One moment he was far ahead and beckoning it on, the next shouldering hard against it while pushing it forward—all the while with his band in lock-step. Chris Layton was spinning a drumbeat, attempting to contain the torque of sound within its weave, as Reese Wynans pushed his keyboards into chasing SRV's riffs around the room. Tommy Shannon, never leaving his spot, kept the whole thing grounded through the laying of a heavy bass line. Outside, a genuine Texas flood was shattering summer's grip.

162

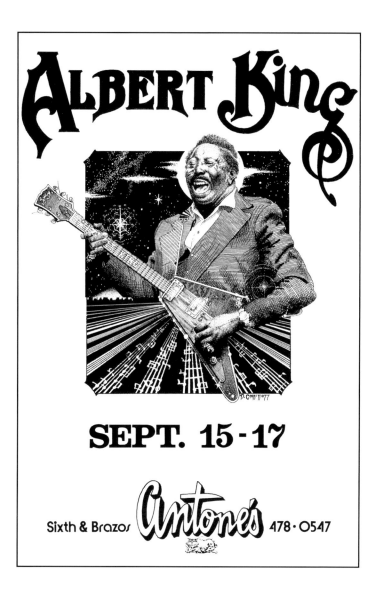

Above: **Albert King, Antone's, 1977**

The big man with his Flying V. This poster was commissioned for his second show at the first Antone's. This also was the Albert King show of legend, where Clifford persuaded him to let a young white boy from Dallas, Stevie Vaughan, join him onstage. Albert did, and blues history was made. The two formed a bond that was unbreakable until first one and then the other died. This poster is my very earliest attempt to 'draw' the music. Here, I took a standard approach and just inked in lines, bars and notes in a glyphic rendering. The real innovation here is depicting Albert King's trademark "standing notes." The one currently being plucked is hovering above the neck of his guitar, just to the right of his hand. The previous, now fading, hooks into the space between his left arm and his body.

haunt his playing more than any of the others. Upon meeting Albert, Stevie was seized by the notion to play with the literally larger-than-life bluesman. He petitioned Clifford Antone to help make it so. Albert was very private, possessed of a stern demeanor, and had never been an easy man to approach—a perception that his six-foot-four, 250-pound frame continuously reiterated. Nevertheless, Clifford persuaded Albert to let the skinny white kid sit in, assuring him that the young bluesman was something other than ordinary. For Stevie, Albert King was the guy with the bona fides and a bender of notes like no other.

The white kid mounted the stage, and in short order the two blues guitarists were trading licks. Albert opened and lit up the stage with tones soaring from his Flying V. After the band smoothed the field, Stevie held forth. The force and confidence of his passages took Albert aback; the great man dropped his hands and then his jaw. Photographs taken at the time show him leaning forward, taking in completely SRV's intricate note structures and sinuous phrasing. Albert King deliberately reached across and pulled the curtain over his beloved "Lucy," as if he didn't want the guitar to witness Stevie's unanticipated playing.

It was an iconic moment within an iconic performance. Albert King and Stevie Ray Vaughan standing on the Antone's stage that night incarnated the musical alchemy that would signature the club's first venue. For me it changed everything that doing music art in Austin was all about. It was one of those magic moments that this town was capable of producing—a short but intimate passage of time that welded one to the music.

I have many other memories of Stevie playing. Most involve his gigs and sitting in on the gigs of others at Antone's or performances at other clubs around town such as the Rome Inn, Steamboat Springs, the Austex Lounge on South Congress, or Alexander's on a then-rural Brodie Lane. But there's one performance that still sticks with me after all these years. It was during that period in the seventies when the clubs were required to close down at midnight—or at least to stop selling booze then, which was essentially the same thing. A late-night coffee-and-Coke joint had opened near the corner of Sixth and Congress, which catered to another type of coke-consuming crowd for whom the witching hour was merely the shank of the evening. It was called After Ours, and was located in a charming old second-story walk-up bar just around the corner and a half-block west down Sixth from Congress.

Stevie walked in. He had just finished a gig somewhere and was, you could tell, still energized from it. These days were in the heart of SRV's drug-and-booze period—as indeed they were for most of the people in that room. But after he had entered, unpacked his guitar, and situated himself upon a stool, it was obvious that he was mightily sober. He settled in, hunched over his Stratocaster, looked around the room slowly, and paused to grin broadly at someone he recognized. He was wearing the soft cap that signatured his appearance in those days. Leaning forward, he slowly began to pick out probably the most haunting version of "Sleepwalk" that I have ever heard. As he slid out the steely tones of Santo & Johnny's 1959 classic, the room's chatter terminated in a sharply graded hush. From where I was sitting by the front window, I could see

Right: **Stevie Ray Vaughan, Steamboat Springs 1874, 1979**

To celebrate an end-of-winter performance at Sixth Street's Steamboat Springs nightclub I executed a muted red-blue-purple piece, with yellow backlight. As an homage to my colleague and friend, Guy Juke, I executed it in my version of his trademark "faceted" graphic styling. The show itself was a sizzler—literally. With a late winter norther moaning down the street outside, the heating system was cranked up to capacity, and beyond. Nevertheless, as was typical of Stevie's shows, the joint was jumping.

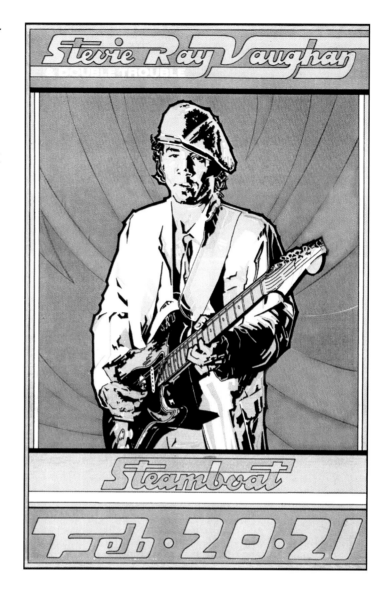

Stevie's reflection in the mirror to his side. His eyes were closed and he wore a smile as smooth and slow as the notes he played. They rose from his guitar like vapors almost perceptible.

Shortly after this performance, things began to change very quickly for Stevie. In 1977 he left the Cobras, the band that had given him his greatest visibility up to that point, and started his own, the Triple Threat Revue, with Lou Ann Barton. The following year Chris Layton joined and was followed later by Tommy Shannon, giving form to the cohort Double Trouble. Shortly after, Lou Ann left the band and Stevie took up the vocal slack—adding a powerful new dimension to his performance. His voice, a surprise to many, including me, seemed to merge with his guitar stylings like a hand fills a glove. In 1982 the band broke into the international spotlight at the Montreux Jazz Festival, where Stevie encountered a hostile reception to his electric sound by

acoustic fans, somewhat akin to what Dylan experienced in the 1960s. Bob Hammond, no stranger to Dylan himself, signed the band to its first record contract. They cut *Texas Flood* as their premier offering in 1983. Two more albums followed in as many years, and Stevie's career just exploded. Now Stevie Ray Vaughan and Double Trouble, the tight group received the accolades, awards, rewards, and celebrity that come with genuine professional accomplishment and recognition. After a fourth album was released in 1986, it all caught up with Stevie on a London stage as that finger of fate pushed down again and he collapsed from exhaustion during a performance there.

The next year both Stevie and Tommy left a detox facility in Atlanta. Torqued personally by the death of his father Jim months earlier and a divorce from Lenny, his wife of eight years, Stevie had come to a crossroads in his life. Holding fast to his passion for—and the success of—his music, he confidently pursued a new path, one more sober and mature. And it showed. In 1989, the release of a fifth album, *In Step*, revealed just how deftly he navigated that new road. That year also yielded a renewed association and affection for his brother, Jimmie. They began working together professionally and to lay down the tracks for a collaborative recording. Secure and confident, both personally and professionally, Stevie Ray Vaughan stood poised to reach even greater heights in both those arenas as the last decade of the twentieth century began.

It was not to be. On August 27, 1990, on the fourth anniversary of his father's death, Stevie perished in a helicopter crash at Alpine Valley, Wisconsin. A huge shockwave of grief and incomprehension shot through the music community in Austin. It was a hit of such magnitude that more than two decades after the event, the ringing of it is still palpable. For the blues family in that community, the loss has been incalculable.

Be that as it may, Stevie was ours. He was a true treasure, forged in the fire of his blazing talent, by the hammer of this town and anvil of its music. Beyond that, he was a friend. I really hadn't interacted much with him in the last half-dozen years or so before his death. The last time we had really crossed paths was at the incredible week-long tenth anniversary celebration at Antone's on Guadalupe in 1985. But we had really gotten to know each other at the original spot downtown in the early years. He was just a kid then, at once shy and incredibly endearing. But what impressed most of all was his genuineness—a rare amalgam of true humility and an unshakable confidence in himself and what he was capable of doing. Beyond the dazzle of accomplished musicianship, if you look, it is these qualities that informed nearly every performance.

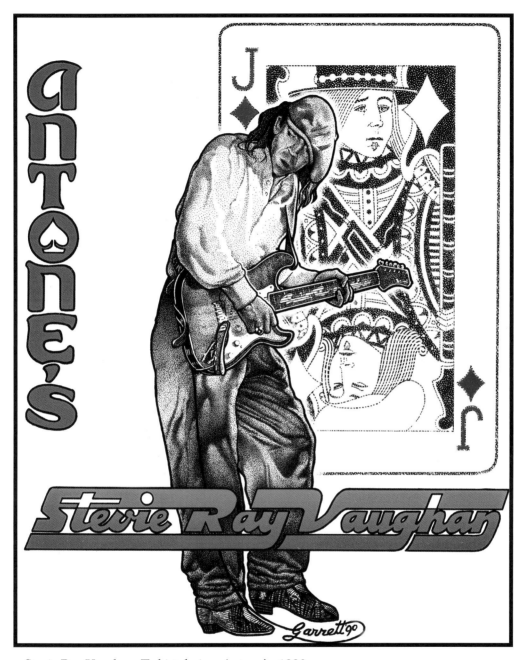

Above: **Stevie Ray Vaughan, T-shirt design, Antone's, 1990**
In the spring of 1990, Susan Antone asked me to do a T-shirt design for SRV. She had me do one of his brother earlier in the year, and she now wanted one of Stevie. Here I've placed a full shot of him against the background of a jack of diamonds. I've also swapped out Stevie's image for Jack's, and staying true to motifs, placed a spade in Antone's 'o'. It is one of my better pen-and-ink drawings. In a few short months, Stevie would be gone.

Above: FLATSTOCK 4 promotional poster, 2004

The FLATSTOCK poster show series was created by the American Poster Institute as a series of exhibitions featuring the work of many of the most popular concert poster artists working today. It has accompanied the SXSW conventions in Austin all of this century. I was asked by the South Austin Center for Popular Culture to create a poster for the 2004 convention. Here I have added wings to an older image I created to promote children and music. It stands against an outdated Austin skyline. On the sidebars I have listed the names of some of my colleagues, and in the bottom space I have honored many of Austin's music art printers and screen printers.

8

Austin 2015

You can only take with you what you give away.
—unknown

We came for the party but stayed for the music. The festivities ended, but the music lingered on. Back beat, sinuous phrasing, bottleneck slide, and other vibrational delights were woven into a soundtrack that played behind a life lived in this city. The energy from it and the mass of musicians, venues, and listeners was sufficient to pull it all together into a genuine community that had its being by virtue of the music.

The Saxon Pub, Friday Happy Hour

They begin to arrive around five. The music won't start for more than an hour, but seating and parking issues call for an early arrival. These and other things have changed in, and in the vicinity of, the Saxon Pub, one of the last of the old Austin venues.

Its location puts it in the crosshairs of the latest real estate boom. It is the fourth—and strongest—such tectonic shift since the music went hometown in the 1970s. The club is slowly being surrounded by new development. A couple of miles south down Lamar, another even more venerable music hall, the Broken Spoke, sits niched between developments as well. These places have solid musical pedigrees. Once they were part of a sizable group of small- and medium-sized rooms that formed much of the foundation upon which Austin's music reputation was built. To be sure, there are newer venues, risen like mushrooms from the medium of the city's musical past, but these places are the actual fiber and tissue of that past.

The people moving through the doors of the Pub have filled these two music halls and many more for decades. Now with less hair, more girth, and faces honed by the years, they engage in a familiar ritual, seeking out a good spot inside—one where the sound is sweet and the line of sight to the stage direct.

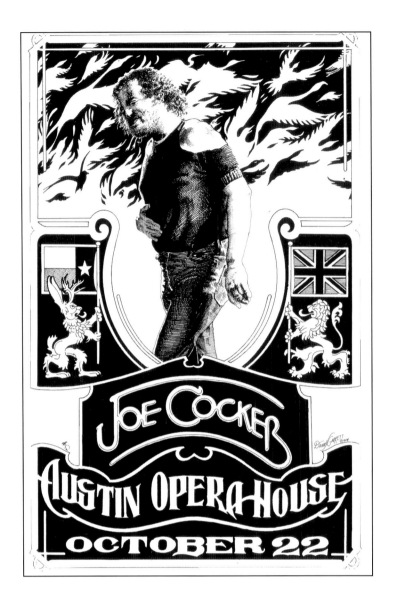

Above: Joe Cocker, Austin Opera House, 1978
As the music scene in Austin rapidly matured in the 1970s, more and more A-list musicians angled to appear in the various venues. Here is one of them. In 1978, Joe Cocker had a huge reputation, and when his tour hit the Austin Opera House, he put on an incredibly well-produced show. I have pictured Joe here before a roaring fire, symbolizing that popularity. The fire is made of birds in flight, including some negative spaces between the flames. Here, also, is a lion in heraldic proportions, signifying Britain, along with a jackalope, also heraldic, signifying Texas.

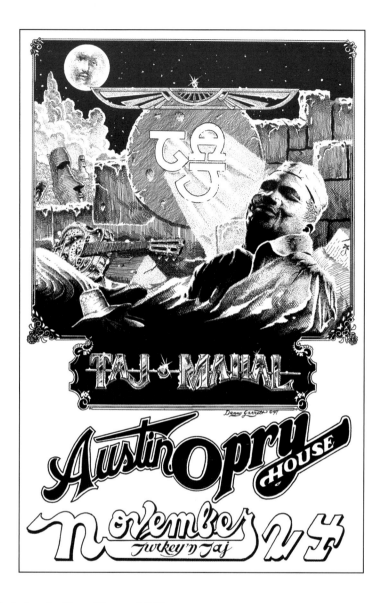

Above: Taj Mahal, Austin Opry House, 1977

Just like I did with Clifton Chenier on my first Antone's poster, I have given Taj two faces here. One is the face in the moon and the other is Taj emerging from the sand, behind the ruins of some ancient place. The moonlight shining through Taj's name unites the two, and goes some length to explain the smile on his face. Clouds like trees, Easter Island heads, a dobro, a straw hat, and a mysterious wing set, together with the faces complete a rough graphic circle. This is a one-color poster, and a rare instance of the base art being printed as a split fount—blue to black. It should also be noted that it took place on Thanksgiving—hence the "Turkey 'n Taj" sentiment.

For the show, the marquee out on the street reads "Denny Freeman," but the band calls itself TG BaD, a descriptive moniker simply meaning two guitars, bass and drums. Denny would probably be the first not to call it his band. He is one guitar; the other is John X. Reed, with Speedy Sparks on bass, along with the drummer, Rodney Craig. If there is a detected directive role onstage, it would seem to emanate from the drum throne, with Rodney shouldering most of the vocals and calling out on occasion to the audience.

These guys are old Austin, but as musicians, they are at the very center of its hometown music community. Between them, they constitute well over a century of working-musician experience. They have played together before, sometimes as bandmates, for years. They've filled in with other bands when musicians had gigs elsewhere, just as others have done for them. They've played recording sessions and toured with some of the biggest names in American music. They've done these things, and more, to create the music for so long and in so many ways that they, along with the community of musicians they've shared this town with, have come to resemble a very large band in and of itself.

They are here to perform and interpret some of the music they hold dear; music that drove them, from the beginning, to be what they are. Onstage they interpret from a personal time-line where this music kept a life beat, starting up long ago in their teenage hearts. They're here to play the blues, pop, country, and self-penned instrumentals that unreel from their musical DNA. Most of all, they are here to play that old-time, solid, unvarnished rock and roll. And eager to receive it is this audience—mostly listeners long familiar with both the music and the musicians. Together, the band, audience, and venue round out the in-house city limits to that hometown community.

It is, in fact, community itself that has played such a big role in the evolution of Austin's contribution to music. And not just Texas or American music. Ian McLagan, the veteran British rocker of Small Faces and Rolling Stones tenure, was an Austin citizen from 1994 until his death in December of 2014. He put it this way in an interview with the *Austin Chronicle:* "I like the fact that Austin's the first place I've ever lived where there's a real sense of community. People care about their neighbors. It's twenty years next month that I've lived here. This is my home."

It really has come to be about community. Even now, that can be a charged word, one now somewhat diminished in these parts. That's due in part to its first two syllables, the Cold War, and some notions around the struggle for civil rights. But at one time it meant something dear to most of the people in this state, and it really helped to have one. The very idea of Texas came to be a fact through its communities. As it passed through the postwar years of change and upheaval, that sense of being together went through many challenges. Over time, and in a very real way, it seemed to fade away, or at least perceptively diminish.

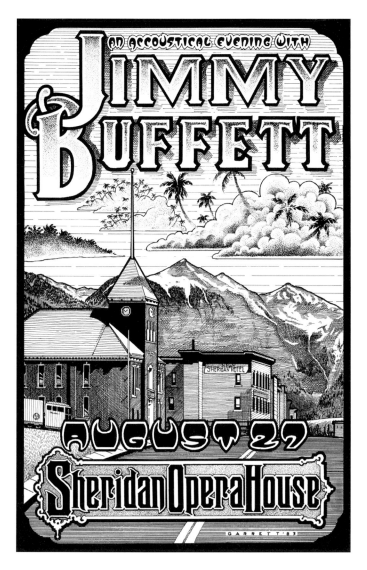

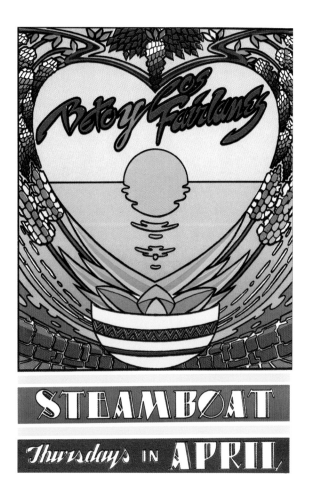

Above left: **Jimmy Buffett, Telluride, Colorado, 1983**

This piece was commissioned by Doug Moyes, a close personal friend and founder of Castle Creek. I did this poster while on an extended trip to that beautiful mountain town; the venue was the venerable Sheridan Opera House there. By the early eighties I was able to pick up poster gigs on the road. The image is pretty straightforward here—a simple rendering of downtown Telluride looking east toward the mountains that separate the town from Ouray on the other side. The cumulus clouds provide a platform for tropical palms in the sky, as well as a semiotic nod to Jimmy.

Above right: **Beto y Los Fairlanes, Steamboat Springs 1874, 1980**

In 1979 and 1980 I did a few full-color posters for Steamboat Springs. This is the one I did for Beto y Los Fairlanes, the salsa and jazz combo, that rocked Austin music all through the 1970s and beyond. A full-color poster is a four-color poster—that is, cyan (blue), magenta (red), yellow, and black—CMYK. By combining the primary colors for ink, paint, and dyes with black, you get a full color spectrum. In this piece I did that manually with acetate overlays. There is a huge heart surrounding this sun, and if you look closely, a horned face with yellow eyes in the form of a potted plant.

In the late sixties and early seventies, youthful Austin seemed to buck that trend. A very conscious sense of community had somehow persevered there, and only deepened when the music came to town. And come it did, with musicians streaming in from all over the state—but especially, it seems, from Dallas and Lubbock. Some, like Doug Sahm and Willie Nelson, were native sons returning home from afar as if by a beckoning. A genuine music community formed up, and it came to nest within others, both resident and incipient.

Many quickly joined these migrations for reasons all their own. Suddenly Austin seemed the place to be. But as the seventies dawned, it was still mostly a Texas kind of thing. To be sure, there were those drawn in from out of state, as if by a piper's tune. Many of those newcomers were largely from the Northeast or Midwest—black market entrepreneurs attracted by the abundance and proximity of smuggled Mexican contraband. Still, they came, and so did others—from the broad reaches of the state, and beyond.

It was within this interplay of communities that a vibrant artistic creativity blossomed. At its source were the musicians themselves, the fount of it all. They were caught as always between creative calling and economic necessity, nothing new among artists, but especially keen concerning musicians. As they settled in, they interacted with and were animated by this creativity and the sounds being made by other musicians around them. It became a cherished experience in and of itself to observe such interplay onstage as the musicians themselves evolved along with the music. This became personal as players became friends. As much as anything else, the memory and continuity of this history is what drives such occasions as that at the Saxon Pub.

I was one of the lucky ones whose work and life was infused into the music being made. I became an Austin music artist, along with a dozen or so others, just as the scene was forming up. I was fortunate to be among their number, privileged to work with the musicians and the venues, and blessed to have seen it all come to pass.

In those years when the music was young, many people bent the torque of their lives to its thrall. Career trajectories, opportunities elsewhere, and even family life accommodated or yielded to the desire to stay, to hear, and to be a part of what was taking place around the music. Because the experience was so pervasive, we willingly became part of and celebrated this community and the music that informed it.

By eight o'clock it's over. As usual, TG BaD wraps up its show with a crescendo set that concludes with "Sugaree," a 1961 jumper by Hank Ballard. In another familiar moment for the hometown music crowd, the postshow mingling begins. Outside, conversations are joined—some through pot smoke—around the buzz that the music has created.

For many, a lot of the gigs these days are like this—early, intense, and over, at the latest, by 10:00 p.m. Back in the day, this would be the shank of the evening. Many people didn't even leave the house until ten. The chasing of the muse in those early years has yielded to the awaiting of her arrival, now. True, there was more excitement and energy when the music was new and

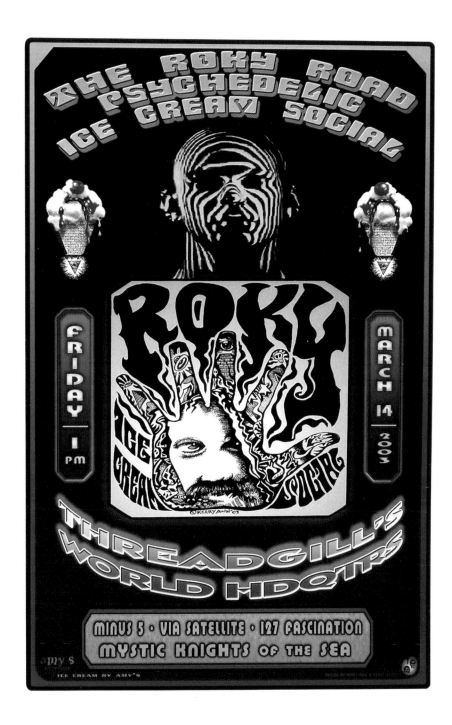

Above: **The Roky Road Psychedelic Ice Cream Social, Threadgill's World Headquarters, 2003**
Besides craving fun, music, and the absurd/weird, Austin does love its iconic musicians as well. I would argue that few are more iconic that its very own native son and innovative musician, Roky Erickson. Here, in another artistic jam—this time between me and Kerry Awn—we have endeavored to capture a bit of that community affection. Kerry did the center graphic of Roky, while I did the rest. Kerry's is drawn; mine is generated by computer. This blatant attempt at glorifying Roky is the result. The two ice scream cones are nothing more than inverted eye-topping pyramids. All the better to see you with . . .

Above: Nortons/Hole in the Wall/ Austin, 1997

Much of the art I did was logos for individual bands and venues. This one is a combination of the two—the Hole in the Wall, the venerable venue across from UT on the Drag, and the Nortons. The Nortons was a group composed of Will Indian, John X. Reed, Speedy Sparks, and Rusty Traps (their names are on the wall behind). The band was named after Ed Norton, a character on the Honeymooners, played by Art Carney. The group, originally formed by Homer Henderson, did early and classic rock and roll covers and some original pieces. One of them, "Surfing Chupacabra," is seen on the wall to left of Carney's portrait, while a quarter note illuminates the wall to his right. The year 1997 was also the year of comet Hale-Bopp, which I have enshrined in four graphics bracketing the dates.

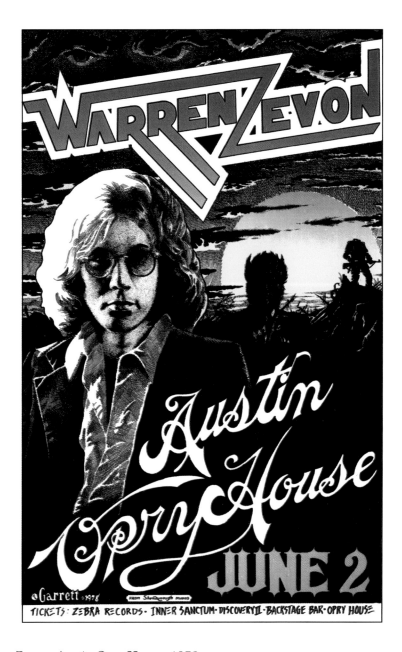

Above: Warren Zevon, Austin Opry House, 1978

In 1978 Warren Zevon was a hot commodity. Like most musicians, his success didn't happen overnight. Zevon, as a teenager, moved from Los Angeles to New York City to become a folk singer. Yes, folk singer. By 1975 he had returned to Los Angeles. He entered the So Cal rock scene and became a regular collaborator with such talents as Jackson Browne, Fleetwoood Mac, and Linda Ronstadt, all of whom covered his music. In 1978, he came out with *Excitable Boy*. It was that tour that brought him to the Opry House stage, which prompted the commissioning of this poster. After a stellar show, I made my way backstage to get his signature. Even though it had been less than ten minutes before I got there, he was obviously under the influence of something a bit stronger than beer. It was nothing I hadn't seen before, and I just chalked it up to an occupational hazard.

the hometown emerging. But now the performances are burnished by years of professional pol-ishing, and what was once raw and edgy is now tight and accomplished—with that edge having long ago penetrated the heart like an arrow.

The power of American rock and roll strikes you as you hear these guys perform it. It was a Lone Star communion of sorts, however, that made it all resonate here. To those who made and those of us who heard the music, that is where it all started. Whether it was a transistor in a dark-ened bedroom, forty-fives at a sock hop, or out on a moonlit country lane dancing to the car radio, rock and roll was our entrée into a life serenaded by music.

It was that fervor that most of us brought with us when we ventured out into the world and Austin became our home. And it stayed with us as our musical tastes matured and expanded. It was there at the Armadillo when the hippies and the cowboys came together, because both were resident within our DNA. It remained so at Antone's when white musicians, playing along-side black ones, turned the music blue. It was also just as much there at Hill on the Moon, any of Willie's picnics, or Stevie's sets at the Rome Inn. It was most certainly there at the Quiet Valley Ranch outside Kerrville. It stays with you, and it stays on.

New Austin

It's January of 2015, and other music fans move through a different doorway. This time, it's at the Burley Auction Gallery, down the road from Austin in the old German settlement of New Braunfels. There are some there who frequent the Saxon, but this group is much more widely ranged, coming in from all around the state, and some beyond. Inside, the joint is packed to over-flowing, with even more in virtual attendance via telephone and Internet. They are here to pick over memorabilia from Armadillo World Headquarters, offered up by its founder and first jefe, Eddie Wilson. Such an offering has awakened intense interest and aroused memories that swirl like vapors around a venue gone now some thirty-five years.

Through such mist the items are called forth, memories and auction emotion driving prices higher, as people seek a material connection to a place and the times that were had there. There are vintage metal and neon signs, beer clocks, display cases, countertop accoutrements, furniture, custom boots and leathers, and a baby grand piano, as well as assorted ephemera of all shapes, sizes, and purposes. Among the offerings are items that hail from the visual realm of the venerable venue. Mostly posters, some original art, photographs, and signage, they constitute a tapestry of images, woven at the outset of Austin's musical adventure.

This is part of an inevitable process. Time has rolled on, and old Austin has come to part-ing with some of the things of its past. This was stuff that at one time its dreams were made of. What stands to be ultimately lost to time though are not just items at an auction, but the notions behind them, in whatever guise they took. It's really a lot like the rapidly changing cityscape itself,

and the community that once powerfully informed and still influences it. Those notions came from that community and they, to a large degree, are what has made Austin the place that it is today, and the first placeholder in the many ways that the city is perceived.

Such notions were passionately held when the creativity that arose around it was all being laid down. The passion was such, and the success of the music so thorough, that a cultural structure emerged that was strong enough to create, support, and enhance the reputation that Austin enjoys today. At the outset, neither the local government nor the chamber of commerce did very much to bolster this culture. In point of fact, after initially being embarrassed by the attention that a bunch of hippies had somehow generated, they offered only a tepid endorsement, even when its undeniable success started to be translated into material success for both the city and its businesses. That cultural structure was really created by the "old Austin" that you hear so much about.

Now there's a new season upon the city. What was once discovered and created by countercultural refugees is now recognized by the world. We are creatures of time, and there's a sadness in us as we see familiar things depart. We knew that little paradise of ours couldn't last, but it was so rich and so nurturing, and lingered for so long, that we somehow forgot that simple fact. It was gratifying to have lived it, and doubly so to share that experience with those that came later. This place seemed made for making music—and other art.

That is just what we wanted when it all started up. The music succeeded with such ease that we knew recognition would shortly follow. It took a while, but that's exactly what happened. The posters, art, and other offerings at the Armadillo auction are part of a visual record of what took place in the hometown Austin music community. Such images record what went down when the musicians came to town, and how that changed and enhanced what happened within the city limits of Austin.

The images brought forth by the auctioneer's gavel, as well as the ones in the pages of this book, are snapshots of the music and its relationship with this state and its capital city. They tell a real story.

INDEX